Conspiracy Dwellings

Conspiracy Dwellings:
Surveillance in Contemporary Art

Edited by

Outi Remes and Pam Skelton

CAMBRIDGE
SCHOLARS

P U B L I S H I N G

Conspiracy Dwellings: Surveillance in Contemporary Art,
Edited by Outi Remes and Pam Skelton

This book first published 2010

Cambridge Scholars Publishing

12 Back Chapman Street, Newcastle upon Tyne, NE6 2XX, UK

British Library Cataloguing in Publication Data
A catalogue record for this book is available from the British Library

ISBN (10): 1-4438-1905-0, ISBN (13): 978-1-4438-1905-3

TABLE OF CONTENTS

LIST OF PLATES

Plate 6.2. Jill Magid, *Evidence Locker*, 2004. Multimedia installation including DVD edited from police CCTV footage, sound piece, novella, website. Liverpool, England. Courtesy of the artist.

Plate 6.3. Jill Magid, *Evidence Locker*, 2004. Multimedia installation including DVD's edited from police CCTV footage, sound piece, novella, website. Liverpool, England. Courtesy of the artist.

Plate 7.1. Rafael Lozano-Hemmer, *Body Movies,* 2006. Interactive projection, Hong Kong, China. Photo by Antimodular Research. Courtesy of the artist.

Plate 7.2. Rafael Lozano-Hemmer, *Under Scan,* 2006. Public art installation, Leicester, United Kingdom. Photo by Antimodular Research. Courtesy of the artist.

Plate 7.3. Rafael Lozano-Hemmer, *Surface Tension,* 2007. Venice Biennale, Italy. Photo by Antimodular Research. Courtesy of the artist. Photo by Antimodular Research. Courtesy of the artist.

Plate 7.4. Rafael Lozano-Hemmer, *Alpha Blend,* 2008. Interactive display with a built-in computerised tracking system. Photo by Antimodular Research. Courtesy of the artist.

Plate 7.5. Rafael Lozano Hemmer, *Third Person*, 2006. Interactive display with built-in computerized tracking system. Photo by Antimodular Research. Courtesy of the artist.

Plate 7.6. Rafael Lozano-Hemmer, *Standards and Double Standards,* 2004. Art Basel Unlimited, Basel, Switzerland. Photo by Peter Hauck. Courtesy of the artist.

Plate 8.1. Paula Roush with the Webcam Operators, *cctvecstasy*, 2009. Live synchronous performance at the WebCamNow and the QUAD, Derby. Courtesy the artists, AGM09: under_ctrl and Radiator Festival, Nottingham.

Plate 8.2. The Webcam Operators, *cctvecstasy*, 2009. Live synchronous performance at the WebCamNow and the QUAD. Courtesy the artists, AGM09: under_ctrl and the Radiator Festival, Nottingham.

Plate 9.1. Willie Doherty, *Non-Specific Threat,* 2004. Video still, single channel video installation, duration: 7.45. Courtesy of the artist, Matts Gallery and Alexander & Bonin, New York, London.

Plate 9.2. Locky Morris, *Town, Country and People*, 1986. Detail of the mixed media installation. Courtesy of the artist.

Plate 9.3. Philip Napier, *Gauge*, 1997. Multi-media installation (Part 1), Orchard Gallery, Derry. Courtesy of the artist.

Plate 9.4. John Aiken, *About Face*, 1991. Steel, wire reinforced glass and wood, 316 x 216 x 25 cm. Courtesy of the artist.

ACKNOWLEDGEMENTS

We would like to thank South Hill Park, artists and colleagues whom we have worked with for this book project and the Surveillance exhibitions and *Conspiracy Dwellings: Symposium on Surveillance in Contemporary Art* at South Hill Park in 2007-08. We also would like to thank Central Saint Martins, College of Art and Design, University of the Arts, London for their funding, Arts Council England for their funding of the symposium and Pam Skelton's exhibition at South Hill Park and the Arts and Humanities Research Council for their funding of the production and research of Pam Skelton's *Conspiracy Dwellings* project. We would especially like to thank all authors for their contribution and artists for offering their images as reproductions in this publication.

EDITORIAL

OUTI REMES AND PAM SKELTON

Conspiracy Dwellings: Surveillance in Contemporary Art brings together a collection of essays by theorists and art practitioners focusing on artworks made in the midst of conflict or from the position of a commentary or a critique. It presents a collection of nine essays by Anthony Downey, Christine Eyene, Liam Kelly, Robert Knifton, Verena Kyselka in interview with Outi Remes, Maciej Ożóg, Paula Roush, Matthew Shaul and Pam Skelton.

These authors provide a global selection of responses to surveillance, considering the works of artists from South Africa, Mexico, the former German Democratic Republic, Poland, Northern Ireland and the United Kingdom. The essays in this collection span the period of time from the 1970s to the present day, through a variety of topics that all converge on the subject of surveillance. These include its impact on behaviour, architecture, urban space and citizenship lived and personal experience, resistance, positionality, censorship, control and state power, civil liberties, human rights and ethics. Some of the authors comment on the ubiquitous phenomenon of surveillance cameras in the midst of our cities or digital software that is used by radical technologies that promise to revolutionise invasive surveillance techniques in the future; whilst others explore surveillance in relation to tabloid and reality-television culture and as a vehicle for creativity, voyeurism, social networking and self-promotion.

The Surveillance Studies Network in the United Kingdom uses the term "dataveillance society" to describe the country's 4.2 million CCTV cameras in which its inhabitants make, on average three hundred CCTV appearances a day.[1] Advanced technologies and current policies allow daily

[1] David Murakami Wood, ed., *Report on the Surveillance Society: For the Information Commissioner by the Surveillance Studies Network*, 2006. http://news.bbc.co.uk/1/shared/bsp/hi/pdfs/02_11_06_surveillance.pdf (accessed October 28, 2009) also: Sir Paul Kennedy, *Report of the Interception of*

data collection and the monitoring of work, travel and telecommunications, radio-frequency identification (RFID tags, mobile phone triangulation, store loyalty cards, credit card transactions, London Oyster cards for travel, satellites, electoral roll, NHS patient records, personal video recorders, phone-tapping, hidden cameras and bugs, worker call monitoring, worker clocking-in, mobile phone cameras, internet cookies and keystroke programmes.[2] Councils, police and the intelligence services make five thousand requests every year for approval to access records of communications data such as private phone, email and text records.[3] In 2009, more than seven percent of the country's population is logged on to the national DNA database.[4]

While these new technological advances become commonplace we ask to what extent is surveillance an accepted and acceptable form of mass observation. In the United Kingdom CCTV cameras are taken for granted in a shopping mall or a railway station, but where should the line be drawn and how far does surveillance have to go before it worries us, and at what point is the citizen considered a threat to the state. While surveillance serves as an accepted means against crime prevention, this collection invites further discussion on the impact and social costs of these systems to deliver what they promise. According to forty-four research studies on CCTV schemes by the Campbell Collaboration, CCTV has a modest impact on crime and is mainly effective in cutting vehicle crime in car parks, especially when used alongside improved lighting and the introduction of security guards.[5] Today, in post 9/11 times and in the midst of economic recession, political uncertainty and suspicion, we welcome debate about the use of surveillance in defining democratic and human rights and liberties, but acknowledge its creative potential in widening and introducing new dimensions to the canon of art in relation to debates which focus on the gaze, the panoptic, interactivity, the position of the

Communications Commissioner, 2009, http://www.official-documents.gov.uk/doc ument/hc0809/hc09/0901/0901.pdf (accessed October 28, 2009).

[2] Ibid.

[3] Ibid., 504,073 requests for communication data were made in 2008. The requests do not include content, only data such as numbers and time of calls.

[4] Surveillance: Citizens and the State for the Lords' constitution committee, see: http://www.guardian.co.uk/uk/2009/feb/06/surveillance-freedom-peers (accessed October 26, 2009).

[5] Brandon C. Welsh and David P. Farrington for *Camberwell Systematic Review, Effects of Closed Circuit Television Surveillance on Crime,* 2008, http://db.c2admin.org/doc-pdf/Welsh_CCTV_review.pdf (accessed October 26, 2009).

viewer, artistic self-construction, and in providing non-institutionalised exhibition space for new artistic talent in web-based projects.

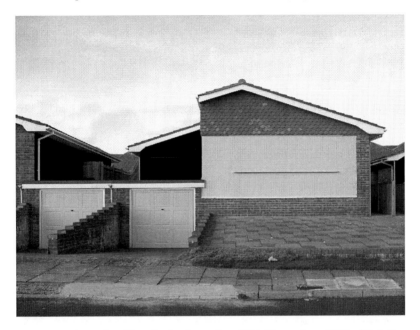

Plate 0.1 Greg Daville, *Sunk,* from the *Urbicide* series, 2005. Digitally manipulated print. Courtesy of Greg Daville's Estate.

This book is an outcome of the surveillance exhibitions at South Hill Park Arts Centre in late 2007.[6] The exhibitions consisted of four shows. The Bracknell Gallery presented *Conspiracy Dwellings: A Portrait of a Model City*, the visual art project by Pam Skelton with invited contributions of new work from C.CRED, Tina Clausmeyer and Verena Kyselka, exploring the legacy of state surveillance in the former East German city of Erfurt. Pam Skelton's essay in this collection returns to the making of her video installation and the discovery of almost five hundred files from the East German Secret Police (Stasi), locating the conspiracy dwellings active in 1980-1989. Expanding beyond the regional boundaries, the essay and the exhibition consider home as a domain for the invasion of human rights and personal autonomy.

[6] South Hill Park, Bracknell, United Kingdom, December 1, 2007-January 20, 2008.

Simultaneously, the Mansion Space Galleries presented three surveillance-related exhibitions: Greg Daville's *Rescued Items* exhibition presented two series of digital photography that explored failings and aspirations of visual, verbal, and written communication. Daville's *Rescued Items from Babel* (2003-2005) series consists of humorous self-portraits in staged environments of stored information, considering ways in which we store information at home, work and as a society. Daville's series *Urbicide* (2005-2007) considers safe space, reconstructing suburban architecture as a metaphor for the human condition with regard to planning, self-sabotage, and aspiration. Daville presents architecture without windows and doors; his spaces are safe but isolated.

Surveillance, the international group exhibition, co-curated by Outi Remes and Martin Franklin, explored political, visual, technical and social surveillance, featuring film and mixed media work by Mark Cocks, Alex Haw, Monica Heller, Sam Holden, Brede Korsmo, Kevin Logan, Victoria Lucas, Jonathan Moss, Walter van Ryn, Jodie Sadker, SLVA, Mike Stubbs, Carl Rohumaa, Cally Trench, David Valentine, Justin Wiggan and John Wild. In the Community Gallery, the *Arts and Minds* exhibition presented wall-based artwork by the patients of the Broadmoor Hospital, the West London Mental Health NHS Trust, created in the trust's adult education centre, occupational therapy units and ward, under close supervision and observation.

South Hill Park's programme included *Conspiracy Dwellings: Symposium on Surveillance in Contemporary Art* on January 18, 2008. The symposium and the four exhibitions have provided us with the opportunity to bring these debates together in this collection of essays.

Pam Skelton, Matthew Shaul and Verena Kyselka's contributions converge on the legacy of the Stasi in East Germany. Pam Skelton's essay "Konspirative Wohnungen // Conspiracy Dwellings: A Personal Report" considers with the benefit of hindsight, the unresolved and still problematic issues encountered whilst working with the Stasi Records archive. The project investigates the phenomenon of the Stasi conspiracy dwellings in Erfurt, a city in former East Germany. Avoiding the polarisation between victim and perpetrator, it draws attention to the architecture and structure of surveillance imposed on its citizens by the state. It demonstrates the complexity of memory, trauma and the blurring of the boundaries of victim and perpetrator, raising questions for artists and commentators of censorship ethics, federal data protection and German law.

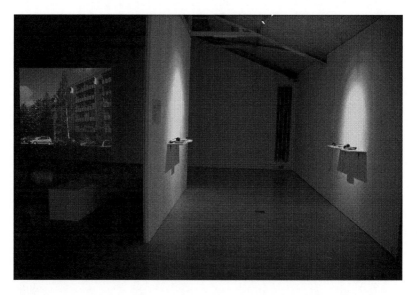

Plate 0.2 Conspiracy Dwellings: A Portrait of a Model City, 2007. Installation view, the Bracknell Gallery, South Hill Park, 2007-2008. Photo by Judith Burrows. Courtesy of C.CRED and Pam Skelton.

Matthew Shaul and Verena Kyselka focus on life under the surveillance of the East German Secret Police. In "The Impossibility of Socialist Realism: Photographer Gundula Schulze Eldowy and the East German Secret Police," Shaul writes about Schulze-Eldowy's uncompromising observations of the day-to-day reality in Berlin-Mitte from the late 1970s onwards, focusing on her photographic series *Tamerlan* and *Berlin in Eine Hundenacht*. Through interviews with the artist, Shaul connects Schulze-Eldowy's powerful photographic works to their time of production and to the critical reception they received from the Stasi.

In an interview with Outi Remes, Verena Kyselka recalls her experience as an artist, living under surveillance in East Germany. In "Pigs like Pigment" Kyselka describes the creative life of the underground art scene in the 1970s and the 1980s and the determination of many artists to make art that did not conform to the official style of socialist realism imposed by the state. The underground art scene operated with knowledge that informers mingled with artists and sympathisers while providing insider reports for the Stasi. These reports often resulted in interrogations, inquiries, investigations, court proceedings and fines for artists who were suspected of "subversive" activity.

Christine Eyene's essay focuses on the role of the artist activist in apartheid South Africa. "Gavin Jantjes, *Freedom Hunters* (1976): Subtexts and Intertwined Narrative," brings the history of resistance art and political struggle into the debate through a focused analysis of *Freedom Hunters,* a print by Gavin Jantjes. Eyene employs the images of photographers Peter Magubane and George Hallett that are used in *Freedom Hunters* to re-construct a fragment of the history of apartheid in South Africa. Drawing upon the concept of the "polyphonic dimension," developed by art historian Amna Malik, Eyene considers Jantjes' work as a vehicle to convey the multiple narratives of violence, oppression, surveillance and censorship active in apartheid South Africa at that time and in so doing connects the source of apartheid to the remnants of Nazi ideology in South African politics.[7]

In "The Lives of Others: Artur Zmijewski's *Repetition* and the Aesthetics of Surveillance," Anthony Downey examines Zmijewski's controversial film *Repetition* (Poland, 2005). Zmijewski's film recreated the conditions of the infamous Stanford Prison experiment, conducted by research psychologist Philip Zimbardo in 1971. Following Zimbardo's model, Zmijewski recruited unemployed volunteers who were arbitrarily allocated the role of prison guards or prisoners and observed in a constructed prison built by Zmijewsk. Over a period of six days camera's recorded the inmates and the guards until the participants called a halt to the experiment on the seventh—it had got out of hand. The film exposed a disturbing aesthetics of surveillance by which according to Downey the viewer is co-opted into a contrived and disturbing scenario.

In "You'll Never Walk Alone: CCTV in Two Liverpool Artworks," Robert Knifton addresses the manipulation of narrative adhering to images, and the performance of identity within CCTV. On February 12, 1993 the toddler James Bulger was abducted and murdered. The moment of his abduction in the shopping centre by two older children was captured on CCTV. In 1994, using this widely reproduced CCTV footage, artist Jamie Wagg exhibited *History Painting: Shopping Mall* at the Whitechapel Open Exhibition. The press vilification of the artist for using this material raises a host of issues about art's engagement with CCTV, crime and surveillance. Knifton also considers Jill Magid's *Evidence Locker,* a work in which the artists recorded presence on Liverpool's CCTV network as she walks the streets of Liverpool is mapped and later retrieved. The artist requested access to this footage using "subject access request forms"

[7] Amna Malik, "Conceptualising Black British Art through the lens of Exile," in Kobena Mercer, ed. *Exiles, Diasporas & Strangers* (London: Institute of International Visual Arts; Cambridge, MA: MIT Press, 2008), 166-188.

which take the form of love letters to the CCTV operator. Magid's work combine's an uneasy set of contentions about the control exerted through watching, together with the desire to be viewed whilst submitting herself to the gaze.

Maciej Ożóg and Paula Roush also take up the seemingly paradoxical characteristics of surveillance in media practices and interactive technologies that co-opt the participation of user's in artworks that oscillate between the desire to be seen and the fear of observation. Maciej Ożóg's essay "Surveilling the Surveillance Society: The Case of Rafael Lozano-Hemmer's Installations" focuses on artist Rafael Lozano-Hemmer's use of digitally enhanced and augmented optical tools of surveillance and post-optic devices to create interactive installations that map a hybrid reality of surveillance culture. Lozano-Hemmer's public art work comments on the very nature of interactive technologies which draws attention to the present state of surveillance that is mirrored at the core of interactivity and the construction of its technology. Although based on principles of participation, activity and freedom of choice, interactivity Ożóg maintains, depends on voluntary exposure to technological observation.

In "From Webcamming to Social Life-Logging: Intimate Performance in the Surveillant-Sousveillant Space," Paula Roush examines the relationship between webcamming and the subversion of surveillance in her artistic practice that explores webcam communities as a platform for cyberformance curating. In these online communities, cam girls and female artists perform hybrid online-offline interventions to create an intermedial time space, characterised by the aesthetics of webcam "grab" a term proposed by Theresa Senft to describe the dynamics of web spectatorship. "Grab" is not characterised by voyeurism but commodity fetishism, which women webcam operators resist, due to their inevitable failure to please all consumers/viewers, all the time.

Liam Kelly is also, considering a hierarchy of dominance between "controller" and "controlled" in the binary between seeing and being seen. Kelly discusses the architecture and the emotional and physical environment of surveillance through the work of artists Willie Doherty, Locky Morris, Philip Napier, John Aiken, Dermot Seymour, Rita Duffy and Paul Seawright. Kelly's essay "Seeing You/Seeing Me: Art and the Disembodied Eye" examines the emotional fabric of the surveilled environment in Northern Ireland in the 1980s and beyond. Kelly considers the ways which these artists have interrogated and engaged with surveillance and intelligence gathering, landscape and the environment to present the city as a written text that can be deconstructed.

In its variety of approaches to art and its relation to surveillance, we hope that this collection will be of particular interest to artists, art and cultural professionals, scholars and art historians. We also hope that it provides a reference for anyone interested in the political and social implications of surveillance in relation to behaviour, technology, policies, habits and desire that both encourage and discourage artistic creativity and enable our daily life to be recorded.

KONSPIRATIVE WOHNUNGEN //
CONSPIRACY DWELLINGS:
A PERSONAL REPORT

PAM SKELTON

Introduction

A tram rattles by; somewhere a dog barks, church bells ring, children, an airplane, birds and wind. This is the sound of normal life in Erfurt. Slowed and distorted, as if through cotton wool, the same noises can be heard in the local art gallery as audio tracks in the videos of English artist Pam Skelton. Façade by façade, picture by picture, the houses of Erfurt blend together in these videos. The viewer sees the city of the present and at the same time stands in its past. A code is written on every picture: the identification of a Stasi conspiracy dwelling. Guidance officers and informants would meet in those flats. And like the informers, those meeting points would be given names: 'Rose' or 'Nelke,' 'Gitta Frenzel' or 'Paul Dunkel,' 'Schiene' or 'Prag.'[1]

Konspirative Wohnungen // Conspiracy Dwellings is a visual arts project that explores the legacy of state surveillance in former East Germany in the last decade of the regime's existence from 1980-1989. The project has revealed a network of almost five hundred secret apartments in Erfurt that the former East German Ministry of State Security (Stasi) used for

[1] Liane von Billerbeck, "Plazchen fur IMS, Ein Kunstproject uber konspirative Wohnungen der Stasi entzweit Erfurt" (Places for Informers an Art Project about Stasi Conspiracy Dwellings Divides Erfurt), *Die Zeit*, Nr. 46, November 8, 2007, Feuilleton, 56. Translated by Henrik Potter.
http://www.zeit.de/2007/46/Plaetzchen_fuer_IMs (accessed November 23, 2009).

meetings with their informers. The conspiracy dwellings were "safe houses" rented or borrowed specifically for the purpose of surveillance. It was in these rooms that an informer was briefed and assignments given that would involve spying on friends, family or colleagues.

The study of the conspiracy dwellings developed from discussions with statistician and Stasi historian Joachim Heinrich that began in late 2002. My ongoing work on the relationship between specific sites and their histories had prompted these discussions and had resulted in this collaborative cross-disciplinary research with two distinct streams, an art project and a social scientific study. In September 2007 a series of audio/visual installations were displayed in the former East German city of Erfurt. This essay aims to confront some of the issues that arose in the process of working on this project and to consider the complexities and contradictions encountered whilst working with a politically sensitive archive and a contested past.

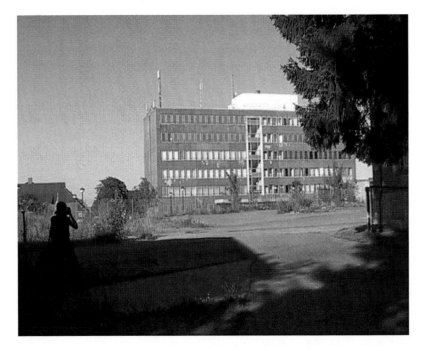

Plate 1.1. Pam Skelton, 2003. Stasi Headquarters, Erfurt, digital image. Courtesy of the artist.

The Stasi in Erfurt

The German Democratic Republic commonly known as East Germany was established as a socialist state created in the Soviet Zone of occupied Germany in 1949. The four decades of its existence (1949-1990) were defined by the Cold War, an era of antagonism between the United States and the Soviet Union and their respective allies. In 1950 the Socialist Unity Party (SED) established the Ministry of State Security (MfS), otherwise known as the Stasi, to protect the socialist German State from its enemies.

In 1991 the Stasi Records were opened to the former citizens of East Germany. This meant that, henceforth, the people had the right to apply to see their Stasi files. Access to these files would reveal the identity of those who had informed on them. In the early 1980s surveillance intensified as the regime became weaker, with the number of informers estimated at one in every sixty-eight people.[2] The informers often led double lives, oscillating between an ordinary everyday existence and that of a Stasi informant. Art, culture and religion were targeted as being of particular interest to the Stasi and people associated with these areas were routinely monitored. The average citizen experienced the Stasi as an omnipresent force creating unease, distrust, suspicion and self-censorship: they lived "in the belief that they was being furtively recorded and analysed."[3]

It is within this political climate that my project collaborator, Joachim Heinrich, had grown up. In the 1980s Heinrich was based in Erfurt, worked at the university and was a leading environmental activist in a group that was closely monitored by the Stasi. This had earned him the title "Enemy of the State," an appendage that could have led to his imprisonment. The damage that the Stasi inflicted on people's lives is described by Gerd Popper in James A. McAdams's book, *Judging the Past in Unified Germany* in terms which bear a general resemblance to Heinrich's experience:

> Over the years the Stasi had managed to destroy entire families by deliberately sowing mistrust between husbands and wives, parents and children. Under pressure from the MfS [Stasi,] teachers and school administrators had been persuaded to inform on their students in exchange for petty privileges and cash bonuses. University professors had been spied

[2] This would amount to 174,000 informants and 91,000 full time agents in a population of only seventeen million.
[3] Barbara Miller, *Narratives of Guilt and Compliance in Unified Germany* (London and New York: Routledge, 1999), 3-4.

on by their colleagues and tips from collaborators had regularly resulted in harassment by the police. 'The Stasi systemically sought to destroy our personal and professional lives. It was criminal. Worse than that, it was evil.' (Dissident Gerd Popper).[4]

After unification Heinrich moved to Munich while retaining a professional base in Erfurt. Working with the environmental group's Stasi files in which he was named, he has since continued an ongoing study of the surveillance practices of the Stasi in Erfurt.

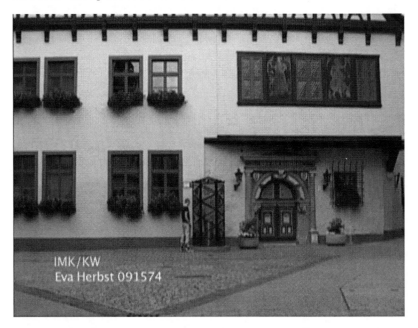

Plate 1.2. Pam Skelton, *Konspirative Wohnungen // Conspiracy Dwellings,* 2007. Video still (Old Town), a five channel video installation and public art project, Erfurt, Germany. Courtesy of the artist.

My first fieldtrip to Erfurt took place in July 2003. It had changed a great deal since my last visit there shortly after unification in 1991. Tourist brochures now describe Erfurt, the regional capital of Thüringia, as "possessing a charming blend of wealthy townhouses and reconstructed half-timbered buildings, overlooked by the towering spires of St. Mary's

[4] James A. McAdams, *Judging the Past in Unified Germany* (Cambridge: Cambridge University Press, 2001), 56.

Cathedral and the Church of St. Severus." The city, renowned for its cathedral, university and connections to Martin Luther was carefully renovated after German re-unification. It is considered to be one of the finest medieval centre's in Europe. In contrast, Heinrich's city took shape as a hybrid space occupying both past and present and filled with memory. Our excursions around the city contrasted with the tourist itinerary described above. It consisted of visits to the derelict or transformed sites of the former Stasi Administration that to me appeared incongruous in their close proximity to the charms of the old town. We visited the room in which the environmental group's meetings had taken place; the flat where Heinrich had lived; a tributary of the river Gera that had been a main focus of the environmental group's campaign. Heinrich had brought with him a mysterious, unauthorised list made up, as it turned out, of a mixture of Stasi's conspiracy dwellings and other surveillance outposts. I studied the list with great interest. That week we visited some of the dwellings, notably Hotel Erfurt, situated opposite the station and Café Rommel where we drank tea.

My interest in these clandestine meeting places was not without misgivings. I was therefore keen to hear the opinion of others. In Heinrich's view the conspiracy dwellings were no longer a sensitive issue; the subject may not even especially interest the people of Erfurt. The feedback from the meetings at the Erfurt Stasi Documentation Centre and the Thüringen State Commission for the Stasi Documents (TLStU) was reassuring. They recommended that we submit a written application to the Federal Commission for the Stasi Documents (BStU) in Berlin to access the files.[5] However, this would be dependent on the retrieval of index F78 Strassendatei, a street map that contained the addresses of the conspiracy dwellings.

In the autumn of 2003 Heinrich submitted the application to the BStU and established a partnership with the Frederick Schiller Universität in the nearby town of Jena. This affiliation would subsequently bring sociological

[5] The BStU is an independent authority that is responsible for administering the Stasi Records. It is an archive which reputedly holds a labyrinthine 180 kilometers of records. The BStU was set up to protect the interests of the victims of the GDR and administrates applications to access files. It offers researchers a unique resource for study. The TLStU and the Erfurt Stasi Documentation centre are State outposts of the BStU. http://www.bstu.bund.de. (accessed December 10, 2009).

expertise to the project and would result in the publication of the book *Gehëime Trefforte des MfS in Erfurt*.[6]

Heinrich's research focused on a study of the conspiracy dwellings files. His detailed analysis of the files was to shed new light on the process of recruitment, maintenance and their pattern of distribution in Erfurt. For example, his work revealed that the Stasi preferred to rent rooms directly from reliable comrades, many of whom were the widows of communist party members. Candidates were required to be forty to sixty years old, male or female, married or single, without children in the household and either sympathetic to the Communist Party or members of it. The number of individual rental agreements made with the Stasi amounted to approximately sixty percent.[7] The tenant or owner of the flat was known as the "informer of the conspiracy dwelling" (Inoffizieller Mitarbeiter de Konspiration, abbreviated as IMK). These people were not involved in spying; their role was to liaise with the Stasi guidance officer to guarantee secrecy and ensure that the preparations prior to each meeting with the informer went smoothly. The flat must be left empty—refreshments such as coffee and cakes, beer and tobacco, must be prepared in advance and left ready on the table. Only the Stasi guidance officer would know the identity of the informer who would come to the flat on a designated day and time.

Work in Progress

In July 2004 I was able to study copies of the conspiracy dwellings files together with an early version of the street index database that Heinrich had prepared. It was a sobering thought to consider the extent that internal security played in the paranoid delusions of a state that was in fear of its own population. The files contained copious descriptions of the premises, information about the facilities and plans of each property. They also contained photographs of the façades and views from the buildings. Windows, entrances and stairwells of the conspiracy dwellings, and even nearby bus stops, were often marked in pen.

I did not want to draw attention to individual narratives of blame or guilt and it was important not to implicate any of the residents who lived

[6] This is translated as "The Secret Meeting Places of the Stasi in Erfurt," *Gehëime Trefforte des MfS in Erfurt*, ed. Heinrich Best, Joachim Heinrich, Heinz Mestrup (Erfurt: TLStU, 2006).

[7] Joachim Heinrich, "Topographie KW Erfurt" in *Gehëime Trefforte des MfS in Erfurt*, ed. Heinrich Best, Joachim Heinrich, Heinz Mestrup (Erfurt: TLStU, 2006), 12-51.

in the flats. Heinrich and I both agreed that the addresses and exact location of the conspiracy dwellings should remain unknown. Whilst I was at least clear about this, I was concerned about the apparent lack of guidelines available on data protection for the Stasi Records. I was also puzzled by the vagueness of our project collaborators and advisors who seemed reluctant to discuss the sensitive issue's that underpinned this study. Had the Thüringen State Commission for the Stasi Records and the researchers at the Frederick Schiller Universität whom I had consulted explained the laws of data protection regarding the Stasi Records I would have been alerted to the potential pitfalls that awaited the project.

> Buildings shelter life by sustaining a collective sense of time, a form of cultural synchronisation. Buildings act as a reassuringly stable witness of whatever we do by surviving longer than us and evolving more slowly.[8]

Mark Wigley in the above quote evocatively illustrates the quality of reassurance that buildings can induce. Buildings can be seen as our protective skins and the domestic space of the home is normally a place of security, a retreat from the rest of the world. In *Conspiracy Dwellings* the home has lost it "homely" quality. Discussing this with cultural geographer Jessica Dubow she notes that they are disturbing, precisely, because the camera stands as a vehicle of mediation between the conventions of architecture and the representation of state power. Dubow suggests that it is the keeping of secrets, of turning away, that makes the conspiracy dwellings "a place of surface…a disengagement with probing."[9]

The conspiracy dwellings were located throughout Erfurt, dispersed in the housing estates in the suburbs that converged on Moskauer Platz, Berliner Platz, Roter Berg and Rieth in the north; Herrenberg, Wiesenhügel and Melchendorf in the south. They were to be found in the Old Town, in the city centre shopping precincts, the bourgeois villas south of the railway station and the tower blocks of the Juri-Gagarin-Ring that flanks the inner ring road of the city. Many of these streets and estates were named after the cities and heroes of the Soviet Union that commemorated the four decades of housing projects undertaken by the East German state.

I spent the summer months of 2004-2007 documenting the buildings. My day would begin early with a large-scale map of Erfurt and a spreadsheet containing a list of the addresses. The first task was to locate

[8] Mark Wigley, "Insecurity by Design," in *In-Security, Cahier on Art and the Public Domain*, vol. 6 (SKOR, 2004), 105.
[9] *Pam Skelton and Jessica Dubow in Conversation*, April 29, 2009, Institute of Contemporary Interdisciplinary Arts, University of Bath.

each of the street names on the map and to mark them with a coloured felt tip pen.

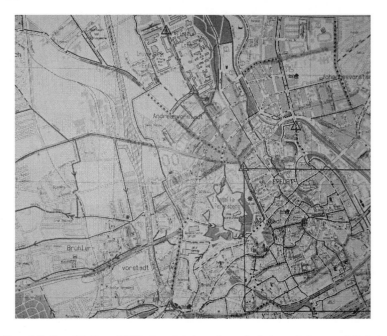

Plate 1.3. Pam Skelton, 2006. Annotated section of photocopied map of Erfurt. Courtesy of the artist.

The next step was to transfer this information onto enlarged photocopied sections of the map; these provided me with my itinerary. Each day I would set out with a monopod, (a one legged tripod) a compact video camera and provisions in a backpack to document the conspiracy dwellings.

In the Old Town and city centre areas, I discovered that the conspiracy dwellings were mainly located in rooms above shops, or in offices and public buildings. In the suburbs they were mainly hidden in estates of anonymous flats in quiet leafy streets. A number of roads had been renamed after German unification and some housing blocks containing conspiracy dwellings had been demolished.

Plate 1.4. Pam Skelton, *Konspirative Wohnungen // Conspiracy Dwellings,* 2007. Video still (Juri-Gagarin-Ring), a five channel video installation and public art project, Erfurt, Germany. Courtesy of the artist.

I became aware of the various positions that the act of recording induced. My intervention represented the position of the objective observer, the voyeuristic lens of the camera, the eye of the informer and the all-seeing Stasi. In practice, the unease I experienced while pointing the camera arose or subsided depending on how potentially intrusive my viewpoint might be. I often felt as if I was spying on a community. Although I was not secretive, the acts of documenting the dwellings were still not fully transparent. Someone might ask me what I was doing, but this happened rarely. Most of the time I was left to the practicalities of filming and navigating the city on my bicycle. The bicycle was my preferred means of transport as it enabled me to get to know the city in detail. As I cycled, I became aware of the distinct character of each of the districts I visited. I also noticed that the conspiracy dwellings were often grouped in close proximity to each other and that the highest densities were clustered in the Juri-Gagarin-Ring.

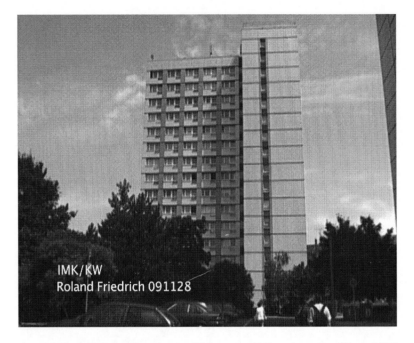

Plate 1.5. Pam Skelton, *Konspirative Wohnungen // Conspiracy Dwellings,* 2007. Video still (Juri-Gagarin-Ring), a five channel video installation and public art project, Erfurt, Germany. Courtesy of the artist.

Alongside the documentation of the conspiracy dwellings, the applications for funding continued, as well as the search for possible exhibition venues in Erfurt. These processes were supported by some of the most active and influential arts workers in the area. In particular Frank Motz, the director of the ACC Gallery Weimar, the artist and curator Verena Kyselka and Frank Hiddemann then the curator of the Evangelischer Kunstdienst without whom the exhibition and public art project in Erfurt would not have taken place.

Konspirative Wohnungen // Conspiracy Dwellings: an exhibition

The public art project and exhibition directed and managed by Verena Kyselka opened on September 28, 2007 at Kunsthaus Erfurt in three of its gallery spaces and at five satellite venues: Erfurt Town Hall, Berliner Platz Public Library, Radisson SAS, Erfurt, glassbox Gallery, University of

Erfurt, and the State Parliament of Thuringia. This was made possible by a grant received from the Federal German Culture Foundation.[10]

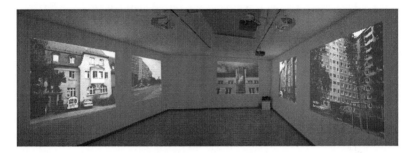

Plate 1.6. Pam Skelton, *Konspirative Wohnungen // Conspiracy Dwellings,* 2007. View of the installation at Gallery Kunsthaus Erfurt, A five channel video installation and public art project, Erfurt, Germany. Photo by Falko Behr. Courtesy of the artist.

The ground floor gallery at Kunsthaus Erfurt contained information about the project and events that had been organised to run alongside it. On display was Heinrich's digital print of the map of Erfurt that indicated the positions of the conspiracy dwellings. Tina Clausmeyer's visualisation of the Stasi dwellings was exhibited as a double-sided black and white poster.[11] Heinrich's book *Geheime Trefforte des MfS in Erfurt,* together with other books on the Stasi, published by the TLStU were free on request.[12]

In the first floor gallery the five looped videos of *Conspiracy Dwellings* were projected onto the walls. I had edited the video footage into five sections representing the districts of Erfurt: "Old Town and City Centre," "Juri-Gagarin-Ring," "City North," "Northern Suburbs" and "South Erfurt." Superimposed alongside the images of the façade's as they appeared on the projections lay the code names and registration numbers of each of the conspiracy dwellings. Statements by anonymous bystanders, informers and Stasi officers came into view intermittently.

[10] We had entered into a partnership with the Thüringen State Commission for the Stasi Documents to fulfil the Federal German Culture Foundation's requirement that funded projects are facilitated by a German organisation. http://www.conspiracydwellings.net (accessed November 23, 2009).

[11] Tina Clausmeyer was a research assistant on the project.

[12] The TLStU is the Thüringen State Commission for the Stasi Documents. http://www.thueringen.de/tlstu/index.html (accessed November 23, 2009).

In the basement gallery *Permanent Ignition: The Stasi Edits*, a work by the artists group C.CRED (Ola Stahl and Kajsa Thelin) was presented as an audio installation in four sections. The work was compiled from edited conversations between the artists and interested individuals from Erfurt, who had volunteered to talk about different aspects of life in East Germany. These conversations took the form of convivial discussions in informal circumstances and places. *The Stasi Edits* opened up a cross-section of positions that brought together some of the contradictory aspects of life in the former East German State such as "co-existence and conflicting views," "positions and politics," "victims and perpetrators," "guilt and forgiveness," "coexisting and conflicting ways of talking about the Stasi." Visitors to the exhibition could "take time to listen" to the audio works presented. Christoph Tannert describes them as "all full to the brim with thought and commemoration, provoking, surprising, peculiar, shocking...".[13]

Art and Politics

A few days after the opening of the exhibition in Erfurt a list containing the full addresses of the conspiracy dwellings was presented on Joachim Heinrich's website.[14] Powered by Google maps and Google Earth any Internet user could now easily locate and identify the conspiracy dwellings in map, satellite or hybrid format. The work had been launched on the back of the art project for maximum effect without my agreement and without my knowledge. The reason for the disclosure, according to Hildigund Neubert the Commissioner of the Thüringen Commission for the Stasi Records, was for the sake of transparency and clarity. The publication of the full addresses would prevent innocent people from being accused.[15] Heinrich also offered the same justification. However, according to his research the collaborators who rented their rooms to the Stasi were often elderly widows "mainly of pensionable age" that had

[13] Christoph Tannert, "Take Time and Listen," and C.CRED, "Permanent Ignition: The Stasis Edits," in *Konspirative Wohnungen // Conspiracy Dwellings*, ed. Verena Kyselka and Jörg M Schindler, exhibition catalogue (Kunsthaus Erfurt, 2007), 19-23 and 35-40. These essays and others are also available from the project website.

[14] http://www.stasi-in-erfurt.de/ (accessed December 5, 2009). The interactive webpage is powered by Google maps, financed by the Thüringer Kulturministirium and supported by the Thüringen State Commission for the Stasi Documents (TLStU).

[15] Liane von Billerbeck, *Die Zeit*, op.cit.

"received as recompense between 30-50% of their total rent."[16] With this in mind, it is difficult to determine what research function could be served by the publication of these addresses. Verena Kyselka the director of the art project, points to the bitter exchange that followed with the Landesverwaltungsamt (National Administration Office) about data protection.[17] The Landesverwaltungsamt had initially called for the removal of the conspiracy dwellings addresses on Heinrich's website for reasons of confidentiality, although the German law allowed their publication (a fact that many people including myself were ignorant of).[18] A few days later, this ruling was withdrawn and the site was allowed to remain online after discussions with Joachim Heinrich and Hildigund Neubert, the Commissioner of the Thüringen Commission for the Stasi Records (TLStU).[19]

The TLStU had administrative power over the art project and influenced it financially (they administered the grant awarded by the Federal German Culture Foundation). They also were influential in other ways that proved to be detrimental. First, they took control of the art project by dismissing our original commissioning partner, the Evangelischer Kunstdienst for having exhibited the work of the prominent East German artist Willi Sitte.[20] Next, they effectively altered the context of the art project by their backing of Joachim Heinrich's Google map webpage and finally, they cancelled the scheduled debate "State Surveillance Today" due to take place on the last day of the exhibition.[21] Birgit Kummer reported:

[16] Joachim Heinrich, "Topographie KW Erfurt" in *Gehëime Trefforte des MfS in Erfurt*, op.cit., 33.

[17] Birgit Kummer, "…Betroffenheit ist kein gutter Ratgeber," *Erfurter Algemeine*, November 9, 2007.

[18] The Stasi Records Law of 1991 (StUG) gives the Federal State Commission for the Stasi Documents (BStU) exclusive rights in the dissemination of the Stasi Records:
http://www.bstu.bund.de/nn_710372/EN/Office/Legal__Bases/Stasi__Records__A ct/stasi__records__act__node.html__nnn=true (accessed December 18, 2009).

[19] Thomas Gerlach, "Der Spitzel als Gast," *Die Welt Magazine,* November 20, 2007, 10.

[20] Willi Sitte is considered together with Werner Tübke as being the most important artists from communist East Germany. Sitte is a controversial figure. He was the president of the official Artists Union and a strong defender of communism and the SED (Socialist Unity Party).

[21] Cancellations of this kind are more normally associated with censorship in the GDR era.

Hildigund Neubert, the commissioner in charge of the Stasi Records, cancelled the closing event at the Max Weber College in Erfurt on the grounds of political imbalance... The panel discussion "State Surveillance Today" had included Professor Rosemarie Will, a former member of the Socialist Unity Party of Germany (SED). Rosemarie Will is currently Director of the Humanist Union at the Humboldt University in Berlin and was, until 2006, a judge at Brandenburg's constitutional court. Internet activist, Michel Blumenstein and political researcher Dr. Ruediger Bender, among others, accepted the invitation to speak at the event... Hildigund Neubert yesterday defended herself on the grounds that the Interior Minister and the State Investigation Bureaux would not take part. "I had wanted a controversial debate and not a one sided criticism." She found the whole episode "not so dramatic."[22]

The Return of the Past

The subject of conspiracy dwellings had arisen twenty years earlier and is considered in journalist Jurgen Gottschlich's account of the nine thousand addresses published in *taz* on 18 June 1990. Gottschlich was the chief editor for domestic politics for *Tageszeitung (taz)*, a left liberal daily paper produced in West Berlin. At this time the editorial staff of the paper's East German edition had been integrated with the West German board. Gottschlich recalls how a disc containing a list of all the Stasi conspiracy dwellings came into their possession. In his article he does not say how this disc was acquired, but mentions that journalists often came across Stasi material both legally and illegally. During editorial discussions, Gottschlich was made aware by his East German colleagues that they were hesitant to publish the list of addresses. The list was published despite their reservations. Gottschlich maintained, "not a single person was victimised as a result of our action." The East German journalists had objected firstly on the grounds that the publication of the addresses would not be constructive and would open old wounds. They also felt that the flats might have new tenants who would be wrongly suspected of Stasi connections that they never had. Random visits to the listed flats were then organised by the West German reporters, which according to Gottschlich showed that most of them were empty. However, this did not change the minds of his East Germans colleagues many of whom left the paper.[23]

[22] Birgit Kummer, "Publikum musste wieder gehen" *Erfurter Allgemeine*, November 16, 2007.Translated by Henrik Potter.

[23] Jurgen Gottschlich, "The Price of Truth: how disclosures affect Germany's East-West relations" in *Track Two. Focus: Truth, Reconciliation and Justice*, vol. 6, no. 3-4, (Centre for Conflict Resolution and Media Peace Centre, 1997), 21,

The opinions of Gottschlich's East German colleagues were over-ruled and justified by the conclusion that "not a single person was victimised," yet whether this claim can be verified is left in doubt. Certainly seventeen years later, the publication of the Erfurt conspiracy dwellings (this time on an Internet site) is still a controversial and challenging issue. The lack of complaints received by the Stasi Records Commission perhaps speaks of a concern that is muted rather than revealed or resolved.

The important role attributed to research into the Stasi Records is without doubt justified, but the extent to which these records can be used to shed light on past misdeeds needs to be closely scrutinised. James A. McAdams points to the grey areas that surround the Stasi legacy in which the misdemeanours of collaborators ranged from serious crime to petty complicity and where it is not always clear to establish where guilt lies in what had been described as a "deformed" society where the avoidance of involvement with the Stasi was virtually impossible.[24] German author Stefan Heym's assessment of the Federal State Commission for the Stasi Records (BStU) is also revealing. In its legal confrontation with the Stasi legacy he claimed that together with another government body set up to administer the sale of the East German state properties the BStU had "more power than the Politburo in deciding individual fates."[25]

Summing Up

At the opening of the exhibition at Kunsthaus Erfurt, Frederike Tappe-Hornbostel, representing the German Federal Cultural Foundation, emphasised in her address the value of shifting the focus of enquiry away from the victim/perpetrator paradigm. She also identifies the inherent tension and contradiction of this position in a country where wounds run deep. Tappe-Hornbostel writes:

> We are accustomed to re-evaluating the past in terms of perpetrators and victims. Oddly enough, this project does not take this approach. What do we see when we view (the images of) the conspiratorial apartments? Are

http://www.ccr.uct.ac.za/archive/two/6_34/p21_international.html (accessed November 23, 2009).
[24] James A. McAdams, *Judging the Past in Unified Germany* (Cambridge: Cambridge University Press, 2001), 61.
[25] Cited as a reference to BStU (Federal State Commission for the Stasi Documents) by the writer Stefan Heyme in Barbara Miller's *Narratives of Guilt and Compliance in Unified Germany* (London and New York: Routledge, 1999), 91.

they memorials to the perpetrators? Are they memorials to the victims? What we see are pictures in which both the perpetrators and victims are absent. From a German point of view, this approach might seem quite embarrassing or even offensive. Yet it emphasizes the quality of Pam Skelton's project as much as the intelligent decision of the Kunsthaus Erfurt to trust a foreign artist with such a sensitive subject.[26]

It must be remembered that Tappe-Hornbostel's speech was delivered prior to the disclosure of the conspiracy dwellings addresses; but many of the tensions inherent to the project had already been felt. Nevertheless, the events that were to overtake *Conspiracy Dwellings* cannot have been other than a source of concern and embarrassment for the projects funders as well as friends and supporters. Joachim Heinrich's website provoked a strong reaction and a great deal of media attention by its use of shock tactics. It also reveals a flaw in a system that negates the reconciliation of a difficult past. Subsequently, Heinrich went further by placing on his website the real name and photograph of a man who had informed on him and was forced to defend himself at court. Much of the media coverage and the interactive map can be found on his website.[27]

Inevitably this essay raises many more questions than it has been able to answer, with concerns that far exceed this author's knowledge of history and politics. Yet, Germany's two dictatorships remain embedded as symptoms of a past that still haunts the present. How could it be otherwise? Inevitably, it is the victor's justice that determines how history is represented as Andrew H. Beattie implies: the mission of the German parliament is "not the reconciliation between victims and perpetrators, or the understanding between westerners and easterners," but the "contestation of political legitimacy with reference to history."[28]

Two months after the close of the exhibition in Erfurt *Conspiracy Dwellings: A Portrait of a Model City* opened in South Hill Park, Bracknell, England. This did not give me very much time to digest the tumultuous events that had taken place in Erfurt. It offered me however, the opportunity to re-think the original installation in a more neutral

[26] Frederike Tappe-Hornbostel, German Federal Cultural Foundation. Quoted from her opening speech on September 28, 2007, Kunsthaus Erfurt.

[27] http://www.stasi-in-erfurt.de/, op.cit.

[28] The Bundestag's two Commissions of Enquiries were "Working through the history and consequences of the SED Dictatorship" and "Overcoming the Consequences of the SED Dictatorship in the Process of German Unity," Andrew H. Beattie, *Playing Politics with History, The Bundestag Inquiries into East Germany* (New York and Oxford: Berghahn Books, 2008), 128, 245-254.

setting and to consider the ways in which at least some of the issues encountered could be brought to other audiences.[29]

At South Hill Park, the visitors to the exhibition did not share the same personal history as the citizens of Erfurt and anyway *Conspiracy Dwellings* was shown there in the context of other exhibitions about surveillance. The school groups that visited the exhibition related to it as part of their class discussion about human rights. That the simultaneous exhibition of work by the Broadmoor Hospital patients was considered more controversial can be considered an important lesson.[30]

[29] *Conspiracy Dwellings: A Portrait of a Model City,* South Hill Park, Bracknell, United Kingdom, December 1, 2007-January 20, 2008.

[30] *Conspiracy Dwellings* was funded by the Arts and Humanities Research Council, the German Federal Culture Foundation, Arts Council of England, the Thüringen State Commission of the Stasi Archives and South Hill Park Arts Centre.

THE IMPOSSIBILITY OF SOCIALIST REALISM: PHOTOGRAPHER GUNDULA SCHULZE-ELDOWY AND THE EAST GERMAN STASI

MATTHEW SHAUL

Twenty years after its demise the enduring image of the German Democratic Republic (GDR) in the collective mind of the West remains the swathe that the Berlin Wall cut across Germany's capital city and the tightly circumscribed and relentlessly monitored society that languished behind it.

So efficiently did East Germany's monolithic security apparatus the Ministry for State Security[1] and the country's hermetic political and social culture obscure the realities of life behind the "Wall" that it comes as a surprise to discover the richly bohemian culture that was able to develop in the forty years of the GDR's existence out of sight of, but in many ways responsive to, western popular culture. Most surprising perhaps is that, as hermetic as it was, the inner German border, while an efficient barrier to personal interaction, was entirely porous to the currency and exchange of ideas with almost the entire country able to enjoy unrestricted access to West German television broadcasts.[2]

This porosity was particularly potent in the realm of photography, and was primarily the result of the affinities a group of photographers centred at Leipzig's influential High School for Graphic and Book Arts,[3] had

[1] The Ministerium für Staatssicherheit (or MfS).

[2] The only part of the former East Germany that experienced any difficulty at all in receiving Western television broadcasts was Dresden and Eastern Saxony as far as the Polish border. This area was known accordingly in East German slang as *Tal der Ahnungslosen* (valley of the clueless). For further information on the influence of West German television in the GDR see: Hans Jörg Stiehler and Michael Meyen, *"Ich glotz TV" Die Audiovisuellen Medien der Bundesrepublik als kulturelle Informationsquelle für die DDR* in *Klopfzeichen Kunst und Kultur der 80er Jahre in Deutschland*, ed. Bernd Lindner and Rainer Eckert (Leipzig, 2002).

[3] The High School for Graphic and Book Arts (Hochschule für Grafik und Buchkunst or HGB, Leipzig) was East Germany's sole art school offering the

developed with the "documentary" photographic aesthetic pioneered by western practitioners such as Walker Evans, Henri Cartier-Bresson and Robert Frank.[4]

In a tightly controlled society, which rejected photographers' status as autonomous artists, photography surprisingly offered a uniquely plural, democratic and even critical visual language which was in substantial dialogue with, and responsive to developments in the West. This dialogue between East German photographers and their colleagues in the West and the unique photographic landscape that developed out of it owes an enormous debt of gratitude to the French Cultural Institute in East Berlin for providing an unexpected forum for the exchange of ideas and methodologies. The institute's director, Dominique Paillarse, recognised the richness of the GDR's photographic culture and arranged frequent visits to East Berlin by luminaries of the documentary tradition such as Henri Cartier-Bresson, Robert Frank and Helmut Newton, many of whom maintained professional contacts with their East German colleagues that lasted many years.[5]

Through an examination of the Stasi's *modus operandi*, and an interview with the artist, I intend to "map" the East German state's increasingly inept and inexact attempts to constrain both the practice and the public profile of a young Berlin based photographer, Gundula Schulze-Eldowy, from the late 1970s through to the final collapse of the Berlin Wall in November 1989. I will also demonstrate the difficulties the surveillance apparatus experienced in developing an understanding of the country's bohemian creative communities and in determining what measures might encourage art and artists to exhibit a clearer fidelity to the reductive mandate of Socialist Realism.

opportunity to study photography. It offered only four studentships a year and graduates, unlike their colleagues in photojournalism, were able to join the National Association of Artists (VBK-DDR) and pursue freelance careers.

[4] A documentary photographic style may be defined as a "fundamentally observational and realist mode employing un-manipulated negatives and without any declared intention to change the world." Mark Sladen and Kate Bush, *In the Face of History, European Photographers in the 20th Century* (London: Barbican Art Gallery, 2006), 11.

[5] "We enjoyed the patronage of Dominique Paillarse, a 'photography fanatic' and director of the French Cultural Institute in East Berlin (the only western cultural institute in the entire eastern bloc). Through him we were regularly able to meet and exchange ideas with Henri Cartier-Bresson, Robert Frank and Josef Koudelka..." Arno Fischer (Gundula Schulze-Eldowy's colleague and tutor at the HGB Leipzig). Interview with the author, Gransee, M. Brandenburg, January 13, 2007.

Working obsessively in the district of Berlin-Mitte from the late 1970s onward, Gundula Schulze-Eldowy's photographic series with themes such as *Nudes, Workers,* and two remarkable photographic essays *Tamerlan* and *Berlin. in Eine Hundenacht (Berlin. On a Dog's Night)*, were an unforgiving portrait of East Berlin's officially unacknowledged underclasses, bohemians and miscreants, the city's appalling environmental degradation and collapsing infrastructure.

One of the earliest and most noteworthy examples of Schulze-Eldowy's modus operandi, the series *Tamerlan* (1978–87), was a ten-year photographic diary mapping her relationship with Tamerlan, a dispossessed (and very nearly vagrant) old woman whom she had originally met in an East Berlin park. The images convey a proud and once clearly elegant, middle class woman living in uncontrolled squalor. The images were a damning indictment of a society, which understood itself to be classless and believed it offered its workers material security and a "cradle to grave welfare state."

First meeting in East Berlin's Kollwitz Platz in 1978, Schulze-Eldowy at first photographed the old woman cautiously and from a distance as she sat alone smoking on a park bench only to find herself invited to take close-ups and to listen to a confessional narrative which encompassed Tamerlan's early life in West Prussia, her marriage in the 1930s, the privations of the war (and the two abortions she endured), her husband's call up into the Army in 1939 (and his return deeply disturbed at the end of the war) and finally the birth of her son in 1948.

In poetic writings, which were exhibited alongside the photographs Schulze-Eldowy acknowledges in the face of these emotional outpourings how she quickly became part of the old woman's life and notes the deep wounds she carried, as a result of almost unimaginable horrors of the Second World War. Even in the late 1970s these continued to create huge dislocation in her life particularly as a result of the obsessive relationship she had with her only son. As Schulze-Eldowy has put it in her own writings:

In 1948, she gave birth to her son Achim. He was her doom. Tamerlan overloaded him with her pent-up love and spoilt him. She even worked night shifts at the post office in order to be with him during the day. This love became a travesty. The older he got the greater were his expectations.

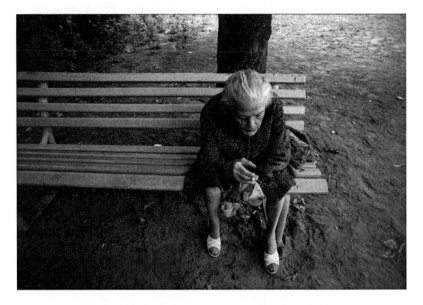

Plate 2.1. Gundula Schulze-Eldowy, *Kollwitz Platz*, Berlin, 1979. From the series *Tamerlan*, 1979-1987. Gelatine Silver Print. Courtesy of the artist.

And she fulfilled them as far as she could. Later, when he was already grown up, he rarely went to work and lived on her income. This did not change when she became a pensioner. If she could not fulfil his wishes, he beat her. As time went on he sold her valuables and furniture and betrayed her shamelessly.[6]

Realising that her camera had been a "passport" to their early meetings, Schulze-Eldowy notes that her photography became an almost unnoticed facet of their relationship and she became a participant in the narrative of the final years of Tamerlan's life, tracking the loss of her economic independence, the collapse of her health, and her eventual death with a breathtaking poetic intimacy.

Tamerlan, and many of Schulze-Eldowy's other photographic series, underscore a desire to capture existential experience pictorially, representing an uncompromising barometer of society's preoccupations and obsessions. Making no attempt to paper over the cracks in the socialist system, her

[6] *Tamerlan*, unpublished writings by Gundula Schulze-Eldowy, 1978-1987. Translated by Cecile Malaspina.

work pulled sharply away from the idealised vision that the socialist state had of itself.

In a closed and secretive East Germany, the articulation of implicitly socially critical themes and in the 1980s, their regular appearance in public forums seems paradoxical, particularly because East German art historical doctrine cast photography in a permanent "supporting role" in the grand narrative of Marxist art history. While any kind of subjectivity or formalism was frowned upon, photography was in large measure disregarded by the organs of the state, allowing photographers to generate a level of creative freedom that was not available to artists in other media.

Unlike painters, sculptors and authors—who were amongst the most important standard bearers for East Germany's doctrinaire brand of Stalinism—photographers were left pretty much to their own devices, and not considered worth the investment that a high level of surveillance would require.

The change in attitude that was to encourage photographers to develop a more experimental visual language came in 1977 when East Germany ushered in a new cultural policy based upon the principles of broadness and diversity."

Poorly defined though as they were, these new principles committed the state directed mantra of Socialist Realism, in theory at least, to an engagement with the realities and contradictions of the attempt to forge a socialist society in Germany. Henceforth, there were to be "no more taboos" in the area of culture, and Socialist Realism was to take on a more fluid form described as *Kunst im Realen Sozialismus* (Art in Real Existing Socialism).[7] One aspect of this new directive was the expansion of networks of nominally independent, artist run-gallery spaces, where programming became increasingly experimental and where the contradictions that the socialist system imposed on individual experience were never far from the surface. Being extensively bureaucratic and attuned to rigidly codified cold war definitions of oppositional activity however, East Germany's surveillance culture was slow to develop an understanding of fine art photography and equally slow in determining how to move against it.

In the 1980s the willingness of these independent galleries to showcase Schulze-Eldowy's confessional, diaristic and implicitly socially critical photographic portraiture and the enormous audience that developed for it,

[7] *Kunst Im Real Existierende Sozialismus*–a development of the Stalinist doctrine of Socialist Realism which, in theory made allowances for the inequities and contradictions that the attempt to achieve socialism in Germany offered up, and which allowed artists some latitude in representing these in their work.

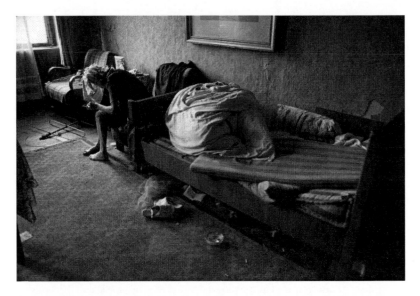

Plate 2.2. Gundula Schulze-Eldowy, *Berlin*, 1979. From the series *Tamerlan*, 1979-1987. Gelatine Silver Print. Courtesy of the artist.

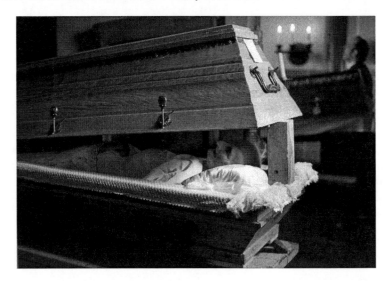

Plate 2.3. Gundula Schulze-Eldowy, *Berlin*, 1982. From the series *Berlin. On a Dogs Night*, 1979-1987. Gelatine Silver Print. Courtesy of the artist.

forced the East German state to radically reassess its attitude to photographers, photography and their function in the public domain. The state agency entrusted in reunified Germany with the care of the Stasi files is the Bundesbeauftragte für die Unterlagen des Staatsicherheits Dienstes der Ehemaligen Deutschen Demokratischen Republik. In the copies of Schulze-Eldowy's files made available to me,the real names of the informants are deleted leaving for scrutiny only the operational code name given to all the Stasi's "unofficial employees." Generating a meaningful linear narrative from the reports into Schulze-Eldowy's behaviour and associations, compiled by different case officers and informers, is both challenging and confusing for researchers.

One of the clearest indications of the Stasi's attitude to Schulze-Eldowy's photography however is the confusion and indecision of the agency itself in regard to the artist and her work. The notes clearly indicate that individual Stasi operatives had little or no experience of contemporary visual arts or, of the "ephemeral" or "viral" marketing strategies used by artists to promote their work. Neither apparently did they have any understanding of photography beyond the family snapshot. Individual operatives could only see nebulous, ill-defined threats to the purity of the socialist message in her numerous photographic cycles and lacked a code of practice, which might have allowed a better understanding of her *modus operandi*. In spite of their terrifying reputation the Stasi remained largely impotent and until almost the eve of the Berlin Wall's collapse were unable to develop a clear strategy to employ against her.

Whilst the Stasi invested substantial time and resources seeking "treasonable" intent in Schulze-Eldowy's practice, behaviour and associations, their observation reports also evince a comprehensive failure to understand her rootedness in Berlin-Mitte—the level of trust that was extended to her by her subjects that allowed her to photograph the kind of "private intimacies" that would raise eyebrows in any political or social system. The case-notes also fail to recognise what was perhaps the only "politically" controversial element in her work—the way her photographs functioned as a conduit for opinions, which could be expressed visually rather than verbally.

In the same way that perhaps Wolfgang Tillmans or Nan Goldin have been able to bring the interpersonal dynamics of their immediate circles to the world's attention through their work, Schulze-Eldowy's photographic engagement with the people around her yielded an unforgiving, yet often tender portrait of a shattered, dysfunctional, but bohemian community whose infrastructure, domestic economics and relationships were still substantially marked by the trauma of the Second World War. The

undisguised privations, which Berliners had to negotiate on a daily basis, were a clear, but unspoken, riposte to state propaganda.

As the artist herself has put it:

Berlin-Mitte was the heart of Germany—to some extent the heart of Europe. The Reich Chancellery was here—where Hitler died, and from where all the German wars of the early twentieth century were directed. This, intuitively, fascinated me about Berlin. I wanted to know what this 'heart' looked like in reality. I loved the way people talked about the war, how the walls spoke, and what people's apartments looked like. The people (who had survived the final Soviet assault on Berlin) had been affected by unimaginable horrors. They had lost all their dreams and were simply unable to dream again. I called them the survivors. They lived alone and in the shadows, unnoticed until I came and found them.[8]

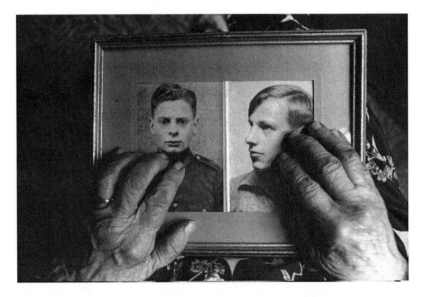

Plate 2.4. Gundula Schulze-Eldowy, *Fallen Sons*, Berlin, 1979. From the series *Berlin. On a Dog's Night*. Gelatine Silver Print. Courtesy of the artist.

[8] Gundula Schulze-Eldowy. Interview with the author, Berlin, December 2005.

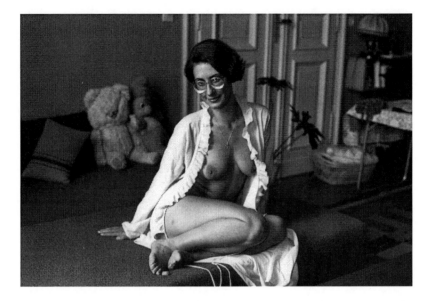

Plate 2.5. Gundula Schulze-Eldowy, *Angelika*, Leipzig, 1983. From the series *Nudes*. Gelatine Silver Print. Courtesy of the artist.

Schulze-Eldowy remained largely "unnoticed" by the authorities while she trained as a photographer in the relatively protected atmosphere of the Leipzig Art School, only coming to the Stasi's attention when she completed her studies and began to exhibit publicly in East Berlin. Unable to adequately pigeonhole her with the GDR's shadowy and fragmented "political" opposition, the Stasi instead became obsessed with the numerous foreign contacts her increasing international notoriety was generating, assuming that these could only be conduits for the gathering of intelligence or destabilising the state. In January 1985, "Gustav," an "unofficial employee" of the Stasi (and as was usually the case, a member of Schulze-Eldowy's close personal circle, who had agreed to inform for the Stasi) was sent to enquire about *Nude Photography in the GDR,* an exhibition organised by Schulze-Eldowy at the House of Culture in Treptow, East Berlin from January to February 1985.

"Gustav's" report highlights a collective feeling amongst employees with whom he had spoken at the gallery of having achieved something unexpected and unlikely by the mere fact that the exhibition had been allowed to go ahead. This was largely the result of the decision not to advertise the exhibition and to promote it by word of mouth only.

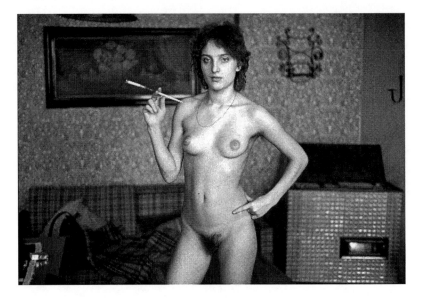

Plate 2.6. Gundula Schulze-Eldowy, *Petra*, Erfurt 1982. From the series *Nudes*. Gelatine Silver Print. Courtesy of the artist.

Crucially, also, the unusual decision not to produce an exhibition poster to advertise the show had clearly been extremely effective. The authorities were not alerted to the exhibition prior to its opening and it had proved very popular with local workers becoming the "secret tip" at the local barracks, receiving numerous visits from officers in uniform with overall visitor figures far outstripping the average for exhibitions at the House of Culture.

On January 22, 1985 a gallery talk that was attended by over a hundred visitors was held in Treptow, which "Gustav" reports, represented a comprehensive validation for Schulze-Eldowy and her practices. The only criticism being the suggestion that her photography was "too pretty" and did not go far enough in depicting the realities of life in East Germany. For "Gustav," Schulze-Eldowy's proclamations and the opinions expressed by members of the public during the gallery talk were an "emotionally laden, philosophically unclear stream of consciousness expressed by people who were not in a position to properly compartmentalise or validate the manifestations of social life they encountered in Schulze Eldowy's work"

(or presumably echoes of their own experience they recognised in the photographs).[9]

Interestingly, Schulze-Eldowy herself echoes the events and some of the opinions expressed by "Gustav:"

> When my nudes were exhibited in Treptow in 1985, I gave a gallery talk and so many people turned up that we had to hold the talk in the hall outside.[10]

In particular, pointing to the reaction to her nudes, she went on:

> Of course the Stasi sent a representative to the meeting to observe and to heckle and he shouted, 'It's nobody's business but my own what goes on in my bedroom. This peeping around is indecent behaviour.' Then another man stood up and agreed adding, 'Yes, that's precisely the point, you're ignoring people's problems, you're pushing everything into the private sphere and you don't seem to be interested in what's going on in the world outside.'[11]

Photographing in ordinary domestic situations, Schulze-Eldowy created what remain some of the most unusual nudes in post-war European photographic history. Combining an almost entirely non-sexual nudity with incongruous motifs of domesticity she emphasises the idea of "inner emigration;" the desire to withdraw into the private sphere and to shelter from the excesses of state culture.

Although uncertain of the precise threat that Schulze-Eldowy's photographic series represented to the stability of socialist society and lacking a judicially watertight route to constrain her under East German law, the Stasi began nonetheless to employ a strategy intended to hinder the progress of her career and dissemination of her images and to spread disinformation about her and her work amongst East Berlin's artistic community. Informers were tasked with spreading the opinion that her work was concerned only with negative, superficial impressions of socialist society, that it was theatrical and narcissistic and that it presented the contradictions of socialism without providing any proper socio-economic context. Reports from numerous informers suggest that her

[9] Report by an unofficial employee of the Stasi "Gustav", Gundula Schulze-Eldowy Stasi Files, Bundesbeauftragte für die Unterlagen des Staatsicherheitsdienstes der Ehemaligen Deutschen Demokratischen Republik (BfuSeDDR), Berlin, January 17, 1985.

[10] Gundula Schulze-Eldowy, interview with the author (Berlin, December, 2005).

[11] Ibid.

intimate associates began to question how she had managed to secure authorisation for the exhibition of her nudes at Treptow, or whether her work had anything to do with art at all.[12]

In an intercepted letter to the prominent Swiss-American photographer Robert Frank, whom she had met at the French Cultural Institute, she writes:

> I have the feeling that some people would gladly lynch me or burn me as a witch in the marketplace [because] I want to convince them that everything they have believed in until now is wrong.[13]

Another development in Schulze-Eldowy's career, and one which helped her to achieve a level of international notoriety was the recognition in some quarters of the East German political establishment that she might provide a positive representation of East Germany's socialist culture. As her notoriety spread she was offered a solo exhibition in Zurich and, unexpectedly granted a temporary passport by the ministry of foreign affairs allowing her to visit Switzerland.[14] Her exposure in Switzerland led to further offers of exhibitions in Italy and the opportunity to participate in the prestigious photography festival at Arles, France (although she was unable to extend her temporary passport and was not able to go).[15] This presented the Stasi with the unexpected problem of having to constrain Schulze-Eldowy's burgeoning notoriety on the stage of international fine art photography.

Schulze-Eldowy's files contain frequent and dismissive references to the artist as a "careerist charlatan" who was interested only in her own advancement. There was however recognition that her position as a East German photographer was part of her artistic persona which provided her with a unique platform from which to promote herself in the international art world and that she was thus unlikely to seek a permanent exit visa.[16]

[12] Report by an unofficial employee of the Stasi informer "Peter Rodinel" (BfuSeDDR), Berlin, March 7, 1988.

[13] Gundula Schulze-Eldowy, interview with the author, Berlin, December, 2005.

[14] The passport and exit visa was intended to be used for a single return trip to Zürich in January 1985, but because it was not otherwise endorsed Schulze-Eldowy used it for fifteen separate trips to West Germany and West Berlin until its expiry.

[15] Stasi operational report (BfuSeDDR), Berlin, June 14, 1989.

[16] Stasi operational report (BfuSeDDR), Berlin, August 16, 1989.

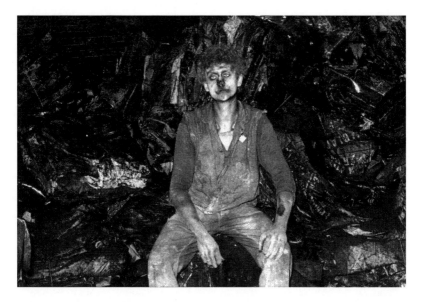

Plate 2.7. Gundula Schulze-Eldowy, *Andreas the Soot King*, 1980s. From the series *Work*. Gelatine Silver Print. Courtesy of the artist.

Perhaps referencing the struggle between the "modernisers" and more conservative elements in East Germany's political fabric, Stasi officers were unable to view Schulze-Eldowy's national and international exposure as anything other than a threat to East Germany's internal stability, and became increasingly obsessed with the idea that she was in the pay of the CIA.[17] Conversations were held at senior level to try and ascertain what the (non-existent) intelligence gathering rationale was that underpinned the French cultural attaché's intensive lobbying on Schulze-Eldowy's behalf for an extension to her passport to allow her to attend the Arles Photography Festival.

By August 1989, the Stasi's files manifested a clear determination to move decisively against her with plans for a search of her apartment and detailed questions asked about who visited her, whether she entertained visitors overnight, whether she had a long term partner, whether there were empty apartments in her block and which other tenants of the block she had the closest relationships with. The report indicated that this process was to end in severe sanctions such as arrest and imprisonment as a result of "the negative attitudes towards the political circumstances in

[17] Stasi, operational report (BfuSeDDR), Berlin, January 9, 1989.

East Germany which she brings to expression in her work."[18] Ironically, because of the collapse of the Berlin Wall in 1989 and the massive popular uprising, which saw the peaceful overthrow of the dictatorial regime, the Stasi's plans to move formally against Schulze-Eldowy were never acted upon.

The long and extraordinary delay between Schulze-Eldowy's appearance on the Stasi's radar and their decision to formally move against her raises enormous questions about the practical limits on the power and use of surveillance. Equally compelling are questions around photography's ability to create its own truth and to express ideas visually rather than verbally. No less relevant was the regime's desire to reduce human behaviour and culture to tight, inflexible definitions.

Rather than overt subversion, Schulze-Eldowy's empathetic and confessional photography was the by-product of the remarkable purity of documentary photographic practice as it had developed in East Germany, combined with responsiveness to international influence, which was an anathema to many of the country's deeply conservative hierarchy. As the 1980s wore on there was an increasing lack of definition about what kind of state East Germany wanted to be, and how it wanted artists to reflect a society that was economically considerably better off than other Eastern Bloc societies, yet steadfastly refused the kind of democratic freedoms that citizens throughout the rest of eastern Europe were beginning to enjoy for the first time since the end of World War II. As the Honecker regime aged it became increasingly obvious that the country had neither the resources nor the understanding of contemporary visual art necessary to coerce artists or the public into defining themselves according to the regimented principles of official socialist culture. Confirming this, Schulze-Eldowy has suggested that:

I have been asked whether subversion was a deliberate part of my visual language and I've always said no. But, because it was impossible in the GDR to be an artist and to be against the party, confrontation was initiated as soon as one took up a stance that in any way didn't conform to the way that the state saw itself. As the demise of the GDR approached, the authorities simply no longer had the strength to constrain me. However, the Stasi's efforts to control me were never clear and always contradictory. When I first showed at *Galerie Sophienstrasse 8* (in the mid 1980s) three Party members appeared. Instead of taking the show down they said,

[18] "Proposal to carry through a conspiratorial search of living quarters," a discussion of the practicalities of, and rationale for, searching Schulze-Eldowy's flat in Berlin.

'Your pictures are very powerful, especially the *Tamerlan* series. We've received an order from the party leadership to "tone down" the show, but now we've seen it, we don't know what to do.' So we went through the show together and took down one nude, one dead person and one fat person. They couldn't read the iconography, the really subversive pictures stayed on the wall, and people generally understood this.[19]

This led me to question whether Schulze-Eldowy felt that she had developed a visual language that was illegible to the authorities but entirely legible to the public at large, to which she answered:

Yes, you could put it that way. The authorities were very easily steered by verbal interpretations. These three party members literally asked me 'what is this picture about?' and I told them. They could only accept a very narrow and literal reading [of the themes and ideas in my photography]. It was very much more complicated for poets and playwrights.[20]

Because Schulze-Eldowy's work can be considered to be observational and photography was not regarded as a real art form, it did not fit into the Stasi's definitions of "subversion." Simultaneously the totalitarian state seemed unable to cope with or develop an effective strategy to counter the genuine international interest in her work or for the tenor of public debate that took place around it.

Younger East German photographers like Schulze-Eldowy realised that the authorities were looking for precise written definitions on which to hang their objections to particular ideas or themes. Like many of her colleagues she eschewed the habit of attaching titles to the work beyond a place and date and worked up narratives in layers giving the authorities no precise definition to react against.

The Stasi failed to break Schulze-Eldowy's career. They were, however, extremely effective in restricting her national and international profile and with almost no bibliography around her work, this photographer's remarkable contribution to post-war photographic history is only now being seriously considered twenty years after the collapse of the Berlin Wall, after very nearly fading into obscurity.

That Schulze-Eldowy's uncompromising observations of the East German day-to-day reality both came into being and survived the Stasi's attentions is both testament to her creative spirit and the inability of the dictatorship to pigeonhole her activity.

[19] Gundula Schulze-Eldowy, interview with the author, Berlin, December 15, 2005.
[20] Ibid.

In spite of the fact that its tentacles extended into the most intimate spheres of its citizens' lives, East Germany and its security apparatus was cumbersome, exhausted and unresponsive by the late 1980s and the Stasi was unable to formulate an efficient response to the creative energy they considered so dangerous. In spite of its disciplinarian reputation, it was unable to hold back the popular agitation for freedom of expression of which Schulze-Eldowy's photography was symptomatic—neither did the Stasi have any understanding of the international character of the contemporary visual arts. It was resoundingly unsuccessful in ending Schulze-Eldowy's career—stopping her working—and yet East Germany's all knowing all seeing surveillance apparatus remains for many observers the yardstick against which all surveillance states are measured.

PIGS LIKE PIGMENT:
INTERVIEW WITH VERENA KYSELKA

OUTI REMES

Outi Remes: Would you please discuss your early experiences of living in East Germany in the seventies.

Verena Kyselka: I grew up under state surveillance in East Germany. It is hard to describe the feeling of being under constant suppressed surveillance. I began to suspect it, although I did not know anything definite. One day it turned out to be a hard reality, which has had consequences that have affected the rest of my life.

In the middle of the 1970s, when I was young, my father was imprisoned by the Ministry for State Security (Stasi). My father had been in contact with a group that helped people to escape illegally from East to West Germany in specially prepared vehicles. In 1972, my father had assisted two women to escape. He was arrested for human trafficking in 1976 and was subsequently sentenced as an enemy of the state to seven years in prison. His arrest was followed by years of surveillance by the Stasi's informal agents known as IMs.

After the German Democratic Republic (GDR) collapsed, my family became aware of the extensiveness of the Stasi files. My father discovered ninety-five files that contained wide-ranging information about him and his family. These files included recorded telephone calls and observation reports by Stasi agents. The surveillance operation was codenamed "meniscus," referring to my father's profession in orthopaedics.[1]

My family home was observed at all times and the Stasi had a key to the house. When the family was not at home, the agents moved in and out and were not concerned whether the family would notice their presence. There was a grey car with two people constantly parked in front of the house. At that time, we had suspected that the car was from the Stasi, but we did not pay much attention to them. Eventually, it became part of the

[1] Meniscus is the cartilage in the knee joint.

street scene. Once, my sister approached the agents. She was going out and asked them to let her friend know that she had already left the house.

My family remained under surveillance, particularly during the time that my father was detained and awaiting his trial. I was branded by the arrest of my father and was not allowed to go to a university. As my fellow artist Gabriele Stötzer-Kachold has said: "In the East you were already broken as a child. One has to reconstruct one's life and identity from the fragments."[2]

In the late seventies, I had my first contact with artists. Their alternative lifestyle attracted me. These artists did not follow the principles of Socialist Realism, the official art style in East Germany. Socialist Realism focused on figurative portraits of workers, represented as idealised model-citizens. In Socialist artworks, the robotic workers marched side by side as described in one of the songs by an East German youth organisation: "When we march side by side and sing the old songs, and when the forests resound we feel it has to succeed…"[3] In my opinion, this depiction of factory and agricultural work was uninspiring.

The expulsion of the singer-songwriter Wolf Biermann in 1976 from East Germany provoked a wave of emigration by many established artists. How would you describe the artistic scene at the time? What were the alternatives for the artists that did not follow the official policies and style of Socialist Realism?

The confiscation of Biermann's East German citizenship occurred during his official tour in West Germany. This was followed by the increasing development of alternative and subversive scenes that extended across a range of art forms and media. Some of the young people were not permitted to begin their art studies while others had been dismissed from their degree courses because of their critical and political views. Many artists were self-taught but hardly any of them were socially organised. Freelance artists in East Germany were expected to become members of a professional association, which provided them with a tax code. Without membership an artist was considered to be anti-social, which could result in imprisonment. The legislation defined such anti-social activity as hostility against the state.

[2] Personal communication between Verena Kyselka and Gabriele Stötzer-Kachold.

[3] *When We March Side by Side* by Michael Englert, lyrics by Hermann Claudius, 1915. The song was used by SED, the socialist party, and the youth organization Freie Deutsche Jugend (FDJ, Free German Youth). http://www.altearmee.de/wannwirschreiten.htm. (accessed December 11, 2009).

The underground artists worked mostly in unskilled jobs, which provided them with official registration. Many of these artists had applied to leave East Germany for the West. In principle, it was possible to make such an application. However, it often resulted in serious reprisals that affected their vocational careers, sometimes for years. Therefore, exhibitions and readings were commonly organised in private flats and punk concerts in churches. A variety of hand-produced art newspapers and books with poetic texts were published illegally; underground film festivals that presented super 8mm films were common.

I began training as a painting restorer, working for the Protestant church. My training and work provided for my living. The work also enabled travelling in East Germany.

I was once asked by a Stasi officer what I thought about Socialist Realism and the Bitterfeld Conferences. These conferences (1959 and 1964) focused on the relationship between intellectual and practical work. I explained the Stasi that I did not use the Socialist Realist style because I could paint neither well nor realistically. Looking back, Socialist Realism and the Bitterfeld Conferences failed: art that combined naturalism with optimism and present harmony was superficial and propagated the politics of the ruling elite. Art must be free: it should neither exploit for an ideology nor let politicians decide what good art is like.

In the eighties, the bohemian art underground scene was known for its unofficial exhibitions and readings. How did it affect your artistic practice?

At the beginning of the eighties, I lived in Dresden. After the departure of the painter and sculptor A.R. Penck, the Dresden art scene centered around the painters Cornelia Schleime and Ralf Kerbach who had applied to leave East Germany. As a result, they were officially forbidden to exhibit their art.

The poet Sascha Anderson also worked in Dresden and played in the art band *Zwitschermaschine* (twittering machine) and published self-produced art books. Anderson later became the self-styled manager of the Prenzlauer Berg scene in East Berlin that was popular among artists in the eighties and included many young people who rebelled against the official ideology: it contained a vast creative potential that wanted to express itself. The exhibition *Bohemian World and Dictatorship in the German Museum of History* (Berlin, 1997) was a good expression of this energy.

Rainer Eckert from the University of Leipzig writes in the catalogue *Klopfzeichen Mauersprünge: Art in the Eighties in Germany*:

Art and artists have a special status in dictatorial societies, which is hardly comprehensible in democratic times. Every mediocre artistic comment attracts panic-stricken attention from the ruling class, if it does not correspond to the canon of permissible expressions of opinion. This attention results in fear in the artist, but at the same time, it allows a sense of self-confidence and demonstrates such strong significance of art, which rarely can be found in democracy.[4]

Recently, Cornelia Schleime, who was involved in the Berlin Prenzlauer-Berg underground scene in the eighties, recalled: "Success was not important at that time. We wanted individuality—to be radical and work without purposes and ideologies. We aimed at creating pictures that were timeless. This was our criteria."[5]

This was the time I entered the art world. I painted, wrote poems, played in a band and worked intensively with a group of artists in Erfurt. We organised exhibitions and readings in my studio and flat, and shot super 8mm films that were used in performances. My figurative painting was focused on the female figure. *Dropout* (1989) is a good example of my paintings from this period. It represents a central female figure breaking away from a crowd of people, expressing an attempt to escape. The painting has a sense of the new era that began a few years prior to the political changes of the second half of the eighties.

Different art forms such as painting, music and performance emerged alongside one another. In 1986, I co-founded the band *EOG, Erweiterter OrGasmus* (Extended Orgasm). Its motto was: "Everyone plays an instrument that she does not master." We did a few shows corresponding to this concept that were completely chaotic. Not surprisingly, these concerts resulted in performance bans and penalty fines and we were increasingly attracting attention from the public. We were proud to be part of the underground. However, it was also daunting because breaking the official bans could lead to imprisonment and the fines were expensive. Later I was involved with another feminist group, *Exterra XX,* that struggled to gain recognition in the male dominated milieu.

[4] *Klopfzeichen Mauersprünge: Kunst und Kulturder 80er Jahre,* Rainer Eckert and Bernd Lindner (Faber & Faber, Leipzig, 2002) 14.

[5] Cornelia Schleime, "Pathos der Landnahme," in *Boheme und Diktatur in der DDR, Gruppen, Konflikte, Quartiere: 1970 bis 1989* (online catalogue, 1997) and Claudia Petzold, Paul Kaiser, B&S Siebenhaar, "Pathos der Landnahme," in *Boheme und Diktatur in der DDR, Gruppen, Konflikte, Quartiere: 1970 bis 1989.*

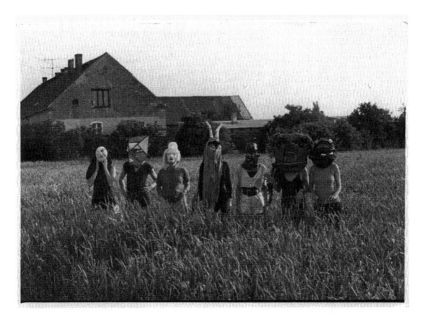

Plate 3.1. Exterra XX in Farmyard, Lietzen, 1989. Photo by Claudia Bogenhard. Courtesy of the artist.

Were you influenced by any groups or artists from the West?

The movement of *Die Neue Wilden* (The New Wilds) from West Berlin inspired me. I was also particularly influenced by new wave and punk music, and the American performance artist Laurie Anderson who worked on a variety of experimental music and art rock styles.

Although punk music was strongly disapproved of by the Stasi, it was an essential component of the young art scene in East Germany: it had creative potential for art. Many artists with a visual arts background played in punk bands, which was a way to release anger and encourage public fury. The Erfurt based punk band *Schleim Keim* (slime germs) from the early eighties is a good example of this. *Schleim Keim* shouted lyrics in their few concerts that took place in churches. The song, *Spies in the Café* (1982), can be translated as follows:

Spies in the café
When I see this
Everything hurts
From nose to toe

The Russian is to blame for it
The Yank is to blame for it
Who is now to blame for it?
Who is now to blame for it?
(Dieter Ozze Ehrlich, *Schleim Keim*)

How effective was the Stasi surveillance in the eighties? To what extent did it constrain the cultural scene and how did you deal with the knowledge that you were surrounded by spies?

Everybody knew that the secret service informers operated within our ranks. There were imposed fines, interrogations and court appearances due to unauthorised public activities and so-called conspiratorial gatherings. It is hard to believe that the underground scene succeeded in surviving over such a long period of time. However, if we had focused on the Stasi and surveillance, we would have been unable to find the energy for creative practice. I gained vitality from my activities. We shared a sense of illegal adventure that enabled us to survive in the totalitarian system. During the eighties, the pressure of the state authorities began to ease. Some artists were allowed to emigrate to the West after years of waiting. However, for others, surveillance intensified.

Die Wende, the political change from 1989 to 1990, marks a complex process of the change from socialism and a planned economy towards a democratic process in East Germany. The underground scene could now access their Stasi files. What was your response to the files?

Suddenly, I knew who had been watching and reporting on my life. My Stasi file, codenamed "Pigment," focused on my activities from 1986 to 1988. I was surprised to find that there had been informers within every circle of my friends. I was shocked to learn that I had been considered an enemy: a pseudo-artist and a decadent person who had to be isolated and whose friendships had to be discouraged. I also found several reports and notes that were written before 1986 in card indexes and files. Due to my father's imprisonment I had always been under surveillance. My files demonstrate that the Stasi officers seemed to be confused why I had not applied to emigrate. The Stasi was suspicious that I had some treacherous plan against the state, and therefore had stayed in the East. I was summoned several times by the Stasi for questioning. I learned from my files that this was intended to be an educational measure. I was always uncertain of the outcome of these interrogations which made me sick.

One of the files attempts to characterise my behaviour. It considers the characteristics that "determine K's behaviour" and the ways in which "she can be incriminated or isolated from her acquaintances and friends." The file analyses an exhibition opening in my flat, attended by eighty people. According to the file, the Stasi had aimed at creating "preconditions that would prevent and discourage the concentration of people at the illegal gallery in Kyselka's flat …"

The "Pigment" files revealed that informers had been deployed to work in my immediate environment. These informers were classified as IMB (Informeller Mitarbeiter mit Feindberührung, informal employees in contact with the enemy). For example, "IMB Breaky" was an amateur artist who used to assist in art events. In return, he had asked me to photograph his break-dance routine.

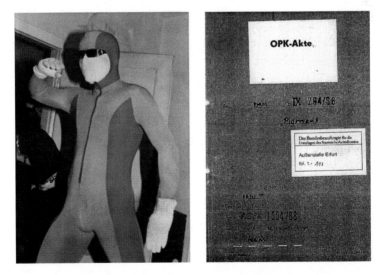

Plate 3.2. (left) IMB Breaky's break dance performance, Erfurt, 1987. Photo by Verena Kyselka. Courtesy of the artist. At this time nobody knew that he was working as an informer. *Plate 3.3.* (right) Copy of Verena Kyselka's Stasi file. Courtesy of the artist.

There was a sense of paranoia related to informers. For example, "IMB Johannes" had been an ambivalent figure in the Erfurt scene and presented himself as a poet, participating in readings. He was a prototype of a classic informer: short, wearing a black leather jacket and typical grey East German trousers with a briefcase. Nobody in the scene walked

around in such clothing. His Stasi reports corresponded to the style of his poems and included files about me. The reports were hateful but described with enthusiasm so-called "hostile actions". According to his recommendations, all of his surveillance subjects required further and closer observation.

It must have been disappointing to find so many informers that had operated among your circle of friends. How have you coped with this betrayal of trust?

Fear was used as a means of applying pressure and the informers were also victims of the Stasi. I was shocked to discover that my former partner, who I had lived with, was an informer. I was particularly hurt by the betrayal of trust and his lack of courage to tell me that he had been an informer. The Stasi informers became useless as soon as they lost their disguise. My partner was picked up by the Stasi from home "for some clarification of facts," which had indicated that there would be an interrogation. I did not know that the Stasi had reminded him of his obligations as an informer. I had never suspected that he worked for the Stasi.

The Stasi employed some well-recognised artists as their agents such as the protagonist poets Sascha Anderson and Rainer Schedlinski. How successful were these Stasi methods?

Anderson and Schedlinski were examples of a new type of agent, created by the Stasi during the 1980s. Schedlinski and Anderson did not focus on destroying groups that were hostile to the republic. Instead, Anderson was celebrated as "the minister of culture for the underground." They aimed to change the objectives of the artist groups from the inside, paralysing their original strategies. In 1991, the double life of Sascha Anderson and Rainer Schedlinski was exposed to the Berlin art scene. I knew Anderson in person. They created an atmosphere of mistrust and disbelief in the scene.

In 1987, the singer Dieter Ehrlich of the punk band *Schleim Keim* released an album in West Berlin with Anderson and the art band *Zwitschermaschine*. Soon afterwards, he was arrested. Anderson had also played with Cornelia Schleime and Ralf Kerbach in *Zwitschermaschine* and was Kerbach's close friend. Kerbach discovered from his file, code-named "Grund" that Anderson had planned to evict the singer and songwriter and to take his position. On one occasion, due to Anderson, the

band's performance in Erfurt was cancelled. On the other occasion, Kerbach wanted to exhibit and perform with his band in an illegal private gallery. Disguised as "IMB David Menzer," Anderson reported the planned exhibition, which was banned by the police. The event relocated to another flat and was photographed by Anderson. Consequently, the gallery was closed permanently. Later, Anderson emigrated to West Germany, following orders from the Stasi. In West Berlin, he continued to spy on the émigré artists that he had known in East Germany.

Schedlinski not only spied on his fellow artists but also reported on organisations and employees of the Protestant and Roman Catholic churches. Schedlinski worked for both ideological and financial reasons: He maintained his popular image while receiving a salary from the Stasi.

Plate 3.4. IMB Udo and Verena Kyselka, Erfurt, 1991. Photo by Bernd Hiepe. Courtesy of the artist.

Today, thanks to German thoroughness in documenting the files and archives and following the collapse of this restrictive system, anyone can apply to view their personal Stasi reports or files that mention them. The files can also be accessed by researchers, although not by the general public. The reports include much intimate and sensitive information. Do you think that the files should be open?

Because of these reports we are now able to read how artists were represented as enemies of the state. The reports are a reminder of a dark period in art and German history. They demonstrate how a friend may be your enemy: the future generations must learn about the censorship, dictatorship and the history of the country.

How did the process of reunification of East and West Germany, which began in 1989, affect your career? How did the newly established contact with the West develop your artistic practice?

Following reunification, I found new exhibition opportunities. In January 1990, in the middle of the Wende period, two hundred artists from East Germany, including myself, were invited by the President of France, François Mitterand, to visit Paris. *L'autre Allemagne hors les murs* (The Other Germany Beyond the Wall, La Villette, Paris) included dancers, musicians, actors, painters, poets, fashion designers, performers, photographers and film makers, showcasing the alternative culture of East Germany in the seventies and eighties. The show brought together many of the most important protagonists artists and groups. Unfortunately, there is neither a catalogue nor proper documentation of the event.

My first official exhibition was at Gallery North (Leipzig, 1989). After the political change, it was followed by more exhibitions in West Germany. These exhibitions included *Daily Life in the DDR* (Basel, 1990) *Atlantis* (Ballhaus Gallery, Düsseldorf, 1991) and *Driftwood* (Town Hall, Mainz, 1991). These exhibitions provided an opportunity to get to know the other Germany and new international audiences.

The look of Western cities and towns was new to me. Despite the longstanding influence of illegal TV programmes from the West, I was overwhelmed by the flood of images that were alien to me—the immense bright advertising boards, the neon signs and the wide range of architectural styles. In the beginning, I read every line of the advertising slogans. It took time to digest the impact of these images. I concentrated on the new geographic dimension and painted on maps. Moreover, with *Exterra XX*, I developed performances focusing on the vanished East Germany, with titles such as *Rusty Germany Greets the Rest of Germany* (1993), *Death of a Terminal Moraine* (1991-1992) and *Atlantis* (1990-1991).

These performances were presented both in exhibitions and theatre. This was the beginning of the process of understanding the history of East Germany.

Your artwork presents an interesting autobiographical story that symbolises wider political ambitions and human right debates. Is personal political?

Yes, I have used my Stasi files to create silk-screen prints and painted on the files. I have explored my letter correspondence with my father during his four years of imprisonment. I formed the letters into a paper figure that seemed to hover in the air, supported by a large number of optimistic thoughts that I addressed to him. *Has My Letter Arrived?* (2004) is an autobiographical installation made at one of the prisons in which my father was detained. It contains one of the letters that he never received. The letter had failed to reach him: it failed to tell him that I would build a kite that he could see from his cell window—I did not know that he could not see through the opaque glass bricks in his window.

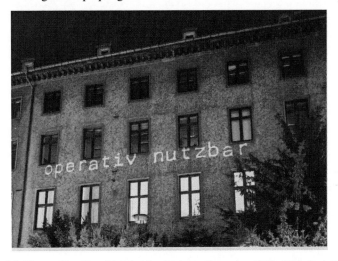

Plate 3.5. Verena Kyselka, *Lightbridge Andreas Opposite*, 1999. Slide installation onto the façade of Erfurt's police headquarters, formerly the Ministry of State Security headquarters. Photo by Falko Behr. Courtesy of the artist.

For the slide installation, *Lightbridge Andreas Opposite* (Erfurt, 1999), I manipulated public space by projecting continuously changing slides onto the façades of Erfurt's police headquarters, formerly the Ministry of State Security headquarters, and St. Andrew's church tower on the opposite side of the road. The church had provided an important, alternative meeting place for young people in the city. The projection consisted of words that I had copied from the Stasi file "Andreas" that

considered St. Andrew's work with young people. St. Andrews was used as a venue for punk concerts. I used phrases taken from the file as an example of the Stasi's language, which was militant and hateful, always showing a picture of the enemy.

The series of collages *Pigs like Pigment* (2007) investigates the factual value of my Stasi files. The Stasi relied on information that was based on subjective accounts, provided by informers. The reports often included a note: "the IM reported openly and objectively." I was interested to explore whether this was a formality or meant that the informant's report was perceived to be a truthful and accurate account about my activities? I studied the reports: what was reported and what were the informant's personal projections. I also studied their oral reports.

In *Pigs like Pigment*, I compare my memory with what was written in my Stasi reports: what did I really do at the time; what did I think; what did I write in my diary; what did I buy; which clothes did I wear? *Pigs like Pigment* is a reminder of the dangers in interpreting everyday life. It considers what can happen if daily life is recorded and filed as evidence. It is an example of misinterpretation and misconception, produced by modern systems of total observation.

One of my recent projects *Territory of Intimacy // Forbidden Kisses* (2008) expands my interest in the consequences of longstanding heteronomy, dictatorship and self-isolation. *Territory of Intimacy // Forbidden Kisses* explores interpersonal relations in Albania. I discovered that kissing was not allowed in the socialist reality of Albania. During my research at the National Film Archive, Tirana, I explored governmentally controlled and censored movies, made during Enver Hoxha's regime (1944-1985), using and editing sequences of the movies for my video installation. Even today, kissing is unusual in Albania: its citizens rarely kiss in public.

My exhibition *Territory of Intimacy // Forbidden Kisses* at the galleries of the Ministry of Culture (Tirana 2009) was cancelled two days after it was opened by Ylli Pango, the Minister of Culture. Pango was dismissed soon after. The social realities of Albania remain one of the last enclaves of an authoritarian society. There is no broad alternative arts scene and this gives rise to a new kind of censorship.

Verena, your story and artworks offer a thought-provoking view of European history in the second half of the twentieth century. This history is not forgotten in the present climate which debates the right to detain suspects and request personal information. Your work encourages these discussions which are today as relevant as they were in the eighties Germany. Many thanks for sharing your story about this challenging period that resulted in so much creative energy.

Plate 3.6. Verena Kyselka, *Pigs Like Pigment*, 2007. From the series *Pigment,*
C-type prints, 70 x 100 cm. Courtesy of the artist.

Plate 3.7. Verena Kyselka, *Pigs Like Pigment*, 2007. From the series *Pigment*, C-type prints, 70 x 100 cm. Courtesy of the artist.

Plate 3.8. Verena Kyselka, *Pigs Like Pigment*, 2007. From the series *Pigment,* C-type prints, 70 x 100 cm. Courtesy of the artist.

GAVIN JANTJES, *FREEDOM HUNTERS* (1976): SUBTEXTS AND INTERTWINED NARRATIVES

CHRISTINE EYENE

In 1978, the South African Parliament passed a banning order on the art of Gavin Jantjes. The incriminating piece consists of two anti-apartheid posters commissioned by the United Nations High Commission for Refugees (UNHCR) to mark the anti-apartheid year. The posters featured images of the Soweto Uprisings (June 16, 1976) and aimed to raise the awareness of the international community on the violence of South Africa's political regime. This was not the first time Jantjes' work had been the subject of discussion in the Houses of Parliament.[1] His famous *South African Colouring Book* (1974-75), described as a "political pamphlet" by British-based art historian Amna Malik, caused similar concern for conveying what was to be known in the 1980s under the all-encompassing term "subversive statements."

"Subversion" was an offence introduced in South Africa's new Internal Security Act in 1982. A "subversive statement" was defined as "a statement which contains anything which is calculated to have an effect or is likely to have the effect (among other things):

- of promoting any object of any organisation which has, under any law, been declared to be an unlawful organisation;
- of inciting the public or any person or category of person to... take part in or support any boycott action;
- of inciting the public or any section of the public or any person or category of persons to resist or oppose the Government, Minister, official of the Republic or any member of a Force;
- of encouraging or promoting disinvestment or the application of sanction or foreign action against the Republic."[2]

[1] Gavin Jantjes in an email to the author, May 28, 2003.
[2] David Bunn and Jane Taylor, "Editor's Introduction," in "From South Africa: New Writing, Photographs and Art," *TriQuaterly*, no. 69, Spring/Summer 1987 (Evanston, IL: Northwestern University), 22.

Although the work about to be discussed was produced in the 1970s, and therefore predates the 1982 act, the above law strengthened and consolidated previous measures designed to repress resistance and opposition to the apartheid regime. As a report published by the International Defence and Aid Fund for Southern Africa and the United Nations Centre Against Apartheid says, these laws "have been built up in successive stages as the regime has responded to resistance by increasing its own powers."[3]

Gavin Jantjes' political work has been extensively written about and this essay does therefore not intend to paraphrase what has already been demonstrated elsewhere. Taking its cue from an analysis developed by Amna Malik in her essay entitled "Conceptualising Black British Art through the Lens of Exile,"[4] this piece proposes to look at under-explored layers of interpretation in one of Jantjes' works.

In her analysis of *A South African Colouring Book*, a collection of silk-screen prints depicting oppression in South Africa, Malik observes that Jantjes combines different art forms: "silk-screen printing," "a Warholian repetition of single photographs" and "the use of newspaper sources and photojournalism—to create a juxtaposition of words and text…which produces a polyphonic dimension…"[5] His appropriation and use of found imagery, she adds, indicate the conceptualism of his approach.[6] A similar *modus operandi* characterises the anti-apartheid poster *Freedom Hunters* (1976).

This essay will focus on the "polyphonic dimension" evoked by Malik through two sets of photographs featured in Jantjes' print. Authored by Peter Magubane and George Hallett, these images convey multiple narratives of violence, oppression, surveillance and censorship. After reframing the discourse on South African resistance art, this essay will analyse the subtext underlying Magubane and Hallett's imagery. It will then examine the processes of citation used by Jantjes and how he succeeded in manipulating a set of "subversive" images while challenging South Africa's censorship apparatus. Finally, we will see how Jantjes' practical and aesthetic approach can be apprehended along the lines of such theoretical notions as "intertextuality," the concept developed by

[3] *Apartheid, the Facts* (London: International Defense and Aid Fund for Southern Africa in co-operation with United Nations Centre Against Apartheid, 1983), 57.
[4] Amna Malik, "Conceptualising Black British Art through the Lens of Exile," in *Exiles, Diasporas & Strangers*, ed. Kobena Mercer (London: Institute of International Visual Arts; Cambridge, MA: The MIT Press, 2008), 166-188.
[5] Ibid., 169.
[6] Ibid., 172.

Bulgarian-French philosopher Julia Kristeva in 1960, as well as in the light of intertwined narratives introduced by Russian theorist Mikhail Bakhtin's idea of "interhuman."

Reframing the discourse on South African resistance art

By many accounts, the narrative framing the interconnection between political struggle and visual arts in South Africa gained currency and authority in a seminal publication put together at the end of the 1980s, by artist and critic Sue Williamson. In the catalogue for *A Decade of Democracy*, one of the exhibitions that celebrated the tenth anniversary of South Africa's liberation, South African art historian Rory Bester considers *Resistance Art in South Africa* as the book that "most eloquently captured" the intense intimacy between arts and politics in South Africa.[7] Likewise, American art historian Mark D'Amato, in an essay published in the catalogue of *Liberated Voices*, argued that:

> Any discussion of contemporary South African art must acknowledge the importance of apartheid in the emerging cultural expressions, the most prominent of which is 'resistance art.' A notable early work on this subject is Sue Williamson's 1990 book *Resistance Art in South Africa*, which identified [...] the content and means by which both white and black artists were fighting that repressive regime.[8]

At the end of this paragraph he concluded that: "[i]t was Williamson's book that really established the discourse on resistance art."[9]

The 1980s represents a particular decade in South Africa. It is the decade of the most repressive state of emergencies.[10] It is also the decade that signalled the failure of the apartheid regime. This period was marked

[7] Rory Bester, "Spaces to Say," in Emma Bedford, *A Decade of Democracy: South African Art 1994-2004. From the Permanent Collection of Iziko: South African National Gallery* (Cape Town: Iziko, South Africa National Gallery, 2004), note 1, 138.

[8] Mark D'Amato, "Beyond the Trauma: The Transition of the Resistance Aesthetic in Contemporary South African Art," in *Liberated Voices: Contemporary Art from South Africa*, Frank Herreman and Mark D'Amato, ed. (New York: The Museum for African Art; Munich, London, New York: Prestel, 2004), 43.

[9] Ibid., 44.

[10] From 1985 until early 1990, South Africa's government under the ruling of president Pieter Botha (1916-2006), was placed under a number of states of emergency to counteract the anti-apartheid resistance, impose curfews, control the movement of people and arrest or ban opponents.

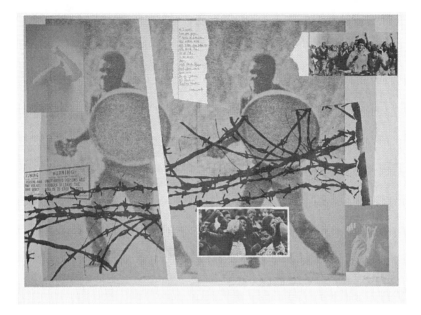

Plate 4.1. Gavin Jantjes, *Freedom Hunters,* 1976. Screen print with collage (1976). Courtesy of the Artist.

by a revisionist trend seeking to write a more inclusive national history. Twenty years after the publication of *Resistance Art* this process is still ongoing, notably in the form of the *Visual Century*—an art history project encompassing a series of books edited by artist, curator and art historian Gavin Jantjes.[11]

Against this background, it is indeed relevant to look again at some of the claims made by Williamson's book. While remaining an invaluable historical resource, *Resistance Art* contains a number of shortcomings

[11] *Visual Century: South African Art in Context, 1907-2007* is a research project that situates one hundred years of South African visual art within historical and art historical contexts, nationally and internationally. *Visual Century* will produce various resources, including four books to be published in 2010. Conceived by Gavin Jantjes, the project director, *Visual Century* is project managed by ASAI, and is funded by the Department of Arts & Culture, and the American Center Foundation. *Visual Century* is based within the Department of Historical Studies, University of Cape Town, http://www.asai.co.za/visualcentury (accessed November 20, 2009). The author's contribution is an essay on South African exiled artists from 1945 to 1976.

acknowledged by the author in her preface to the 2004 re-issue.[12] My intention here is not to engage in a belated review of the book but to focus on an issue that provides a point of entry to our line of enquiry.

In her introduction to the 1989 edition, Williamson posited the Soweto Uprisings as the key moment of her political awareness and presented her book as a testimony of "the way the artists of [her] generation responded to the truths made clear by the events of 1976, the issues [they] addressed, and the work that followed."[13] For Williamson, the student riots "melted the oppressive ice which had frozen South Africans, black and white, into apathy for so long."[14] Further in her text, a statement by writer Breyten Breytenbach is used in support of her claim that black artists, too, closed their eyes to everyday injustice and inhumanity; that they produced "non-confrontational work—scenes of a jostling township life" and that "[g]athering the courage to challenge the state through their work would take time for black artists." [15]

These statements, based on Williamson's own perception of resistance in South Africa's visual culture at the time, overlooked historical facts acknowledged elsewhere, in a publication contemporary to hers. Indeed, among the series of exhibitions aiming to re-introduce black artists in South Africa's official history of art, *Catalogue: 10 Years of Collecting (1979-1989)*, featured an essay by South African art historian Steven Sack in which he wrote, about black artists from the townships, that:

> It was simply not possible for the artists of the townships to paint quaint and picturesque broken-down houses. The environment in which they lived contained far too much violence. It has been suggested that the harsh reality of the township life was largely ignored by the township artists. Undoubtedly many self-pitying and sentimental images were produced, to satisfy the demands of the commercial fine art market... But the work of artists such as Dumile and Motau attest to the enormous anguish and torment and the need to talk of the violence that surrounded them and that, in many instances, destroyed them.[16]

[12] Sue Williamson, *Resistance Art in South Africa* (Cape Town: Double Storey Books, 2004), 6.

[13] Ibid., 8.

[14] Ibid.

[15] Ibid.

[16] Steven Sack, "From Country to City: The Development of An Urban Art," in David Hammond-Tooke and Anitra Nettleton, *Catalogue: 10 Years of Collecting (1979-1989): Standard Bank Foundation Collection of African Art, University Art Galleries Collection of African Art, and Selected Works from the University*

Sack's words serve to rectify some of the misconceptions identified above and point towards visual practices that predate the year 1976. Furthermore, it is paradoxical that although Williamson looked at visual arts, murals, posters and T-shirts, she excluded, from her frame of thought, photography, which quite often provided an iconographical source to popular resistance arts.

Indeed, as suggested in the book *Images of Defiance*, a collection of protest posters: "[l]ike any other work of art, a poster represents a set of aesthetic choices about image, colour, technique and style. These choices are made within a framework defined by existing materials..."[17] For Jantjes who, as Rasheed Araeen writes, "came briefly to London in 1976 and worked with the Poster Collective in Tolmers Square, which produced a series of anti-racist silkscreen posters to be used in schools,"[18] the existing material consisted of images that made literal references to the Soweto Uprisings—in this instance Peter Magubane's coverage of the event—and material that form the subtext of less known narratives of torment, oppression and censorship, as evident in George Hallett's pictures.

Peter Magubane: photography as a statement of resistance

Freedom Hunters is a collage set around a main protagonist, a youth, maybe a student holding a stone in one hand, and a bin lid in the other hand. This character is given importance by Jantjes as he is cropped or extracted from the original scene, and his image duplicated to emphasise his presence.

Taken in the township of Alexandra, one day after the outbreak of the riots, this photograph was reproduced in Peter Magubane, *16 June: The Fruit of Fear* (1986) with the accompanying caption: "a bitter confrontation between the might of the police and black youths armed with stones, sticks and using dustbin lids as shields."[19] The viewer can also distinguish the scarf worn by the young man, to protect himself from breathing teargases.

Ethnological Museum Collection (Johannesburg: University of Witswatersrand, Art Galleries), 57.

[17] The Poster Book Collective, South African History Archive, *Images of Defiance: South African Resistance Posters of the 1980s* (Johannesburg: Ravan Press, 1991), 8.

[18] Rasheed Araeen, "The Other Story: Afro-Asian Artists in Post-War Britain" (London: South Bank Centre, 1989), 65.

[19] Peter Magubane, *June 16: The Fruit of Fear* (Johannesburg: Skotaville Publishers, 1986).

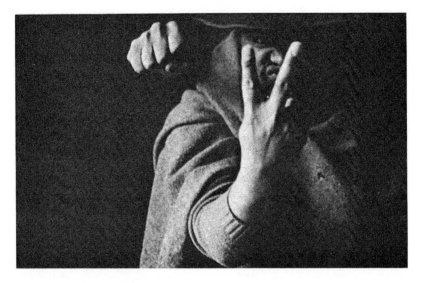

Plate 4.2. George Hallett, *Feni Dumile,* London, 1971. Silver print, black and white photograph. Courtesy of the artist.

Beyond the imminent violence contained in Magubane's photographs, and the duty for South Africa and the world to remember, commemorate, and support the fight for human rights in the land that French philosopher Jacques Derrida called "racism's last word," lies a story linking South Africa and Germany.[20] If 1950 is known as the year of the foundation of the Stasi, it is also the year Berlin-born photographer Jürgen Schadeberg emigrated to South Africa. Schadeberg's first encounter with the country's political climate is recalled in his book *The Fifties People of South Africa* (1987) with the following words:

> Since my English was very poor, I was initially surprised and delighted to find that my travelling companion on the long train journey to Johannesburg spoke fluent German. My delight soon faded as he began to lecture me, insisting that Hitler was on a par with Napoleon and Caesar, singing the praises of the Nazi Movement. His name was Dr van Rensburg, and he was, as I later discovered, leader of the Ossewa Brandwag. Thirty-six hours later, that crisp, dry winter morning, I stood on the platform at the Johannesburg station, having come to the end of the world, baffled. Amazed to find that although 60 million people had just died in a bloody

[20] Jacques Derrida, "Le dernier mot du racisme," in *Art Contre Apartheid.* Exhibition catalogue, *Les Artistes du Monde Contre l'Apartheid*, Paris, 1983, 11-35.

war fought by the forces of the entire free world, racial-hatred philosophies were still flourishing in South Africa.[21]

History attests to the fact that remnants of the Nazi ideology found their way through South Africa's politics.[22] Yet Germany is the country that nurtured the photographer regarded by many as the father of South Africa's photojournalism. When Schadeberg settled in South Africa, he took up a position as photo-editor at *The African Drum*. This position, he writes, was declined by white photo-editors because the magazine was for "natives."[23] He first paired with journalist Henry Nxumalo (aka Mr Drum), then increased the editorial team with journalists, writers and photographers, among whom were Bob Gosani, Peter Magubane, Ernest Cole and Alf Kumalo.

Unlike mainstream South African press that painted the black world either through the prism of exoticism, or worse, under the negative light of poverty and violence, *Drum* epitomised what was to be known as the "Sophiatown Renaissance."[24] The pages of the magazine portrayed black urban life and depicted the township as a cultural hub. This made it an attractive publication to black readers and emerging intellectuals alike. Magubane joined *Drum* in 1954, first as a driver and messenger, but he soon showed an interest in photography. Under Schadeberg's mentorship, he became one of the most respected South African photojournalists of his time.

[21] Jürgen Schadeberg, *The Fifties People of South Africa* (Bailey's Photo Archives, 1987), 7.

[22] Journalist and former editor of the *Rand Daily Mail* (1977-1981), Allister Sparks writes that: "Afrikaners had always have an emotional bond with Germany, ties of ancestry and related language, and how, many of the new generation of Afrikaner graduates headed there for doctoral studies at the universities of Berlin and Munich and Cologne and Leipzig... They returned to South Africa to form a new Afrikaner political intelligentsia imbued with a new messianic idealism... In time a new generation of urbanised, educated Afrikaners arose steeped in the values of the new nationalism and the new politics." Allistair Sparks, *The Mind of South Africa* (New York: Ballantine Books, 1990), 148-149. See also Leonard Thompson, *A History of South Africa* (New Haven and London: Yale University Press, 1990), 184. Anthony Sampson, *Black and Gold. Tycoons, Revolutionaries and Apartheid* (London: Hodder & Stoughton, 1987), 61.

[23] Jürgen Schadeberg, *The Fifties People of South Africa*, op. cit., 7.

[24] Located in the outskirt of Johannesburg, Sophiatown was a vibrant cultural place in the 1940s and 1950s, before blacks were forcibly removed from 1955 onward. The Sophiatown Renaissance is an equivalent of the Harlem Renaissance, the New York-based black literary movement of the 1920s and 1930s.

Drum magazine featured stories as varied as sport, crime, social injustice and protest meetings. During his time there (1954-1963), Magubane took up significant assignments such as the Sharpeville Massacres (21 March 1960). In 1967, after having freelanced for three years (1963-66), he joined the *Rand Daily Mail (RMD)*, a liberal South African newspaper. Accounts of his ordeal at the hand of apartheid are well known. His activity and association with Winnie Mandela and the African National Congress led him to detention from 1969 to 1971, during which time he was kept in solitary confinement. In 1970 he was banned from public life and from practicing as a photojournalist for five years, forcing him to resign from the *Rand Daily Mail*. Although the author does not have specific details on circumstances of his banishment, we know that the latter usually relied on "secret reports by the Security Police."[25]

By June 1976, Magubane had had a first hand experience of the brutality of the regime and made it his duty to bear witness to the struggle for liberation. By doing so, he and the *Rand Daily Mail*, were infringing a number of apartheid laws including, as highlighted by South African researcher Samantha Keogh in her thesis *The Rand Daily Mail and the Soweto Riots*:

- the Native Administration Act of 1927 which made it a crime to promote hostility between blacks and whites. Any reports detailing inter-racial upheavals was a contravention of this law and was punishable by exile or banishment.
- the Riotous Assemblies Act of 1956 that gave the government the power to ban the media from publishing anything, which it saw as being "calculated to engender hostility between blacks and whites."[26]

Since the Group Area Act (1950) meant that townships were an accessible ground to black people, the presence of black journalists among its staff provided the *Rand Daily Mail* with exclusive stories on the township.[27] The Soweto Uprisings were no exception. Magubane's presence as a member of the press did not exempt him from police violence. While documenting the demonstrations, he was assaulted by the

[25] *Apartheid, the Facts*, op. cit., 60.
[26] Samantha Keogh, *The Rand Daily Mail and the Soweto Riots: An Examination of the Tradition of Liberal Journalism in South Africa as Illustrated by the Rand Daily Mail coverage of the Soweto Uprising on June 16, 1976* (Johannesburg: Master of Arts in Journalism and Media Studies, Witwatersrand University, 2005), 123.
[27] The Group Area Act (1950) was an apartheid law designed to enforce separation between races by assigning racial groups different residential areas.

police, had his nose broken, and was hospitalised for five days.

Keogh observed that stories of the uprising ran in the *Rand Daily Mail* with a majority of fair balanced factual reports.[28] "By law," she writes, "the only stories, which had to be pre-approved by the government, were those mentioning the Defence Department, prisons and police force."[29] It is a known fact that spies were operating at the *RDM*. This was attested during the Truth and Reconciliation Commission Media Hearings held in Johannesburg from 15-17 September 1997.[30] However as Keogh argues, since "no censors were placed in the newsrooms by the government there was no real force preventing newspapers from printing what was happening in the country."[31]

Magubane's photographs, published by both the *Rand Daily Mail* and international press, are a record of a historical moment of which we know the place and date of occurrence. As visual components of *Freedom Hunters*, they serve the poster's purpose as facts used to denounce the violence of apartheid and reinstate that the oppressed people were ready to fight for their freedom. But the poster also contains visual elements in which narrative is less directly tied to the abovementioned event. These images are metaphorical. Although they occupy marginal spaces within the pictorial field—the two pictures are placed at the top left and bottom right—they demonstrate the notion of polyphony and the debate on resistance art.

[28] Samantha Keogh, *The Rand Daily Mail and the Soweto Riots: An Examination of the Tradition of Liberal Journalism in South Africa as Illustrated by the Rand Daily Mail Coverage of the Soweto Uprising on June 16, 1976*, op. cit., 84-86.
[29] Ibid., 37.
[30] http://www.doj.gov.za/trc/special/media/media03.htm (accessed: September 19, 2009).
[31] Samantha Keogh, *The Rand Daily Mail and the Soweto Riots: An Examination of the Tradition of Liberal Journalism in South Africa as Illustrated by the Rand Daily Mail Coverage of the Soweto Uprising on June 16, 1976*, op. cit., 37.

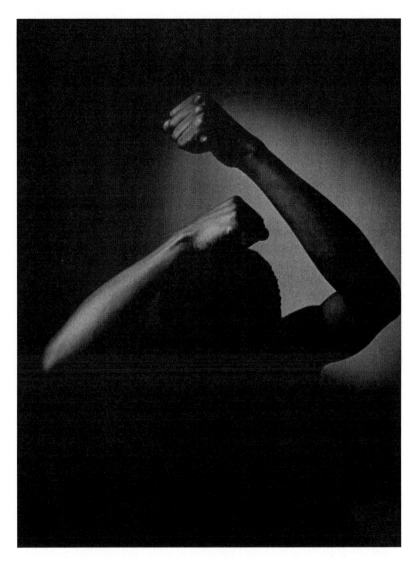

Plate 4.3. George Hallett, South African exile posing for the book cover of Daniachew Worku's, *The Thirteenth Sun* (London: Heinemann Publishers, African Writers Series, 1973). Silver print, black and white photograph. Courtesy of the artist.

Dumile, Hallett, Jantjes and the process of intertextuality

It is many years after having seen reproductions of *Freedom Hunters* that the awareness of a pre-existing knowledge of the peripheral images forming part of the poster revealed itself. Memories of the silver prints, first seen at the photographer's place of exile, give way to a permanent feature on a familiar shelf: *Images*, a book by George Hallett, published in 1979 by writer and protest poet James Matthews consists of a series of photographs taken in South Africa in the late 1960s and in exile in the 1970s. The two pictures authored by Hallett, reproduced by Jantjes, feature on pages twenty and twenty-one. Their proximity in the publication and their presence on the same silk-screen seem to indicate Jantjes' knowledge of the book and maybe of the diptych formed by the pair, as well as the intimate story behind those images. The artist certainly did not operate a random selection. His intention was not to reuse photographs that shocked the world, nor popular snapshots reproducible in a Warholian fashion. Here, the message is more subtle.

In the first picture, an anonymous male figure poses in a performative manner, bare chest and fists clenched over his bent head. Hallett creates an effect of *chiaroscuro* by obscuring the face and bust of the protagonist—as if to allude to the then subservient status of the black population—and by emphasising the menacing fists, rising from darkness to light. One could read this *mise-en-scène* as a metaphor of the struggle bound to lead the oppressed people to freedom. In the second image, the person's face is revealed. His menacing attitude, two fingers up, and a fist emerging from the dark background, express an intense anger. Accompanying these images are words by James Matthews:

> the agony inflicted
> I shall no longer endure
> I shall be me.[32]

One has to refer to the photographer's account to unveil the narratives relevant to our reflection on oppression, surveillance and censorship as a lived experience and visual representation. In these images, Hallett, mostly known for his portraits and social documentaries, was experimenting with aesthetic compositions and metaphorical representation. His pictures of a South African exile and of Dumile belong to one of his lifelong series consisting of a recording of South Africa's history, notably life in exile.

[32] George Hallett and James Matthews, *Images* (Cape Town: BLAC Publishing House, 1979), 21.

Dumile is the artist mentioned by Steven Sack in the citation used earlier in our discussion on resistance art. Dumile's work, Sack writes, did "attest to the enormous anguish and torment and the need to talk of the violence that surrounded him and that, in many instances, destroyed him." Dubbed "the Goya of the Townships," he was one of the few black artists to have gained some recognition in the segregated country. As a painter and a sculptor, his work addressed the inhumanity of life under apartheid in a distinct signature identified by his specific treatment of the human figure such as a contorted body, emaciated limbs, face struck by fear, pain, bulging eyes.

Dumile held his first solo show in 1966 at Gallery 101 (Johannesburg) and received encouraging reviews. However, he also became a target of South African authorities. Durban-based artist Sherene Timol Seedat recalls the *Trans Natal Exhibition* (Natal Society of Art Gallery, 1966) show in which he was taking part as an event that raised the attention of the special branch (South Africa's secret police) which questioned the organisers suspected of "using the exhibition as a cover for subversive activities."[33]

Dumile had been harassed by the police both for his political views and because, under apartheid laws, art did not qualify as a job for a black man. Black people's whereabouts were subjected to the possession of a valid pass and as the latter usually only allowed circulation from the pass holder's residence to their place of work, Dumile found himself being illegal in his country.[34] South African journalist Lionel Ngakane reported in an article published in *Africa Arts*, that Dumile was expelled from Johannesburg and sent back to Cape Town. There, he was referred to his town of birth, Worcester, but was refused a resident permit and even threatened to be sent to a tribal reserve.[35]

Although he was not explicitly banished from his country of birth, the impact of apartheid legislation was an insurmountable hurdle that left him no other option than to choose the route to exile. An invitation by Eric Estorick to exhibit at the Grosvenor Gallery (London), upon recommendation

[33] Prince Mbusi Dube, *Dumile Feni Retrospective* (Johannesburg: Johannesburg Art Gallery, 2006), 41.

[34] The pass law was introduced in 1923 to regulate the movement of black South-Africans, within urban or white areas. Failure to provide a passbook when requested by the police resulted in either in imprisonment or deportation.

[35] Lionel Ngakane, "Dumile: A Profile" in *African Arts*, vol. 2, issue 3, winter 1970, 10.

by South African artist Bill Ainslie, gave him his passport to freedom.[36] Dumile arrived in London in 1968 where he joined a growing community of South African exiles. Some having chosen "voluntary" or "self-imposed" exile, like Hallett in 1970, others being banned from living or working in their country, like Jantjes from 1978 until the end of apartheid.

As far as we know, Hallett never experienced censorship for his career started in the UK. But his record of South African exiles that had fled the apartheid regime and its repressive laws, speak of the impact of the oppression, censorship and banning that threatened or affected any South African who opposed the apartheid regime.

These multi-layered narratives were transposed on one *locus*, the anti-apartheid poster. The context of creation of those pictures, the story behind them and their citation call to mind processes of cross-reference. Oppression, one of the coercive means of dictatorial regimes, assisted by practices of surveillance, is recounted by multiple voices. It is a polyphonic tale, narrated through a variety of media, be they tangible: photography (Magubane, Hallett), collage and silk-screen (Jantjes) or implied: drawing (Dumile). Translated into linguistic terms, this intertwinement of messages and media, or signified and signifiers, to borrow from French semiotician Roland Barthes, could be apprehended through the concept of *intertextuality* developed by Bulgarian-French poststructuralist philosopher Julia Kristeva. "The term *inter-textuality*, she writes, denotes [a] transposition of one (or several) sign system(s) into another." If we consider the anti-apartheid poster as a visual "system," then we can argue that the photographs, pieces of writing, and other elements appropriated by Jantjes shift from being closed entities, finished artworks, to become signs forming part of a larger system: the poster or silkscreen. They become a material, a "pigment," laid onto the medium to convey a certain message. This phenomenon of transposition also applies to Hallett's portrait of a defiant Dumile. The anger one reads on the painter's features stems from the same sort of pain inflicted on black South Africans. In his drawings Dumile explored both suffering and anger. Here the latter is expressed through his performative body, photographed by Hallett and reused by Jantjes to echo, the violence encountered by the *Freedom Hunters* in the real situation of demonstrations, riots and police assaults documented by Magubane.

This reflection can be further considered in relation to the origins of intertextuality in the work of Russian theorist Mikhail Bakhtin. Out of the diversity of his vast theoretical legacy, in this instance, particular

[36] Bruce Smith, *Dumile: Artist in Exile*, exhibition catalogue (Johannesburg: Art on Paper, 2004), 16.

importance can be paid to his interdisciplinary approach for it is through this interpretative grid that one is to approach Gavin Jantjes silkscreen. Amna Malik's idea of "polyphonic dimension" is, indeed, substantiated by Franco-Bulgarian philosopher Tzvetan Todorov's claim that for Bakhtin, the inter-human is an inherent part of the human and that in a context of multiple individualities; each one is the necessary complement of the other,[37] a concept that echoes *Ubuntu* philosophy, an African humanism brandished against the apartheid ideology.

Intellectual productions are therefore not to be defined in terms of "essence" but rather through their authorial and discursive diversity. By using Magubane and Hallett's photographs, Jantjes added multiple layers of interpretations to both his work and the art he appropriated. His anti-apartheid prints gained from the depth of the historical context from which stemmed the borrowed images. They also extended and altered the narratives that defined these images. While Hallett developed personal aesthetic projects—Dumile's portrait was not a commission—iconographical material authored by him was now indirectly involved in a case of censorship. So were Magubane's pictures, which paradoxically—and this maybe reflects the absurdity of the apartheid laws—had been published in the *Rand Daily Mail* and around the world a couple of years before the ban on Jantjes' work.

Gavin Jantjes' anti-apartheid posters were distributed to all UN members and to all UN offices around the world, some 900,000 copies each. The ban on his art lasted until the end of apartheid. As he wrote to the author in 2003:

> No-one inside South Africa could own a work of mine as they would then be in possession of banned material and that was punishable by law. The South African writer James Mathews who owned a few of my graphic prints had these confiscated in a police raid on his house and he has never had them returned. He was however not prosecuted for that. This also meant that the South African National Gallery could not purchase any of my work. This, they only began to do, in 1999.[38]

The story of apartheid, and its control apparatus, assumes interesting though dramatic similarities with German political history: adoption of Nazi ideology, resort to practices of surveillance, spying, harassment and censorship, developed within the same timeframe as the Stasi operations.

[37] Tzvetan Todorov, "L'Humain et l'interhumain," in *Critique de la critique* (Paris: Editions du Seuil, 1984), 96.
[38] Gavin Jantjes, email to the author, May 28, 2003.

The fall of the Berlin wall (November 1989) heralded an era of change. Three months after the media broadcasted to the world images of Berliners climbing over and hammering the Wall, the international community witnessed the release of Nelson Mandela (February 1990).

Conspiracy Dwellings, with its focus on surveillance in contemporary art, provides one of these rare opportunities to show how people from countries so far apart geographically not only shared a similar history of oppression, they also demonstrated the same resilience and determination to achieve their freedom and a recognition of their human rights.

THE LIVES OF OTHERS:
ARTUR ZMIJEWSKI'S *REPETITION*,
THE STANFORD PRISON EXPERIMENT,
AND THE ETHICS OF SURVEILLANCE

ANTHONY DOWNEY

> I like it when art is no longer art, when it stops being art.
> —Artur Zmijewski

In 2005, under the direction of the Polish artist Artur Zmijewski, a "prison" was constructed in Warsaw's historical district of Praga. For a planned period of two weeks, and following on from a screening process, seventeen unemployed Polish men were allocated the role of being either a guard or a prisoner in this makeshift prison. The building, now part of the Van Abbemuseum's collection in Holland, had one-way windows through which five cameramen gathered material that was further complemented with footage from an infra-red surveillance camera.[1] Over the ensuing days, and under constant surveillance, an unedifying game of cat and mouse was played out by the inmates and guards alike; a scenario in which control, subversion, manipulation and, ultimately, gratuitous humiliation became the order of the day. This uncompromising and at times disconcerting footage was used to produce *Repetition* (2005), a film that has since acquired much by way of reputation and critical plaudits. The origins of *Repetition*, both in its concept and objectives, not to mention its *mise en scène*, lie in events that occurred almost thirty-five years earlier under the supervision of the American psychologist Philip Zimbardo. Following on from a series of interviews and a period of psychological assessment, a sample group of twenty four college students—garnered from replies to a Californian newspaper advertisement placed in the summer of 1971—were randomly allocated, after the flip of a coin, the

[1] The Van Abbemuseum acquired the prison constructed of chipboard and the filmed footage for the occasion of their exhibition of Artur Zmijewski's show there in 2007. It was shown alongside a quadriptych of films made by the artist in Israel.

role of either prisoner or prison guard in a research project that came to be known, somewhat infamously, as the Stanford Prison Experiment. To the extent that the project has since been criticised as unethical, in later years by Zimbardo himself, and questioned on the basis of its usefulness in terms of research, the Stanford Prison Experiment nevertheless had an explicit if not intriguing question underwriting it: how do seemingly "normal" people react to having roles (and authority) imposed upon them? After six days, in which he noted that his volunteers had internalised their parts so completely that his prisoners had become traumatised and his guards increasingly sadistic, Zimbardo called a halt to the experiment. The internalisation of roles was so consummate, he noted, that a significant number of participants were finding it increasingly difficult to distinguish their role-play from the reality of the situation, himself included.

Prior to the cessation of the experiment, however, it was observed that the guards were becoming increasingly ruthless and severe during the day and at night, when they thought the cameras were off, they were subjecting their charges to ever more brutal treatment. This brings us to an often overlooked aspect of the Stanford Prison Experiment: what role did the deployment of surveillance (or the apparent suspension of its use) have in producing the behaviour of inmates and guards alike? Despite the fact that both experiments ended with a similar degree of exasperation and concern for the psychological and physical well-being of its participants, to date discussions of Zmijewski's subsequent re-enactment of the Stanford Prison Experiment have failed to fully address either the artist's role in the film as a figure of ultimate authority and power—not unlike that adopted and wielded by Zimbardo—nor his use of surveillance, not least the manner in which it renders viewers complicit in the events portrayed in the film.

I should note from the outset, however, that Artur Zmijewski's *oeuvre* to date is extensive and invariably challenging. To extrapolate from one work and take it to be indicative of his work in general is not my goal here. Nor am I suggesting that art should not challenge ethical, political and aesthetic pieties. It is precisely the contradictions inherent within and the irredeemable ambiguities that underwrite contemporary art today that gives it both an autonomous and yet integrated role to play in the politics and ethics of our time. And those contradictions are nowhere more clearly visible than in collaborative art practices that employ the visual rhetoric of surveillance. However, the relatively underdeveloped discussion of both Zmijewski's role and his use of surveillance in *Repetition* brings to the fore the often problematic relationship between ethics and aesthetics and engages a singular question: can the use of surveillance be anything other

than a compromised form of film-making that—in its deployment of a complicitous visual rhetoric and objectifying practices—situates the viewer in an anterior position of power within a hierarchy of panopticised observation?

Experimental Psychology and the Architecture of Debasement

It may seem somewhat quaint today as we look back through the prism of wrongful arrests and miscarriages of justice worldwide, but Zimbardo was originally aided by the Palo Alto police force who, on a quiet Sunday morning in August 1971, obligingly arrested and conducted full booking procedures on the volunteers deemed prisoners in the Stanford Prison Experiment.[2] Arrested at their places of work and private homes, these individuals were fingerprinted, had mug-shots taken and, upon arrival at the prison, were de-loused and assigned a cell. The prison in question was constructed by boarding up each end of a corridor in the basement of the psychology department at Stanford University, with the ensuing enclosed space ironically referred to as "The Yard." This was the only place where prisoners were allowed to walk, eat, fraternise, or exercise. In order to go to the toilet inmates were first blindfolded so they could not observe the way out of the prison. Nor were any clocks or windows visible in this edifice, an intentional absence that further promoted a sense of alienation and displacement—precisely the conditions that Zimbardo wanted to induce in his charges from the outset.

A central factor in this process of disorientation and alienation, and the subsequent debasement and degradation visited upon these prisoners, was the carceral architecture of control that dominated the experiment and the power that surveillance invests in the observer. Apart from a hidden camera at one end of "The Yard," an intercom system was set up to allow aural surveillance of the prisoners and to make public announcements. It was through such mechanisms that the guards were able to not only observe the detainees but listen in on their conversations. It should be also noted that the abuse meted out to the prisoners, as was later acknowledged, was largely due to the lack of any clear guidelines from Zimbardo as to how detainees should be treated; nor were the guards given any training in

[2] At a later stage in the experiment, Zimbardo was to rue the fact that the police force, due to considerations of liability and insurance, refused to give over the police station for the continued incarceration of his wards. For full, and surprisingly frank, details of the prelude to the experiment and events throughout, see http://www.prisonexp.org/ (accessed December 10, 2009).

policing an institution whose primary function was incarceration. In the experiment, Zimbardo, who played the proactive role of the "superintendent" whilst also being the apparently objective psychological researcher, gave instructions to the guards that were to later become controversial:

> You can create in the prisoners feelings of boredom, a sense of fear to some degree, you can create a notion of arbitrariness that their life is totally controlled by us, by the system, you, me, and they'll have no privacy... We're going to take away their individuality in various ways. In general what all this leads to is a sense of powerlessness. That is, in this situation we'll have all the power and they'll have none.[3]

The situation, needless to say, quickly got out of hand, with prisoners forced to sleep on the ground (their mattresses having been confiscated); threats of further violence being used to quell dissent (including the discharge of carbon-dioxide from a fire extinguisher); the deployment of arbitrary forms of punishment (including press-ups, stress-positions, and solitary confinement); prisoners being forced to go naked, subjected to sexual humiliation, and forced to perform acts of simulated homosexual sex; and, finally, so-called slop buckets being left un-emptied so that the smell of urine and faeces pervaded the cells and further dehumanised those imprisoned within, guard and prisoner alike.[4]

[3] See http://www.prisonexp.org/ (accessed December 10, 2009).

[4] There have been comparisons made here with similar techniques to those used in Abu Ghraib, not least by Zimbardo who recently appeared as an expert witness at the Abu Ghraib court martial proceedings brought against Ivan "Chip" Frederick—the latter being a staff sergeant who was to become the highest-ranking officer court-martialed for crimes at the American-run prison. To the extent that Zimbardo is right in suggesting that the conditions prevalent within Abu Ghraib for prisoner and inmate alike—if taken into account alongside the stresses associated with being in a theatre of war—were so dehumanising to begin with that such abuses were inevitable, his thesis carries a not insignificant degree of purchase. What is more, the absence of any Standard Operating Procedure (S.O.P.) at Abu Ghraib— an absence that exploited the lack of clear-cut procedures in the prison alongside the strategically ambiguous orders handed down from the executive branch of the American government—does indeed find parallel in Zimbardo's vague instructions to the guards in his 1971 experiment. It has been argued, for example, that it is was precisely the absence of any S.O.P., not to mention the Bush Government's intentional obfuscation of its responsibilities under the Geneva Convention, that was responsible for the institutionalised, as opposed to individualized, forms of abuse and torture that were inflicted upon inmates at Abu Ghraib. For a fuller discussion of these issues, see Philip Gourevitch and Errol Morris, *Standard Operating Procedure: A War Story* (London: Picador, 2008) and Philippe Sands,

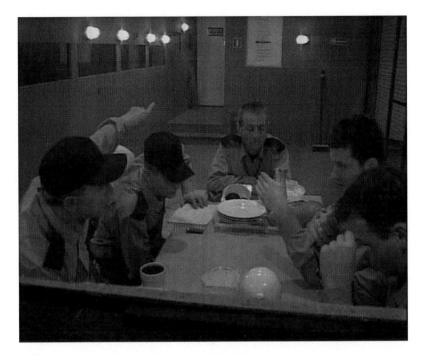

Plate 5.1. Artur Zmijewski, *Repetition*, 2005. Film still, single channel video projection or monitor, 74.15 min. Courtesy of the artist, Foksal Gallery Foundation, Warsaw and Galerie Peter Kilchmann, Zurich.

The Stanford experiment ended on August 20, 1971 and it has been since argued (and refuted) that the experiment amply demonstrated the potential for any individual, regardless of background, to resort to unquestioning obedience within the context of legitimising ideologies that adopt (and adapt) institutional forms. The experiment is also consistently cited to illustrate cognitive dissonance theory; that is to say, the implication that it is situations and contexts that produce an individual's behaviour rather than an individual's personality. However, on ethical grounds, the original Stanford Prison Experiment would be not only

Torture Team: Deception, Cruelty and the Compromise Law (London: Allen Lane, 2008). I have written in depth elsewhere on the subject of torture and its use in Abu Ghraib. See Anthony Downey, "At the Limits of the Image: Representations of Torture in Popular Culture," *Brumaria, 14, Iconoclasm–Iconolatry,* 2009, 29-47, http://www.brumaria.net/erzio/en/publication/14.html (accessed December 10, 2009).

inadmissible today but legally unperformable under the guidelines set out by the American Psychological Associate Ethics Code, the Canadian Code of Conduct for Research Involving Humans, and the Belmont Report.[5] The fact that the experiment cannot be repeated—legally or otherwise—under the original conditions, and therefore cannot be verified, leaves its conclusions far from admissible in terms of substantiative research. It is all the more germane, in light of this, that Zimbardo's research findings were never submitted to a peer-reviewed journal.

Repetition and the Rhetoric of Surveillance: Aesthetics or Ethics?

Zmijewski's film was staged in a similar manner to the original Stanford Prison Experiment, with each individual undergoing screening before being allocated a role in the prison and being paid $40 per day.

Every detail was copied from the original experiment, from the point of arrest to the arbitrary allocation of roles, with the pivotal position of superintendent being adopted by the artist. The experiment was attended by psychologists who were authorised to end the experiment at any threat of danger, a former prisoner (who had served seventeen years in prison) who acted as a counsellor, and a sociologist involved in prison reform. The blurb for the film observed that the only difference in this later work was that the participants were free to give up at any moment. Unlike Zimbardo's volunteers, Zmijewski's were indeed able at any time during the making of the film to commute involvement with no further explanation for their decision but under forfeiture of their fee. That a number of inmates chose to do so—and are shown doing so in the film—should be evidence enough that Zmijewski was encouraging not only a far more open-ended discussion than Zimbardo's experiment but one that took on a degree of ethical responsibility for the welfare of his wards. And, to a

[5] The Belmont Report was produced in 1979 in the aftermath of the scandal surrounding the so-called Tuskagee Syphilis Study, which detailed how 399 mostly poor and illiterate African American sharecroppers, between 1932 and 1972, were intentionally left with untreated syphilis so as to study its unchecked progression. The Belmont Report forms the basis for the protection of human subjects undergoing biomedical or behavioural research. The fundamental tenets and ethical principles of the Belmont Report include: respect for the persons (individuals should be treated as autonomous agents and any persons with diminished autonomy are entitled to protection); beneficence (persons are to be protected from harm and treated in an ethical manner); and justice (who receives the benefits of research and, perhaps more critically, who bears its burden).

certain extent, we could suggest that Zmijewski, the producer and architect of this event, was readily accepting that participation in his re-enactment bore a significant degree of responsibility on his behalf. Nevertheless, his volunteers were drawn from the ranks of the unemployed in Poland, many of whom had not worked for some time, and the reasons given for participation from the outset were uniformly financial. It was noted by prisoner 810, for example, that the warden appointed by Zmijewski on day six—an individual who becomes particularly diligent in his subjugation and humiliation of the prisoners—had not had a job in some time and was therefore happy to take up the role of guard in order to substantiate his eligibility for future employment.[6] Far from examining, or offering insight into, the psychological effects of being allotted the role of a prisoner or a prison guard, which was at least the avowed if flawed aim of Zimbardo's original experiment, *Repetition* would appear to tell us more about what happens when individuals—unemployed Polish men, for example—are put under constant surveillance in an artificial environment and are thereafter cajoled into performing certain roles.

So what, we may ask, was Zmijewski setting out to explore here: the desperation of unemployed men who want to keep their jobs, however we care to define that term, at all costs—even if that meant oppressing their charges? Or, as in Zimbardo's experiment, was the film setting out to examine whether power under certain institutional conditions corrupts those empowered by it? For Zmijewski, as he notes on the screen at the outset of the film, it would appear to be the latter:

> We attempted to recreate the conditions of the Zimbardo experiment, to confirm whether evil is inherent in human nature and always manifests itself whenever we consent. We paid the guards and the prisoners $40 a day.[7]

[6] For Nina Montmann it is *inter alia* the fact of remuneration that compromises Zmijewski's film. She writes, "The questionability of works in which social evils are not discussed but demonstrated, using living subjects treated as objects, is further heightened when most of the participants take part only because of their own deprivation, solely for the (small) fee being offered. Their own motivations and experiences play no role whatsoever; the participants merely perform, either actively or passively, in order to give an art audience the crassest possible sense of its own moral dilemmas by means of a form of shock treatment and the breaking of taboos." See Nina Montmann, "Community Service," *Frieze*, issue 102, October 2006, 7. http://www.frieze.com/issue/article/community_service (accessed December 11, 2009).

[7] Artur Zmijewski, *Repetition,* 2005.

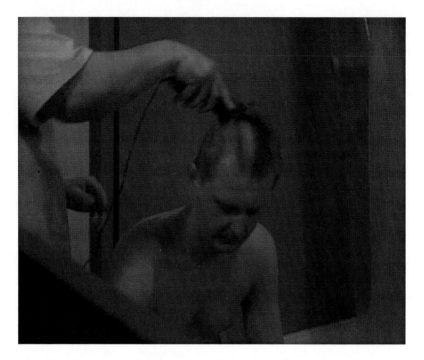

Plate 5.2. Artur Zmijewski, *Repetition*, 2005. Film still, single channel video projection or monitor, 74.15 min. Courtesy of the artist, Foksal Gallery Foundation, Warsaw and Galerie Peter Kilchmann, Zurich.

There is in this statement something that, at best, could be read as disingenuous or, at worst, insidious. The mere allusion to research being performed in this film, and thus producing a form of knowledge that can be in part substantiated or reliably referred to, is compromised from the outset not only by payment to individuals but by the very fact that Zmijewski has chosen an indelibly flawed experiment to re-enact in the first place. From the outset we must enquire into what exactly lies behind the ambition of this film and how do we interpret it: is it to explore, through the very act of repetition, the ethics of the first failed experiment? And if so, why exactly? As a form of knowledge, in this instant psychological, it neither confirms nor refutes an already compromised hypothesis. Is Zmijewski's film about free will and our apparent lack of it in the face of an ideological system of rules? And what role, crucially, does surveillance play here; that is, the very means by which we access the

films and the very means by which Zmijewski controls events within the prison?

In light of his role as prison guard/observer/artist/producer, it is often a source of surprise that Zmijewski has been critically viewed as an objective and ultimately disinterested observer. D.C. Murray suggests that "[i]n many instances, Zmijewski purposefully inhabits the role of a disengaged observer, allowing events to unfold without intervention."[8] This is patently untrue: if anything Zmijewski is the *agent provocateur* and very quickly allows his influence to be felt upon the protagonists in the film. He is a *deus ex machina* of sorts, but rather than resolve conflict he seems to actively encourage it. There are a number of times where he interjects forcibly, like a producer impatient for conflict to arise, in order to speed up the action or create circumstances where discord will thrive. In one particular scene, following a show of insubordination from "prisoner 810" on day four, Zmijewski cajoles the guard in question and notes that the prisoner *must* be punished. "Prisoner 810" is taken from his cell, on Zmijewski's initiative, and coerced into apologising to his fellow inmates before being further humiliated and transferred to a solitary confinement cell. *Mise en scène*, in such fabricated surroundings, can quickly become a form of *mise en abyme*: individuals are placed into an infinity or an abyss of confusion between role-playing and reality. The architecture of debasement, in which surveillance upholds carceral systems of abuse,

[8] Derek Conrad Murray, "Carceral Subjects: the Play of Power in Artur Zmijewski's *Repetition* / Sujets Carceraux: le Jeu du Pouvoir dans *Repetition* d'Artur Zmijewski," *Parachute*, no. 124, Montréal, Canada, 2006, 78-91 (78). In a relatively lengthy exploration of Zmijewski's work, Norman L. Kleeblatt also argues, following on from vague references to the "profound beauty" and "uncanny beauty" to be had in Zmijewski's *oeuvre*, that the artist "offers nothing but dispassionate observation." Again, this is simply not the case, nowhere more so than in *Repetition*, a film which Kleeblatt, despite detailing the majority of Zmijewski's work to date, does not mention nor explore. Nor does he mention *80064*, 2004, a film in which Zmijewski cajoled a 92 year survivor of Auschwitz, one Józef Tarnawa, to have his concentration camp number, the eponymous title of the film, re-tattooed on his arm. Despite these and other instances in which Zmijewski plays an obvious if not decisive role in his films, he still has the name of being objective, a bystander in what is unfolding around him as opposed to a protagonist. See Norman L. Kleeblatt, "Moral Hazard", in *Artforum*, April 2009, 155-161 (159). I have written about Zmijewski's *80064* in a different context elsewhere. See Anthony Downey "Zones of Indistinction: Giorgio Agamben's 'Bare Life' and the Politics of Aesthetics," in *Third Text*, vol. 23, no. 97, 2009, 109-125.

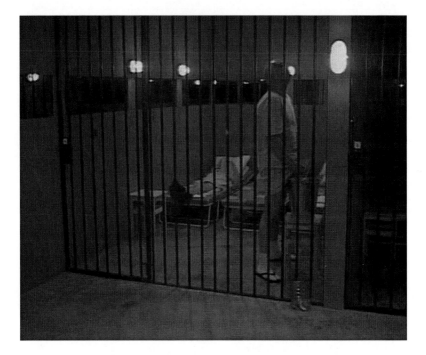

Plate 5.3. Artur Zmijewski, *Repetition*, 2005. Film still, single channel video projection or monitor, 74.15 min. Courtesy of the artist, Foksal Gallery Foundation, Warsaw and Galerie Peter Kilchmann, Zurich.

encourage precisely such recursive levels of ethical relativism and a concomitant absence of accountability.

On day six, at 8.30 a.m., Zmijewski appointed a new warden to oversee the prison, complete with instructions that included forcing the inmates to have their heads shaved. On day seven, following on from the rancour involved in this enforced head shaving, the warden in question has a crisis of confidence and refers to Zmijewski who abnegates his authority over the matter, despite having introduced the very practices that have produced the crisis in the first place. The experiment/film comes to a close with the guards and prisoners alike agreeing that the boundaries of decent and humane behaviour have been overstepped. They subsequently vote unanimously to end the "experiment." It is a somewhat cathartic ending to a compromised idea and it is all the more suspect, following on from the end of the experiment and interviews with the warden, that Zmijewski should pose questions such as "[i]s it automatically the case that if you

give someone absolute power over another, he will become a monster?" We may ask, who exactly is he referring to here, himself or the warden? He is, at the very least and despite his careful tending of the artifice surrounding his apparent objectivity, partly responsible for what has unfolded: a fact that is made evident when, upon Zmijewski suggesting to the warden that he was a good person who turned out to be bad in the circumstances, the latter replies "[I]t may be that two bad people met, you [Zmijewski] and I, and we brought it off together. You devised, I did."

Upon being asked in an interview why he still played the role of a "truant" and from what he was avoiding in this act of truancy, Zmijewski replied that he was attempting to be truant from "ethical, aesthetical or religious obligations—from all duty."[9] Of course, such a statement has to be understood in a specific context; however, it still begs a fundamental question: can we apply ethical criticism to *Repetition* in the same way that many commentators, Zimbardo included, have applied it to the original experiment upon which it is based? If we consider the role of ethics in this film and its making we nevertheless come up against a conundrum of sorts. In a milieu where participative and collaborative practices have become an increasingly notable element in contemporary art, there is the suggestion that ethico-political criticism has usurped forms of criticism that take the aesthetic as their starting point. Works such as Zmijewski's *Repetition* are thereafter judged by the quality and ethics of the collaborative practices that they set in motion rather than what makes them interesting as art. There is much to be said on this matter, including a debate on artistic autonomy, social intervention, and social praxis; however, I want to note how Zmijewski's film could be critiqued in terms of its ethical dimension rather than its aesthetics—the latter being that which gives it purchase as art as opposed to ethico-political criticism.

We may equally ask here, in light of such observations, why art as a practice should be subjected to the criteria of objectivity or disinterestedness—is this not precisely what the aesthetic works against, so to speak: the introduction of ambiguity and contradiction into systems of apparently closed thought? To prescribe the aesthetic to a series of ethical and political considerations is to engage it in either a form of agitprop and propaganda or forms of instrumentalist rationalism—and the pitfalls of such an approach do not need to be necessarily rehearsed here.[10]

[9] "A Storehouse of Limbs: Artur Zmijewski speaks with Katarzyna Bielas and Dorota Jarecka," in *Artur Zmijewski: If It Happened Only Once It's as if It Never Happened* (Ostfildern-Ruit: Hatje Cantz, 2005), 81.

[10] I have written at length on the issues underwriting the relationship between aesthetic, ethics and politics in respect of so-called collaborative art practices. See

At this stage we may have to put to one side both ethical and even political categories—not to mention accusations of coercion and manipulation— and examine the work in purely aesthetic terms: what, in short, is the effect of its framing devices and formal characteristics and how do such devices relate to broader socio-political issues, not least those surrounding surveillance technologies.[11]

The cells in Zmijewski's prison all employed one-way mirrored glass through which four manned and nine fixed cameras recorded all events. Putting to one side, for now, the constant effect of surveillance upon the prisoners and how it produces modes of behaviour, it is all the more pertinent to note that surveillance has its own formal aesthetic: surreptitious shots taken from above, acute angles, often grainy footage, a degree of apparent objectivity, and multiple screens. As an aesthetic form, moreover, it implicates the viewer from the outset in its panopticised rhetoric and the implication of guilt that it places (rightly or wrongly) on those who are being viewed. We, in short, become complicit in the act of surveying and surveillance. The extent to which we can ignore the ethical quandaries that arise in works such as *Repetition* is therefore debatable, nowhere more so than when it is precisely an aesthetics of surveillance that, in drawing us into a form of collusion if not outright connivance in the events that unfold before us, is being utilised for what are arguably dubious ends. Surveillance as a technology of seeing and imagining the world presupposes modalities of guilt in the individuals being observed and therefore encourages, for whatever reasons, a call to judgement in those observing. It promotes a vital lack of transparency, paradoxically, in the very moment of apparently revealing the world to the privileged viewer. The rhetoric and aesthetic of surveillance is not only about a will to truth, the production of truth/knowledge, it also imbricates the observer within a system of knowledge that includes the production of criminological, juridical and sociological models for the study of normative and, crucially, aberrant forms of behaviour. Apart from the discursive production of subjects inherent within such knowledge systems, we need to address how the use of surveillance produces, through a process of internalisation, the

Anthony Downey, "An Ethics of Engagement: Collaborative Art Practices and the Return of the Ethnographer," *Third Text*, vol. 23, no. 100, issue 5, 2009, 593-603.

[11] In focusing on the formal aesthetics of the film, I am putting to one side the narrative aesthetics and the film's apparently cathartic ending. There is much to say on the narrative aesthetics, in terms of both the conflicts and resolutions we witness and how editing generates such readings; however, for the purpose of my argument here, I am primarily interested in the formal aesthetics of surveillance and how it is utilised in *Repetition*.

very behaviour we witness. That Zmijewski's participants know that there are cameras present, and that they are the objects of observation rather than the subjects of communication, is evident throughout the film. "Prisoner 433," who withdraws from the experiment on day five, flicks his middle finger at the one-way glass before his departure and hangs his towel up to block the view of the camera. The gesture is significant insofar as it positions, in one of the few instances in the film when we are denied access to the prison, the viewer as voyeur. We are made conscious of the artifice and the way in which we have been positioned in this film as a guard by proxy. In the rhetoric of surveillance the viewer can be only ever implicated in the process of objectivising the subject who is being observed. We can only, in short, internalise the role of observer with all the ramifications that such a role implies in the context of the architecture associated with incarceration and control.[12]

We, the viewer, engage here in a rhetoric of surveillance that offers nothing by way of a self-reflexive critique on the use of surveillance. Additionally, at no point in the film are we invited to consider the fact that we are also in part incriminated in this makeshift carceral system. Just as the edifice of a prison contains the events therein, the artifice of an objective gaze, central to the original experiment, is precisely that: an expedient device to absolve the viewer of any apparent responsibility for the events that are unfolding. The use of surveillance in *Repetition* also carries with it a rhetoric of truth: this is what we saw and this is how it happened. This is likewise dubious, especially if we consider (although it is largely beyond my remit here) Zmijewski's editing of the footage and the final form that the film took. Nonetheless, surveillance footage is often associated with veracity, both legal and phenomenological. In reality TV shows, it gives the illusion of access to the real, regardless of how contrived that real is in the first place. Recent commentators on surveillance have also noted a degree of correspondence between the forms that mass media assumes and surveillance technologies such as CCTV. For Thomas Mathiesen, "the greatly expanding mass media system provides the necessary belief context, the obedient, disciplined, subservient set of beliefs necessary for the surveillance systems to be

[12] This reading would run counter to Norman L. Kleeblatt's suggestion that the artist's videos "seem incompatible with simulation theories of ethical aesthetics, which postulate that the viewer (or reader) internalises the situation of the protagonist, using his or her own belief system to play out the narrative of a work of literature or art." See Norman L. Kleeblatt, "Moral Hazard," *Artforum*, April 2009, 155-161; (155).

functional."[13] Or, to put it another way, the "synoptic" TV viewing experience—the masses watching the few—finds a counterpart of sorts in the "panoptic" technology involved in surveillance, the latter involving the few surveying the masses.[14] Surveillance is normalised not only through its presence and usages but through its popular cultural inflections. And to this we could likewise add its use in contemporary art practices such as those used in Artur Zmijewski's *Repetition*.

Conclusion

I earlier noted that Artur Zmijewski's work is both challenging and, in turn, a veritable challenge to any embedded or indeed cherished notion of a privileged ethical vantage point from which the artist or indeed viewer can claim the moralistic high-ground. Perhaps this is central to the leap that Zmijewski wants art to make, as expressed in the epigraph to this essay: "I like it when art is no longer art, when it stops being art." This call for an art that integrates the aesthetic within the social order, and thus renders aesthetics responsive (but not necessarily reducible) to the social, political, economic, religious, and ethical milieu in which it is produced, disseminated and exchanged, is a noble and ultimately utopic vision of art—and to that end it should be supported. However, when art employs an aesthetic, such as that associated with surveillance, in order to render the viewer complicit in the debasement of others we have issues that must of necessity address an ethics of engagement. This is not to promote an ethics-based criticism of participative and collaborative-based practices (and the quality or otherwise of such events and collusions); rather it is to suggest an ethics of aesthetics and how such a form would address the role

[13] Thomas Mathiesen, "The Eagle and the Sun: on Panoptical Systems and Mass Media in Modern Society," in *Transcarceration. Essays in the Sociology of Social Control* from the series: Cambridge Studies in Criminology 55, ed. John Lawman, Robert J. Menzies, and Ted S. Palys, (Gower: Aldershot, England, 1987), 59-75 (75). Cited in Dietmar Kammerer, "Video Surveillance in Hollywood Movies," in *Surveillance & Society*, ed. Clive Norris, Mike McCahill and David Wood, 2004, 2 (2/3), 464-473; (465).

[14] In a House of Commons report published in 2009, Lord Goodlad observed the following: "The huge rise in surveillance and data collection by the state and other organisations risks undermining the long-standing traditions of privacy and individual freedom which are vital for democracy. If the public are to trust that information about them is not being improperly used there should be much more openness about what data is collected, by whom and how it is used." See Lord Goodlad, *Surveillance: Citizens and the State*, House of Lords Report, February 6, 2009.

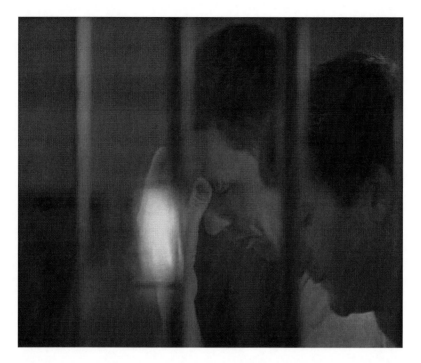

Plate 5.4. Artur Zmijewski, *Repetition*, 2005. Film still, single channel video projection or monitor, 74.15 min. Courtesy of the artist, Foksal Gallery Foundation, Warsaw and Galerie Peter Kilchmann, Zurich.

of the viewer in this rhetoric of surveillance and the panopticised power-play at work in a film such as *Repetition*.

YOU'LL NEVER WALK ALONE:
CCTV IN TWO LIVERPOOL ART PROJECTS

ROBERT KNIFTON

For the contemporary British city-dweller, CCTV surveillance is a fact of the urban fabric. In the UK there are more cameras in proportion to population than anywhere else in the world, accounting for one-fifth of the global CCTV market. As Norris and Armstrong remark, they are omnipresent: "In Britain it is now virtually impossible to move through public...space without being photographed and recorded."[1] Given the ubiquity of CCTV in our cities, the questions of how to theorise, negotiate, and indeed live in such a highly surveilled environment seem crucial. The two artworks introduced here reveal different aspects of CCTV's interaction with everyday urban life. There are three main themes we will examine. Firstly, the narrativising application of CCTV footage: as we shall encounter, surveillance film has often found itself suggestible to the insertion of often contrary narratives with serious implications. Secondly, there are the socio-spatial repercussions of CCTV—how the technology reads city space. For Roy Coleman, "CCTV cannot be understood in isolation from the processes of spatialisation that surround it."[2] Thirdly, following on from David Lyon's assertion that "to participate in modern society is to be under electronic surveillance,"[3] a particular form of participation will be sought: the performativity of the observed, where public space is seen to be enacted by the relationship built up between camera and the watched.

Both the case studies focus on Liverpool: this is highly appropriate, since more than any other city Liverpool has been pivotal to the development, justification and expansion of CCTV systems in the UK,

[1] Gary Armstrong and Clive Norris, *The Maximum Surveillance Society: The Rise of CCTV* (Oxford: Berg, 1999).
[2] Roy Coleman, *Reclaiming the Streets: Surveillance, Social Control and the City* (Cullompton: Willan Publishing, 2004), 62.
[3] David Lyon, *The Electronic Eye: The Rise of Surveillance Society* (Minneapolis: University of Minnesota Press, 1994), 4.

whilst its regeneration agenda following on from European Capital of Culture for 2008 once again make it an ideal example of the socio-spatial issues current in contemporary CCTV surveillance. It was after the Heysel Stadium disaster of 1985, involving Liverpool and Juventus football fans, that video surveillance first gained currency as a means for identifying hooligans at sports grounds. Thus, utilising CCTV, football crowds were imaged *en masse* as potential offenders—an application of narrative that had its tragic outcome in another stadium disaster involving Liverpool fans—Hillsborough in April 1989. At Hillsborough the crushed masses in the stands were being monitored by police, but only as possible hooligans, and those watching were too late to interpret the dangerous human tragedy unfolding. In John McGrath's words, "The crowd were being policed as criminals, and the policing machine was unable to shift to protect them as victims."[4]

That CCTV is generally highly open to interpretative narratives, as evidenced in the Hillsborough footage, is repeated in the case of the abduction of James Bulger from a shopping centre in Merseyside in February 1993. McGrath notes that when James's mother Denise initially saw the footage of her son being led through the shopping centre by two other small boys, she was reassured by it—assuming that it meant her son was safe.[5] CCTV evidence in this case is ineffective, since there is nothing apparently remiss to report. John Walker comments, "In itself the mall picture was mundane, innocuous. Its power to fascinate was surely due to our knowledge of what happened afterwards."[6]

It was this problematic distance between what is shown in the image and what it later was taken to signify in press reproduction of the video still that drew the artist Jamie Wagg to it. In an interview from 1996 Wagg explains, "There is a total kind of disjuncture in time, a displacement of event and image. So you got a kind of signifier and signified that doesn't fit. Whereas when it was presented in the newspapers with all the text explaining how evil the boys were, this disjuncture was hidden. It seemed to me that all I had to do was to take the image out of that context, out of that hysteria, and just present it virtually untouched."[7]

[4] John E. McGrath, *Loving Big Brother: Performance, Privacy and Surveillance Space* (London: Routledge, 2004), 27.
[5] Ibid., 35.
[6] John A. Walker, *Art and Outrage: Provocation, Controversy and the Visual Arts* (London: Pluto Press, 1999), 194-195.
[7] Jennifer Friedlander, *Moving Pictures: Where the Police, the Press and the Art Image Meet* (Sheffield: Sheffield Hallam University Press, 1998), 23.

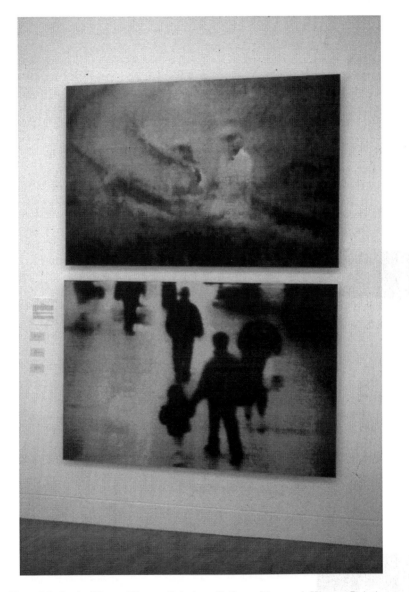

Plate 6.1. Jamie Wagg, *History Painting: Railway Line*, and *History Painting: Shopping Mall, 15.42.32, 12/02/93,* 1993-1994. Laminated ink jet prints. Each 183 x 122 x 7.5 cm. Courtesy of the artist.

Wagg created his work by first photographing the picture from a television news programme, enlarging it on computer and printing it as a large-scale laminated ink-jet print. Thus, there was very little artistic manipulation beyond lifting the image out of its frequently circulated press context. Wagg's portrayal of the CCTV camera shot highlights its narrative indeterminacy outside of its usual press context. Friedlander remarks, "...the media frames issues and tells us what is to be made of them. The images never circulate unsignified. The surrounding text, captioning, and headline limit potential polysemy."[8] Artistic presentation strips this narrative bare, reopening questions that have been closed down, and for McGrath "re-traumatises" the image. He writes, "Wagg reminds us that, whatever visual compensations have been made by journalists and politicians, the CCTV realm is producing images that do not make sense in the narratives of crime with which we soothe ourselves."[9] Whilst McGrath perhaps here overstates the case—after all, CCTV images adhere to narratives of crime by overlapping location, suspects, and time—shorn of this context and viewed in temporal indeterminacy, images from CCTV begin to appear far more ambiguous within narratives of crime.

I would contend that it was this indeterminacy of narrative that made Wagg's work a threatening presence for the media, who instead inserted the artwork within another of their well-worked narrative constructs: the "sick" artist profiting on a family's grief. Wagg's images were selected for the Whitechapel Open of 1994. Three weeks after the exhibition had opened, a *Daily Mirror* journalist wrote an article expressing outrage at the artwork's monetary value, the piece timed to coincide with Bulger's parents visiting the Home Office with a petition demanding that the ten year old killers of their son be imprisoned for life. This media-fabricated narrative of moral outrage against Wagg's work spread to other newspapers. The scandal led to the Whitechapel being closed for two days, the artwork being vandalised and the artist receiving death threats. In this trial by media, the case against Wagg was an odd one. First of all, the works were never for sale and were only valued for insurance purposes, as the artist explains: "that was just the insurance value and that was just off the top of my head. I said two grand each and I was attacked for profiteering. Then I decided to do some sums and work out how much those two pictures had in fact cost me... They actually cost me two thousand five hundred each."[10] Secondly, as we've discussed, the content of the images was of itself innocuous, innocent even, and already widely

[8] Jennifer Friedlander, *Moving Pictures*, op.cit., 6.

[9] John E. McGrath, *Loving Big Brother*, op.cit., 36.

[10] Jennifer Friedlander, *Moving Pictures*, op.cit., 24.

disseminated. As Walker points out, "How can journalists complain about an artist's use of an image when that very same image has been used for gain by the very same journalists?"[11]

An incident from the exhibition highlights this. As Wagg relates, a group of angry men from Liverpool visited the show with the intention of destroying the work:

> The gallery staff escorted them up to the pictures. But when they got upstairs they were really confused because when they'd driven down from Liverpool, they expected to see oil paintings of a dismembered corpse. They'd fantasised about an enormous painting of blood and guts. And when they were confronted with these images, one of them said 'what's all the fuss about, I've seen this before'.[12]

What was all the fuss about? The conclusion to be drawn from Wagg's work and its vilification seems to be that the press has a highly prescribed notion of legitimate subjects for art. The press will not tolerate the reassignment of images it regards as being controlled by its own narrative drive: a classification the otherwise normatively indeterminate crime CCTV still is clearly part of.

The tragic death of James Bulger was a watershed for CCTV in the UK. The case gave the emotive angle and popular support for its rapid expansion, allowing the Home Office, for example, to remove the requirement of planning permission or consultation of any kind before the erection of new CCTV systems. Simon Davies explains:

> In 1993, hard on the heels of the murder of toddler James Bulger, the symbolism that fuelled CCTV was extraordinarily powerful... Put bluntly, an argument against CCTV was interpreted as an argument in favour of baby killers."[13]

At the launch of Liverpool's city centre CCTV scheme in 1995, Home Office minister David Maclean commented, "This is a friendly eye in the sky. There is nothing sinister about it and the innocent have nothing to fear."[14] Justifications for CCTV were largely couched in fighting street crime, and especially in making the city safer for women and children. Yet the spatialisation and agendas that surround CCTV all point towards a

[11] John A. Walker, *Art and Outrage*, op.cit., 196.

[12] Jennifer Friedlander, *Moving Pictures,* op.cit., 26.

[13] Benjamin J. Goold, *CCTV and Policing: Public Area Surveillance and Police Practices in Britain*, (Oxford University Press, Oxford, 2004), 34.

[14] Ibid., 25-26.

different motive: the creation of idealised consumerist space in the city. This can even be traced back to the Bulger abduction scene. As Friedlander notes, "The camera which recorded the image was installed to deter theft, the purpose of its presence was to protect things and not people."[15] CCTV has stakeholders, social interests it is programmed to promote. It is a key agent in the re-politicisation of street aesthetics. For Norris and Armstrong, "public space is being reconstituted, not as an arena for democratic interaction, but as the site of mass consumption."[16] CCTV is a key aspect in the regeneration and re-imaging of our cities since it allows those with social control to define what is ordinary behaviour and to spatially express this normativity through the asymmetry of power the cameras give them: the Foucauldian visible and unverifiable power. Following this logic, McGrath contends, "Surveillance changes the ways we feel and behave within the spaces that are surveyed."[17] And city spaces are now being designed with surveillance as an inbuilt factor. As Benjamin Goold explains, "Ensuring that CCTV systems are integrated with measures such as street lighting and the creation of pedestrian areas has gradually become a key priority in many town and city management schemes..."[18] Modern city planning aspires to create an orderly, idealised space where consumerism can occur unencumbered.

For Roy Coleman this approach clearly echoes Victorian notions of morality and pathology bound up in the streets, linked also to class-bound concerns about an "unproductive residuum." With the re-gentrification of city centres such as Liverpool, regeneration agendas have used CCTV to justify and enforce social displacement and segregation. Coleman asserts:

> One of the key promises made for the 'renaissance' of the city is precisely an idealisation of the 'orderly street.' Powerful constructions of 'regeneration' and 'renaissance' are themselves cited as justifications for particular social control practices that delineate the desired urban aesthetic.[19]

A few examples from Liverpool should serve to illustrate this dynamic of surveillance as agent of spatial cleansing. First of all, there is the issue of homelessness. Following the example of Rudy Giuliani whilst mayor of New York—a city Liverpool has been in dialogue with over policing

[15] Jennifer Friedlander, *Moving Pictures*, op.cit., 4.
[16] Gary Norris and Clive Armstrong, *The Maximum Surveillance Society*, op.cit., 8.
[17] John E. McGrath, *Loving Big Brother*, op.cit., 26.
[18] Benjamin J. Goold, *CCTV and Policing*, op.cit., 13.
[19] Roy Coleman, *Reclaiming the Streets*, op.cit., 114.

policies—Liverpool has arguably utilised CCTV to criminalise the homeless. There were major crackdowns: in August 1995 the local press launched the initiative with the headline: "City Plans to Clampdown on Beggars;" whilst in October 2003 fifty-four homeless people were arrested in the city as part of "Operation Manton."

Secondly, there is the law on skateboarders. Since July 2002 anybody skateboarding in Liverpool city centre can be fined up to one thousand pounds, an offence largely enforced through CCTV. As with the homeless, Liverpool authorities are defining acceptable bodily conduct in public, visible space. In the local paper one skater challenged that definition:

> Skating in the streets adds to the atmosphere and is part of the fun. It's a real kick in the teeth that the council have decided they want to ban us from the streets... I don't think the skateboarders are doing any harm. A lot of people enjoy watching us doing our tricks.[20]

As a final example, there is the Paradise Street shopping complex, Liverpool One, owned by the Duke of Westminster, Britain's richest landlord. The street name "Paradise Street" reflects Victorian concepts of utopia; the shopping centre's particular vision of utopia encloses an entire city block, with its private security force and blanket CCTV coverage. Such ownership of the urban fabric allows an unprecedented level of control, potentially permitting the Liverpool One management to prohibit access to "undesirables" such as the homeless, *Big Issue* sellers, beggars, and young people skateboarding or hanging out with friends. In a *Guardian* newspaper article from 2008, Roy Coleman remarked that, "the privatisation of thirty-five city centre streets with no public right of way points to the consolidation of propertied rights in urban politics along with the power to construct and ideologically represent such spaces."[21] Developments such as Paradise Street represent the apotheosis of the growth of urban CCTV surveillance, as the interests controlling their development privatise public space, creating an asymmetry of power that favours their economic vision of productive, entrepreneurial city space.

What tactics can be employed to exist in such a surveyed city environment? One obvious response is to conform: to accept and adopt the

[20] Roy Coleman, "Surveillance in the City: Primary Definition and Urban Spatial Order," in Sean P. Hier and Joshua Greenberg, *The Surveillance Studies Reader* (Maidenhead: Open University Press, 2007), 237.
[21] "Policing the retail republic," *The Guardian*, May 28, 2008, http://www.guardian.co.uk/society/2008/may/28/regeneration.communities (accessed December 3, 2009).

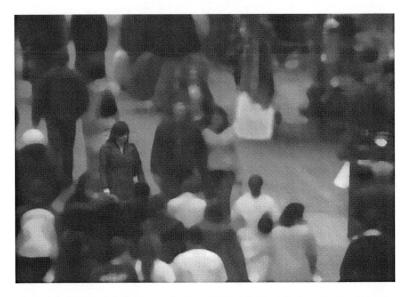

Plate 6.2. Jill Magid, *Evidence Locker*, 2004. Multimedia installation including DVD edited from police CCTV footage, sound piece, novella, website. Liverpool, England. Courtesy of the artist.

identity permitted to you of consumer. However, is there a possibility of resistance to this? For instance, might it be possible to utilise the essential theatricality of CCTV in the city to perform an identity that subverts the surveillance process? It is through this angle of performativity that Jill Magid's art engages with CCTV surveillance.

Magid stayed in Liverpool for thirty-one days, which is the length of time CCTV footage is kept before erasure. We have examined the circumscribed identity of the observed in CCTV surveillance; in her art Magid subverted this by imagining identities and roles for the observer, the camera and its operator sublimated into one entity, so that they became both protagonist and film crew in the artist's directorial vision. This is a noir thriller: an unsettling story of voyeurism, love, jealousy, secret identities, and the erotic potential of being watched. The narrative unfolds in the images captured but also in the subject access request forms Magid had to complete in order to retrieve and view her footage. These are written in the format of love letters to the observer. For example, in one passage the artist details what she was wearing a particular day—this is to assist the CCTV operator in identifying her, but she goes further, mimicking lovers' detailing:

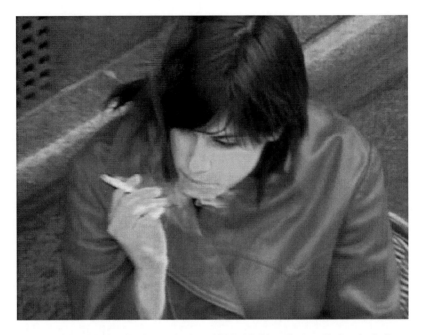

Plate 6.3. Jill Magid, *Evidence Locker*, 2004. Multimedia installation including DVD's edited from police CCTV footage, sound piece, novella, website. Liverpool, England. Courtesy of the artist.

> I was wearing black jeans with grey cuffs, booties, and my blue hooded coat. Underneath—the part you could not see—I wore a long-sleeve t-shirt and a chequered cardigan."[22]

Over the course of the months filming, the operator becomes more controlling, more demanding:

> My phone rang. Where are you? I'm in the bookstore. Did you find what you were looking for? No. Walk outside so I can see you.[23]

The demands of the observer are ambivalent: although they do in some respects conform to the primary CCTV function of a desire for a totalising vision, they equally strengthen the narrative Magid has placed on the system, as the observer performs the role of jealous lover. In one

[22] Jill Magid, *One Cycle of Memory in the City of L: Subject Access Request Form Log#2887. Following Jill Magid 29.01.04-28.02.04.*
[23] Ibid.,16-17.

sequence, the observer suggests that Magid wears a wig, to look like Brigitte Bardot in *Le Mépris*. The film noir overtones are clear—wigs, smoke, street lights. The street names themselves slide into this story: Gambier Terrace where the artist is living becomes Gambler's, and Magid herself takes on the pseudonym "Alison Wonderland"—a merging of spatial and personal—as if she desires the cameras to watch only her personal space. This theme of the public as private and personal is developed in one letter as the artist relates to her observer a dream of the city:

> I dreamt I was in this city, but the city was inside—an interior. I did not see its walls or ceiling but I sensed them. The street was carpeted grey and the light was even like an office.[24]

In the key scene of the artwork, Magid is guided, her eyes shut, through a busy shopping street by the observer. Comparing this selective surveillance within a crowd to a similar scene in another filmic representation—Harry Caul's sonic mastery of San Francisco's Union Square at the beginning of Francis Ford Coppola's *The Conversation*—the ability of surveillance to focus on one element to the exclusion of all others is highlighted. Yet, whilst in *The Conversation* those under surveillance were not aware that they were being recorded and indeed made efforts not to be detectable. Magid on the other hand experiences her surveillance as comfort, anthropomorphising the CCTV system into an embrace:

> I closed my eyes and everything changed. The people around me kept going, I could hear them, but they were muffled. I felt only you. You held me with your eyes and I was safe. After a minute—was it more?—I opened them again.[25]

Indeed for Magid it goes further than this, taking the visual penetration of CCTV surveillance and equating it with sexual penetration. She writes:

> I tell you: I did not critique your system; I made love to it. You blushed.[26]

Magid's piece ends with a symbolic leaving of the city centre CCTV area on a motorcycle ride:

[24] Ibid., 66.
[25] Ibid., 54.
[26] Ibid., 76.

> You said, there is camera number seven. It's the last one we pass. We were
> out of range and we flew.[27]

And yet it is a hollow escape—since leaving one CCTV system only
means entering another: in this case the neighbouring town of Southport.
Like Harry Caul in his stripped-out flat at the end of *The Conversation*,
having given up his search for the bug recording his life, the artwork
leaves a sense of the inescapability yet ineffectuality of surveillance. By
taking on a love affair with Liverpool's CCTV system Magid's artwork
attempted to address the asymmetry of power that system placed upon her.
However, it is a performance that cannot be reciprocated; the passivity of
the surveillance format ultimately breaking down all Magid's tactics of
fostering dialogue. In one such exchange she writes:

> You make a history of everyone you see so that you can remember them
> later. Do you remember them? Or do you forget them because you film
> them?[28]

So, rather than the memories of a beloved, we are left with the amnesia
of the archive.

CCTV is often placed into narratives of utopian or dystopian space: of
course these are highly subjective—one person's Orwellian nightmare
being another's orderly ideal. But CCTV itself doesn't create these
conditions: it is how the space in front of the camera is performed and
explained that is key. It is an artistic task to challenge this—scrutinise the
scrutiny—as Wagg and Magid do in their respective artworks. Since
CCTV images have such potential toward narrative indeterminacy, artists
who work in this field have the opportunity to insert their own determining
text and thus highlight the possible damaging repercussions that can result
from the stories constructed around CCTV footage. Artists such as Wagg
and Magid help articulate the complex power relations at work in CCTV.
On the one hand, the asymmetrical gaze of the disembodied viewer
establishes an uneven power balance, since the CCTV operative is
watching, but cannot themselves be watched—the archetypal "Big
Brother." Yet, both artworks also highlighted that such a privileged gaze
does not necessarily imply control. Watching is a passive position, whilst
those captured on CCTV have an active, performative role in the power
relations being recorded. In these cases, the artists regain control of the
narrative through their awareness of how CCTV operates, and in Magid's

[27] Ibid., 77.
[28] Ibid., 11.

case, her awareness of being watched. For Liverpool during the Capital of Culture 2008, the city was being watched as never before. The words from *Carousel* adopted on the terraces of Anfield have never been truer: You'll Never Walk Alone.

SURVEILLING THE SURVEILLANCE SOCIETY: THE CASE OF RAFAEL LOZANO-HEMMER'S INSTALLATIONS

MACIEJ OŻÓG

Introduction

Surveillance has become a common experience and practice of everyday life at the edge of the twenty-first century. With the diffusion of various technologies of invigilation, an evolution of surveillance as well as a change in social practices of monitoring, observation, and control can be observed. As David Lyon and Elia Zureik remark: "Surveillance is not an unmitigated evil, but rather a two-faced social phenomenon with which many cheerfully collude for the sake of the advantages that accrue to them."[1] The omnipresent, predatory gaze of Big Brother and the anonymous, invisible and disciplinary gaze of the guards of the Panopticon have lost their evil.[2] In the culture of simulacra[3] these symbols

[1] David Lyon and Elia Zureik, "Surveillance, Privacy, and the New Technology," in *Surveillance, Computers & Privacy*, ed. David Lyon and Elia Zureik (Minneapolis and London: University of Minnesota Press, 1996), 6.

[2] The Panopticon was the eighteenth century architectural design for an ideal "house of security" (such as prison, hospital, madhouse, school or factory) proposed by the British philosopher Jeremy Bentham. As an architectural surveillance machine it worked on the principles of permanent visibility and spatial separation of inmates and constant possibility of observation conducted by anonymous and invisible supervisors. The panoptic institution was a new model of disciplinary mechanism that automatised and disindividualised power. However, the Panopticon was not just a new sort of architecture. Bentham regarded it as a general schema for the whole society. He thought that the panoptic principle was the core of disciplinary society. Although Bentham's design has never been realised, the idea of the "disciplinary power of the gaze" has appeared to be one of the most influential ideas of the Enlightenment. The figure of the Panopticon was introduced into the humanities and social sciences of the twentieth century by Michel Foucault who understood it as both a driving force and a key symbol of the modernist project. Miran Bozovic, ed., *The Panopticon Writings*: *Jeremy Bentham*,

have lost their former meaning and their anchoring in the disciplinary and penitentiary context. They have become ambiguous, drifting freely among other floating signifiers on the oceans of market, politics, security and entertainment:

> While surveillance is now ubiquitous, it is also diverse, multi-faceted, and employed in such a panoply of projects that it is almost impossible to speak coherently about surveillance.[4]

The art of electronic and digital media plays a significant role in the landscape of the surveillance culture which is marked by ambivalence and contradiction. Especially, in the case when artists deconstruct and subvert the strategies, politics and ideologies of modern electronic surveillance, exploring myths, superstitions and common knowledge. As a form of critical reflection, analysis and description, art surveils the surveillance society and indicates its essential features. Simultaneously, it shows many hidden and vague dimensions of surveillance, contributing to the self-awareness of the surveillance society. The art of Rafael Lozano-Hemmer can be considered as an interesting example of this.

To be is to be watched

An analysis of the relationship between watching and being watched seems crucial for any attempt of understanding the surveillance culture. This issue constitutes one of the major themes of Lozano-Hemmer's works. His interpretation of the "surveillance gaze" joins analytical inquisitiveness with metaphorical ambiguity. It places the gaze within a relation to the questions of presence, control, and reflexivity.

The interactive installation *Make Out* (2009) analyses the relationship between the viewer's presence, in this case a viewer—interactor, and the activity of other people through visual representations in public space. The monitor screen is filled with hundreds of static images of couples taken

(London: Verso, 1995); Michel Foucault, *Discipline & Punishment: The Birth of the Prison*, trans. Alan Sheridan (New York: Vintage Books, 1995).

[3] After Jean Baudrillard, a sign or a reproduction which has neither relation to any reality nor is a copy of any reality becomes a reality in its own right. See: Jean Baudrillard, *Simulacra and Simulation*, trans. Sheila Glaser (Ann Arbor: University of Michigan Press, 1995).

[4] Kevin D. Haggerty and Richard V. Ericson, "The New Politics of Surveillance and Visibility," in *The New Politics of Surveillance and Visibility*, ed. Kevin D. Haggerty and Richard V. Ericson (Toronto: University of Toronto Press, 2006), 22.

from the net. They resemble a multicoloured and shapeless mosaic; a mass of media representations of people waiting for an inducing impulse or encouragement to be active. This impulse is provided by the shadow of the viewer—interactor who is being tracked by the surveillance camera. The images are set in motion; they portray couples kissing one another. Their activity depends directly on the presence of the viewer—interactor and lasts as long as her/his shadow covers a part of the screen.

Such a construction of the interface, a visual structure and a form of interactivity, is used in all Lozano-Hemmer's works within the *Shadow Box* series. Described by the author as "interactive displays with a built-in computerised tracking system," the series demonstrate the character of surveillance culture, stemming from dictating voyeurism to exhibitionism. As Paul Virilio says, modernity brings a democratisation of voyeurism, which is no longer perceived as a psychic deviation but has become a norm in the society of spectators.[5] In the universe of stars and celebrities, voyeurism and exhibitionism are not only justified and "transformed from individual—psychological criteria to social categories," "from illegitimate to legitimate pleasures," but they also become desirable and normal, not to say necessary forms of behaviour in the mass media society.[6] Watching and being watched are the conditions of participation in surveillance culture. As a result, the appraisal of surveillance is changing. "Surveillance becomes the cost of engaging in any number of desirable behaviours or participating in the institutions that make modern life possible."[7] Existence in the media synopticon, as Thomas Mathiesen described it, and active presence on the stage of global spectacle depends on the presence of an audience.[8] The spectators' gaze enables action, but also forces activity.

A general outlook defines the relationship between the presence of the viewer and the viewed in the *Shadow Box* series. It is a hierarchical

[5] Paul Virilio, "The Visual Crash," in *CTRL[SPACE]: Rhetorics of Surveillance from Bentham to Big Brother*, ed. Thomas Y. Levin, Ursula Frohne and Peter Weibel (Karlsruhe: ZKM Centre for Art and Media, 2002), 108-113.

[6] Peter Weibel, "Pleasure and the Panoptic Principle," in *CTRL[SPACE]: Rhetorics of Surveillance from Bentham to Big Brother*, ed. Thomas Y. Levin, Ursula Frohne and Peter Weibel (Karlsruhe: ZKM Centre for Art and Media, 2002), 208.

[7] Kevin D. Haggerty and Richard V. Ericson, "The New Politics of Surveillance and Visibility," in *The New Politics of Surveillance and Visibility*, ed. Kevin D. Haggerty and Richard V. Ericson (Toronto: University of Toronto Press, 2006), 12.

[8] Thomas Mathiesen, "The Viewer Society: Michel Foucault's 'Panopticon' Revisited," in *Theoretical Criminology*, vol. 1, no. 2, 1997 (Sage Publications), 215-34.

relation; the whole process seems to be controlled by the voyeur, and her/his presence and the direction of the gaze that determine the behaviour of the viewed. In *Reporters with Boarders* (2007), the monitored behaviour of the viewer-interactor sets in motion a sequence of TV news. *Alpha Blend* (2008) and *Close Up* (2006) show active video-clips of people who have interacted with the work, after their activity is stored in its "memory." In *Eye Contact* (2006), the spectator's presence leads to the awakening of the people on the monitor.

However, the relationship between the viewer and the viewed is modified by two factors that challenge the viewer's first impression. Firstly, the control exercised by the viewer is to a large extent limited. Secondly, the mosaic structure of the images on the monitors, along with the impossibility of isolating single video-clips, disallows precise observation. The experience of the viewer-interactor takes shape in meeting a vast amount of data: a chaotic mass. While the viewer's activity animates some of the video-clips, the viewer's only effective tool for influencing the form of their presentation is to body-cast a "digital" shadow on the screen filled with images. Although moving in front of the monitor, the viewer can change the position and the size of the shadow, the viewer has neither the choice nor the possibility of focusing on single video-clips. Paradoxically, on the one hand, the viewer-interactor experiences only a limited command of the fragments amongst the wide range of images. On the other hand, the aspiration to control the screen representations depends on the viewer's body, which cannot be fully mastered either. At the same time, both the viewer and the viewed depend on technology for the presentation of their meeting.

Through a relatively simple structure Lozano-Hemmer's works address the paradoxical nature of surveillance in the media age. We live in the age of "cam era" that democratises the tools of image production.[9] Whilst the Internet enables circulation of media images, the consequences of the Internet and cam era are often unpredictable and contradictory. The Internet dictates voyeurism and exhibitionism in which the effectiveness of both exhibitionistic exposing oneself to the public and the control exercised by the voyeurs becomes problematic. Lozano-Hemmer's shadow of the viewer-interactor is, in this context, an interface at a metaphorical level. The shadow allows activity but also screens it. The spectacle of invigilation resembles the shadow in nature. However, it also makes it difficult to see the details, as in the dimness the contours of the image blur, and its analysis becomes impossible.

[9] Hille Koskela, "'Cam Era:' the Contemporary Urban Panopticon," *Surveillance and Society*, 1 (3), 2003, 292-313.

The basis of the Enlightenment concept of the Panopticon, i.e. rational managing of reality by virtue of analysis and classification, fails in the world in which there is an acceleration of production of objects of perception through all kinds of seeing machines. The controlling gaze is unable to keep up with the affluence of media representations. Total transparency seems in this context to be an abstract idea: the fundamental utopianism of this project.

Arranging relations between light, darkness and shadow allows Lozano-Hemmer to question the relationship between the viewed and the viewer and also the character of the very act of surveillance in a media-saturated world. *Body Movies* (2001) and *Under Scan* (2005) demonstrate these questions. They reverse meanings ascribed to light and darkness. Strong spotlights, that brighten up public places, do not promote transparency but, on the contrary, are used as a screen which covers and makes invisible video portraits of people who are projected on the walls of public buildings (*Body Movies*) or on the ground (*Under Scan*). The shadow, which traditionally symbolises the unclear, the invisible, or the hidden, allows emergence of the projected images from the stream of light, limiting the sphere of visibility. In both interactive installations, the viewers-interactors are usually focused on their shadows. On one hand, in *Body Movies*, they often find themselves as actors in the shadow theatre, paying more attention to the shadow play than to the images that are revealed. On the other hand, *Under Scan* examines the close relation between the participant and the projected characters whose appearance is limited to the silhouette of shadows. The body of the viewer-interactor casts a shadow that generates borders of display that spatially restricts the presence of the image.

This limiting potential also has a time dimension: the presence and length of the projection depends on the attention that a random passer-by will devote to a virtual other met inside one's shadow, which is an example of dictating voyeurism. However, while observation can be understood as a kind of existential imperative, in Lozano-Hemmer's works observation is interpreted also as a process directed by the viewer rather than the object of the viewer's gaze. Thus, voyeurism becomes a form of narcissism. For Lozano-Hemmer, contemporary forms of surveillance are based on fluid hierarchies and interchangeability of the viewers and the viewed. The character of a celebrity replaces the figure of an invisible guard. The fear of invigilation changes into a desire of being watched.

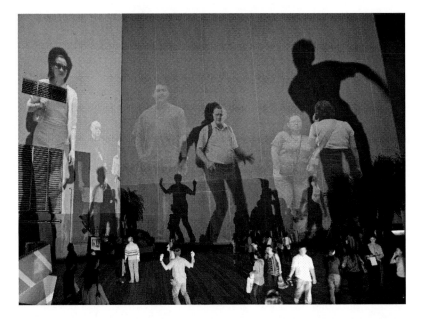

Plate 7.1. Rafael Lozano-Hemmer, *Body Movies,* 2006. Interactive projection, Hong Kong, China. Photo by Antimodular Research. Courtesy of the artist.

To watch is to be watched

Nineteen Eighty-Four (1949) places technology in the centre of surveillance discourses as a tool that allows for invigilation but also defining a particular form of control. The idea of Big Brother, whose gaze is constantly present in every house, enabled by audio-visual technology, became the symbol of panoptic surveillance. At the same time, it introduced a notion of reflexivity: Big Brother combines the complementary features of screen and camera. In Orwell's anti-utopia, technology serves two different, though connected, purposes.[10]

Watching the screen is equivalent to being watched, and an agreement to be invigilated. Orwell's observation, made over sixty years ago, is one of the axioms of surveillance in the age of digital post-optic technology, and especially in the age of the Internet. However, it can also be seen as a characteristic of digitalised optical surveillance.

[10] George Orwell, *Nineteen Eighty-Four* (London: Secker and Warburg, 1949).

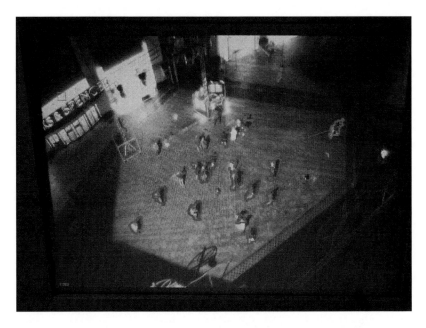

Plate 7.2. Rafael Lozano-Hemmer, *Under Scan,* 2006. Public art installation, Leicester, United Kingdom. Photo by Antimodular Research. Courtesy of the artist.

Lozano-Hemmer's installations explore the effect of the reversed gaze that "creates an uncanny experience that questions who is the observer and who is the observed."[11] While most of his installations-systems react to the recipient's presence there also is much interactive off-handedness, insubordination and/or independence of technology. Lozano-Hemmer's interactive systems have an uncanny capacity for the observation of the viewers-interactors. In *Eye Contact, Surface Tension* (1992-1993) and *Under Scan*, the digital system has a gaze, reacting to the presence and behaviour of the viewer-interactor. This ability of artificial systems to watch and observe people's interaction can be seen as an expression of metainteractive discourse.[12] It can also be seen as a metaphorical

[11] Rafael Lozano-Hemmer,
http://www.lozano-hemmer.com/english/projects/eyecontact.htm
(accessed September 29, 2009).
[12] The notion "metainteractive discourse" describes the kind of discourse within the realm of interactive art that focuses on critical analysis of interactivity and addresses the cultural conditioning and implications of interactive technology

interpretation of Deleuze's observation which pointed to the fact that the development of information technology leads to the emergence of the society of control. Deleuze noticed that in the society of control the gaze of invisible guards situated in the centre of a static architectonic structure is replaced by a changing, dynamic net of observation of everyone/all by everyone, taking the form of the rhizome.[13]

Lozano-Hemmer's interpretation also considers other properties of control in interactive systems such as a tension between the human gaze and the artificial gaze. The artificial gaze is based on automatism, a schematic character and a lack of flexibility. His works react to the presence of the viewer-interactor regardless of who she is, what are her/his motivations, or how one behaves within the space of the installation. Moreover, the process of interaction is restricted to tracing and following her/him or one's shadow. While the viewer-interactor can watch only the effects of movement, the reactions of the system are also minimal. The protagonists of *Eye Contact* awaken from a dream, open their eyes and look directly at the viewer-interactor. This is where their interactivity ends. In *Under Scan,* the virtual characters are less homogenous, predictable and simple in behaviour. However, the relation with which they enter with the viewer-interactor is also simplified. Appearing in one's shadow, they tease the viewer with their presence or disappearance.

Surface Tension presents the most radical limitation of interactivity in which a monstrous eye fills a screen and follows the viewer-interactor, moving within the space of the installation. The sequence of the system's actions remains the same; any individualisation of reactions towards specific viewers-interactors is impossible. Computerised surveillance is intensified because of the unnatural size of the media-enlarged screened eye. On the one hand, this creates an effect of being overwhelmed and dominated by the artificial eye that commands the space of the installation. On the other hand, there is discontinuity of the eye ball's movement, which increases the feeling of alienation towards the non-human gaze: invigilation that takes the appearance of the human eye and is controlled, manipulated and computer-managed. This "humanised" look of surveillance

utilising this technology in an unusual, surprising and subversive way. It refers to the term "metacommentary art" introduced by Erkki Huhtamo. Erkki Huhtamo, "Seeking Deeper Contact: Interactive Art as Metacommentary," http://www.kenfeingold.com/seekingdeeper.html (accessed November 11, 2009). Maciej Ozog, "Krytyczny wymiar sztuki interaktywnej," in *Estetyka wirtualności,* ed. Michał Ostrowicki (Kraków: Universitas 2005), 195-210.

[13] Gilles Deleuze, "Postscript on the Society of Control," *October,* 59, 1992, 3-7.

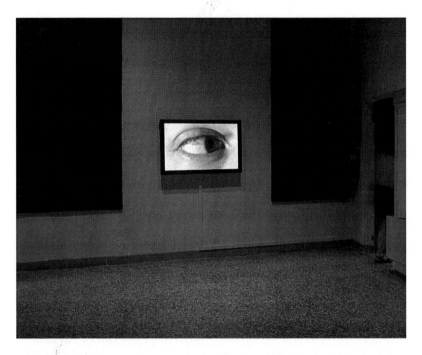

Plate 7.3. Rafael Lozano-Hemmer, *Surface Tension,* 2007. Venice Biennale, Italy.
Photo by Antimodular Research. Courtesy of the artist.

equipment is common and often consciously or unintentionally accepted.
However, such surveillance is often governed by its own and hard-to-
define laws. *Surface Tension* becomes close to the Kafkian vision of the
society of control.

Computerised surveillance, as David Lyon remarks, functions on the
usage of searchable databases that allow collecting, processing and
managing data, obtained as a result of observation.[14] Lozano-Hemmer
encourages a debate about database usage for computerised surveillance
and its cultural implications. There are two forms of databases: the closed
one, composed of a limited number of elements; and the open one,
developing in the course of the functioning of the installation. Both
databases share the simplification of form and semantic content of
particular components: their relations and the principles governing their

[14] David Lyon, "Surveillance as Social Sorting: Computer Code and Mobile
Bodies," in *Surveillance as Social Sorting: Privacy, Risk and Digital Discrimination*,
ed. David Lyon (London and New York: Routledge, 2005), 13-30.

usage. Semantic and structural minimalism of the content corresponds to minimalism in interaction design. As a result, the viewer-interactor is left helpless with the immensity of undiversified and unstructured information, emphasising the paradoxical situation of the viewer-interactor who, even though they can interact with the work, can neither control it nor use it effectively. The interaction becomes an alienating experience. Instead of allowing activity, Lozano-Hemmer's installations place the viewer-interactor in a situation in which the promise of freedom changes into a feeling of limitation or even helplessness with regards to the system which, although reacts to one's presence, does not offer access to its content.

While closed databases seem dependent on the activity of the viewer-interactor, such independence from the interactive invigilation system becomes fiction in the course of interaction. In *Close Up* and *Alpha Blend*, the viewer-interactor is helpless in front of the system that detects her presence, registers one's video portrait and adds the viewer on the database. This process is automatic, since the system is based on an uncomplicated tracking system, activated by the presence of the viewer in its space. This emphasises the relation between watching and being watched by the omnipresent, automatic digital tools of arbitrary invigilation. The viewer-interactor cannot influence the system; she can only refrain from interacting by avoiding a meeting with the digital gaze.

However, the decision to use technology, to interact, means accepting invigilation. It can be even said that approval of invigilation is a *conditio sine qua non* (an indispensable and essential condition) of using interactive technologies.[15] The process of surveillance is not connected to analysis of specific features of the viewer-interactor, but it is initialised and happens automatically. Similarly adding to the database, defining a place within this structure has nothing to do with individualisation. It is also free of any categorisations. A video file, being a record of a successive viewer-interactor's activity, is just another entry in the database. Its subjects are deprived of individual identity and homogenised; they become one of many recordings, forming an undifferentiated mass of data.

[15] Interactive technology refers to hardware and/or software which reacts and/or responds to the input from humans. The basic and indispensable condition of interactivity is the monitoring of the human activity by the technological partner.

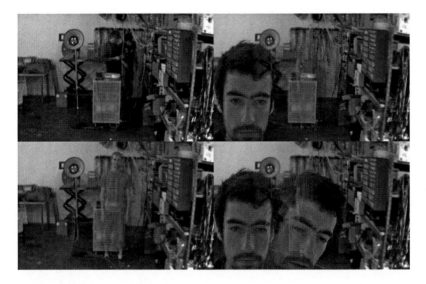

Plate 7.4. Rafael Lozano-Hemmer, *Alpha Blend,* 2008. Interactive display with a built-in computerised tracking system. Photo by Antimodular Research. Courtesy of the artist.

This process is highlighted in the form of presentation of recorded video-clips. Among hundreds of representations of viewers-interactors, it is hard to find one's own image. Thus, the alienating power of the system reveals itself with its detachment from individual representations. The database takes the form of hyper-reality described by Baudrillard,[16] and consecutive visual representations of the viewers-interactors become simulacra; they are empty images, not rooted in the material and with no reference to real objects.

The process of transforming a person's image into one of many signs without the signified is analysed in the *Alpha Blend* installation. While in other realisations the image of the presently observed viewer-interactor is shown among hundreds of others as a video-clip awaiting activation, in *Alpha Blend* the viewer-interactor can observe her media reflection in real time. Her image appears among the previously recorded video portraits and is multiplied. Along with the image in real time, other images are shown, processed, stopped, delayed, displaced and blurred. While it is true that thanks to feedback it is possible to enter into a direct relation with the first image and consequently to control one's own reflection, the other

[16] Jean Baudrillard, *Simulacra and Simulation*, op. cit.

ones are uncontrollably transformed, they become independent and distance themselves from the viewer-interactor who then takes on the position of a passive and un-influential spectator. The viewer becomes a witness of the alienation of one's own image which then transforms into a digital spectre, lacking independent existence.

The visual characteristics of the image is, on the one hand, shown against the same background, which can be read as a suggestion of continuity and coherence of virtual space. It is also a sign of the homogenising power of digital monitoring. On the other hand, the media representation of the former viewer-interactors are captured and closed off in the database and now show their fragmentary, incomplete, dematerialised body. This can also be read as a sign of passing from the flesh and bones sphere to the area of digital representation and simulation: simulation as they are actors in someone's theatre; a representation of a particular person, once added to the database, detaches itself from its carrier, becoming one of the elements of the database and a subject of manipulation whose rules and course are determined by the system. Thus, the process described by Tizianna Teranova of complementing one another, intermingling and merging of spectacle, simulation and observation into a new hybrid form is shown.[17]

I used the notions "captured" and "closed" in relation to "viewer-interactor" with reference to the police and penitentiary context. In *Alpha Blend*, the mechanisms consider interpretations of digitalised surveillance, highlighting the constant presence of oppressive panoptical logic of the relationship between discipline and punishment. Lozano-Hemmer addresses the problem of mechanisms that define the post-optic data surveillance.

To watch is to be processed

The formation of global networks of information exchange presents changes in the strategies and practices of surveillance, along with the dissemination of information technologies. It creates a kind of hyper-base which enables sharing of separate information resource, stored by different subjects for different purposes. This facilitates access to heterogeneous information concerning people, social groups and institutions. The characteristic of this new form of surveillance, defined as "surveillance assemblage," is a widening, diverse and globalised spectrum of monitored

[17] Tiziana Terranova, "Demonstrating the Globe: Virtual Action in the Network Society," in *Virtual Globalization: Virtual Spaces/Tourist Spaces*, ed. David Holmes (London: Routledge, 2001), 95-113.

spaces such as work, entertainment, health or consumption.[18] The emergence of digitalized, data-oriented surveillance is characterised by the shift from physical observation of a real person in real space to new forms of invigilation based on tracing the activities in virtual space, monitoring data (dataveillance) and profiling a virtual data-double of the subject.

Lozano-Hemmer neither uses technologies designed for data mining nor refers directly to the issue of dataveillance. However, he analyses the ways we function in digitally augmented systems of surveillance, focusing on the consequences of monitoring automation. Lozano-Hemmer encourages debate about the influence of this global, networked surveillance on individual identity and social relations.

The installations *Third Person* (2006) and *Subtitled Public* (2005) consider invigilation technologies that serve not only to collect information, but to create new reality. As Lozano-Hemmer puts it: "I ask what would happen if all the cameras became projectors and gave us words and images rather than take them away from us?"[19]

This can be materialised in a motion tracking system and a text generator which creates words for a spectator. Its linguistic definition is constructed from verbs in the third person singular. Thus, every person monitored inside the installation is ascribed one or many potential activities. The process of tracing and designation is smooth. However, the system functions attractively rather than effectively. Its efficiency can be questioned when the choice of words has nothing to do with the current behaviour of spectators and is arbitrarily. Therefore, the system does not recognise and reveal, but stigmatises, marking visitors with accidental definitions. It is based on faulty reasons for invigilation. They impose questions: what is characteristic of their work and what is the reality created in this way?

They function on the basis of constant assumptions which are realised automatically and definitely. Thus, a semantic network is almost (or entirely) detached from the reality imposed on it. It is a virtually irremovable network, as portrayed in *Subtitled Public*. Its definitions adhere permanently to its carrier; they are impossible to deny; they can only

[18] Kevin D. Haggerty and Richard V. Ericson, "The Surveillant Assemblage," in *British Journal of Sociology*, vol. 51, December 2000, 605-622.

[19] José Luis Barrios and Rafael Lozano-Hemmer, "A Conversation between José Luis Barrios and Rafael Lozano-Hemmer," edited transcription of a teleconference which took place in the Sala de Arte Público Siqueiros (SAPS), Mexico City, April 20, 2005, and was moderated by the director of SAPS, Itala Schmelz. Translation from the Spanish original by Rebecca MacSween, http://www.lozano-hemmer.com/english/texts.htm (accessed September 30, 2009).

Plate 7.5. Rafael Lozano Hemmer, *Third Person*, 2006. Interactive display with built-in computerized tracking system. Photo by Antimodular Research. Courtesy of the artist.

be passed on to another spectator while adopting one's verbal stigma. The free transfer of words from one person to another is the essence of the process of "creative invigilation" is not adequate in defining reality, but rather in the process of defining itself. It results in a digital shadow of reality, existing and expanding in the infinite rhizome of databases.

Lozano-Hemmer points out that digitalised surveillance leads to alienation and harassment of the individual. Along with automatic designation, the subject's social status changes; one's identity is seen through the prism of a digital shadow, imposed from the outside, which becomes more real and difficult to question. This process is reflected in the installation *Alpha Blend* (2008) which invites the spectator to view automatic manipulations of his/her image, captured by the CCTV camera and added on the database. Lozano-Hemmer visualises these processes that are not spectacular and happen discreetly, but still have consequences that are no less real than if they were being locked in the cell of the Panopticon. The data-double created as a result reminds us, as Maria Los remarks, of an individual profile from totalitarian files.[20]

Although it is difficult to find apocalyptic motives and nocturnal atmosphere in Lozano-Hemmer's works, they address a danger resulting from digitalisation of surveillance. Information is both the most important value and the most dangerous weapon in the society of control. The basic mechanism of control is analysis and processing of the data. In consequence, what emerges is no longer an image that is an adequate representation of reality, but a hypothetical profile of the future. Profiling and simulating of future behaviour and events takes the place in observation that depends, on the one hand, on the accuracy of accumulated data and, on the other hand, on productive processing.

In this context, popularising all forms of invigilation leads to an increase in data collection. This makes the profiling process more precise, but also enforces a reductionist approach and schematisation; blocking and channelling the flood of diverse, unconnected and contradictory information. Popularising and spreading electronic digital surveillance has resulted in data overflow while, simultaneously, creating simplified images and profiles of reality.

[20] Maria Los, "Looking into the Future: Surveillance, Globalization and the Totalitarian Potential," in *Theorizing Surveillance: The Panopticon and Beyond*, ed. David Lyon (Portland: Willing Publishing, 2006), 69-94.

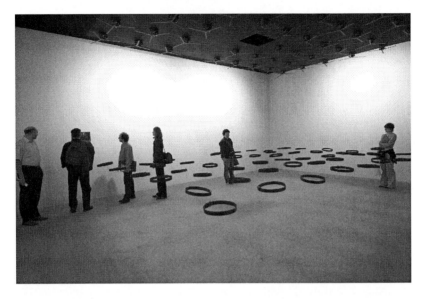

Plate 7.6. Rafael Lozano-Hemmer, *Standards and Double Standards,* 2004. Art
Basel Unlimited, Basel, Switzerland. Photo by Peter Hauck. Courtesy of the artist.

Lozano-Hemmer's interactive sculptures and installations address the
data overflow and over-stimulation of digitalised surveillance systems
defined by Lozano-Hemmer as "subsculptures." *Wavefunction* (2007),
Homographies (2006), *Glories of Accounting* (2005), *Synaptic Caguamas*
(2004) and *Standards and Double Standards* (2004) present standardised
objects of everyday use (chairs, fluorescent light tubes, belts, empty
bottles) which are multiplied to build large-scale interactive landscapes.
They work on two levels: one is triggered by the presence of the viewer-
interactor; the other is generated by the inherent dynamics of the system.
All objects react to the audience and influence each other. Their behaviour
oscillates between slow, systematic, wave-like movements and chaotic
spasms of disorder. The second state is intensified in relation to the
number of the viewer-interactor's whose movements are subject to
observation and tracking. These projects suggest that the more pervasive
surveillance is the less effective it is. The urge for total observation and
transparency results in an overflow of data and system overload. This fact
could be regarded as a promising paradox; yet, the omnipresence of
digitalised invigilation and its unquestionable influence on the lives of
individuals do not allow us to neglect the negative aspects. As Lozano-
Hemmer states in reference to Manuel Delanda:

It is literally about technologies designed to discriminate based on a series of innate prejudices. This new intensification of surveillance is extremely problematic because, in the words of Manuel DeLanda 'it endows the computer with the power of executive decision making.'[21]

Lozano-Hemmer's works are systems which, in a miniaturised, schematic and synthetic form, reflect the mechanisms of the post-optic, digital Panopticon. In their visual form they directly refer to Foucault's description of panoptic society in terms of institutional control. While the chairs in *Wavefunction* may be inspired by minimalism, the fluorescent lamps in *Homographies* are a symbol of bureaucracy that can be interpreted as a sign of the constant presence of oppressive invigilation in the era of interactive technologies. The penitentiary context is directly evoked in *Standards and Double Standards* which consists of paternal leather belts, majestically floating in the air. As a symbol and a tool for preventive control and punishment, those belts are not ascribed to any particular person. They function independently, automatically and in isolation from the context. Through such a construction of artworks, Lozano-Hemmer points out that the normalising power of panoptic architecture is transferred to the twenty-first century in the form of limitless trust in the efficacy of artificial intelligent agents, enabling action and managing our digitalised surveillance systems.

Conclusion

Lozano-Hemmer uses digitally enhanced and augmented optical tools of surveillance, as well as post-optic devices to create interactive installations that map the hybrid reality of surveillance culture. Employing surveillance technology, at the same time he comments on its very nature. He points out that the present state of surveillance is mirrored in the core of interactivity and in the very construction of interactive technology. Although built on principles of participation, activity and the freedom of the users, interactivity depends on the voluntary exposure to technological observation. In this respect, to be an agent of control is to be controlled, to use technologies of invigilation equals being a subject of observation, and to participate in the spectacle of surveillance is to be both a member of the audience and an actor.

Analysing Lozano-Hemmer's rich creative activity, I have identified four main topics within his discourse, concerning surveillance culture:

[21] José Luis Barrios and Rafael Lozano-Hemmer, "A Conversation between José Luis Barrios and Rafael Lozano-Hemmer," op.cit.

1. The issue of gaze and redefinition of vision in the post-panoptic surveillance.
2. The issue of democratisation of voyeurism and exhibitionism in the culture of surveillance spectacle.
3. The influence of digitalisation and the rise of new forms and strategies of surveillance in the digital sphere.
4. Re-contextualisation of surveillance and new prospects for surveillance in information society.

The subject matter and the form of Lozano-Hemmer's works mirror the complex and ambiguous nature of contemporary surveillance. The issues of privacy and identity are contrasted with the question of changes within the public realm, caused by the overflow of information and inflation of surveillance; analysis of contemporary strategies of control and discipline adjoins a reflection on the post-panoptic, post-disciplinary mode of surveillance; critical commentary and distanced observation develops in parallel to the use of surveillance for self-expression and play. Therefore, Lozano-Hemmer's work can be seen as a form of a practical survey in the labyrinth of the surveillance culture.

FROM WEBCAMMING
TO SOCIAL LIFE-LOGGING:
INTIMATE PERFORMANCE
IN THE SURVEILLANT-SOUSVEILLANT SPACE

PAULA ROUSH

> Current digital and live art practice could be
> responding to the cultural climate of acute (in)
> security by explicitly addressing our relationship
> to one another in environments of extreme
> closeness and heightened connectivity.[1]

The growth of personal expression facilitated by the embedding of surveillance technologies in everyday life, namely with the proliferation of biographical video streaming and archiving, has created an intimate space for art and media practice that I explored in the project *cctvecstasy* (2009). This was a commission for *AGM09: under_ctrl*,[2] an exhibition-event that explored "behaviour with technologies of surveillance and counter-surveillance, and how new media artists, designers, writers and performers respond to the cultural environment generated by CCTV and (self) recording."[3] My response was to take up an artist's residency at WebCamNow.com, a popular webcam community, and investigate its potential as a curatorial platform for digital performance. I invited a group

[1] Maria Chatzichristodoulou and Rachel Zerihan, evaluation of the event, *Intimacy Across Digital and Visceral Performance*, Goldsmiths Digital Studios, London, 2007, http://www.goldsmiths.ac.uk/intimacy/ (accessed June 19, 2009).
[2] *AGM 09 under_ctrl*, January 15-25, 2009, at QUAD (art centre and cinema), Derby, curated by Alfredo Cramerotti and Iben Bentzen (AGM). The 7th edition of the media art event AGM was part of the Radiator Biennial Festival and Symposium, Nottingham.
[3] Alfredo Cramerotti and Iben Bentzen,
http://www.annualgeneralmeeting.net/2009 (accessed June 19, 2009).

of collaborators, the Webcam Operators,[4] to work in the WebCamNow channels and develop site-specific works for the webcam portal.

Webcamming practices have been theorised with different results from within the areas of digital performance and cyberformance. On the one hand, an historical account of digital performance equates the use of webcams in the hands of artists with the "subversion of surveillance," and an ironic questioning of webcam's myths of authenticity and immediacy.[5] The field of cyberformance, on the other hand, theorises webcamming in the context of increasing online participation, and the types of collaborations it facilitates within web 2.0 environments.[6] However none of these analyses addresses the increasing intimacy facilitated by the mainstream use of surveillance technologies for personal video streaming and archiving, or the particular aesthetic and spectatorial positions that inform such intimate video practices.

This essay attempts to fill in such gaps by looking at the genealogy of personal video-streaming and placing it within scholarly writing on webcamming and surveillance. Webcamming, the use of webcams to stream live from personal environments to the internet, and develop life-logs that archive such practices as online documentations of the everyday, has resulted in some notorious projects by artists submitting themselves to a form of self-surveillance known as "sousveillance," that destabilises the public/private binary. However as the nature of surveillance changes into one of a participatory nature and people's responses to surveillance change, new questions emerge.

Whilst a counter-surveillance critique had been the domain of media, art and activist discourses since the mid 1990s, it has now become a mainstream feature. This is defined as a new phase of "hijacking

[4] For this event, the Webcam Operators were myself, as "cctvecstasy" in London; Marie Josiane Agossou as "marie_pix" at the London South Bank University; Lina Jungergård, as "opaean" at the Area 10; Aaron de Montesse as "de montesse" at home; and deej fabyc as "deedee4000" at the Elastic Gallery in Malmo; Lara Morais as "By Me" and Maria Lusitano as "alfazema" at the Malmo Academy of Art; Anne Marte Overaa as "anne marte" in her home. Susana Mendes Silva was to perform as one of the Webcam Operators but technical problems prevented her from participating.
[5] Steve Dixon, *Digital Performance: A History of New Media in Theater, Dance, Performance Art, and Installation* (Cambridge, Massachusets; London, England: The MIT Press, 2007), 18.
[6] Helen Varley Jamieson, *Adventures in Cyberformance: Experiments at the Interface of Theatre and the Internet*, MA dissertation, Queensland University of Technology, 2008, http://www.creative-catalyst.com/thesis.html (accessed March 5, 2009).

surveillance," when surveillance equipped tools are embedded in the everyday and countless interactive biographies of the self are streamed live to varying sized audiences.[7] This raises crucial questions for those involved in staging theatrical events in the network. Now that people's lives are performed for the Internet and distributed across multiple social networks as chunks of self-authored content, is it still possible to separate or distinguish performance art from the performative stream of everyone else's lives? How is then online performance conceptualised from a contemporary art and media surveillance-sousveillance perspective?

Live actions in WebCamNow

WebCamNow is one of the many cam-communities that provide a ready-made videochat interface for live video streaming. It connects live webcams around the world without creating a homepage or even a personal profile. Upon entering a username and password, users can choose between two networks, presented as two distinctive spaces. The first, and the one we selected to work in, is the "Open Area" governed by an Adult Content Agreement hence essentially populated by members looking for intimate experiences. The second area "Friends and Family" as opposed to the former caters for mainstream audiences, where users can meet and exchange with the knowledge their behaviour might be monitored. Unlike more recent livestreaming and social network sites, that combine video stream with videologs and other social logging devices, WebCamNow provides no storage of videos, images or messages. Instead, the focus is on live interaction and live performance for the camera.

To decide whom to view or to interact with, the user has to rely on a casual drift through the usually hundreds and sometimes thousands of channels available. Alternatively, the user can rely on strategies imported from gaming mechanics. A popularity rating system is available in the form of a health bar or life bar:

> A life bar, in a gaming environment is used to display a character's remaining life or state of health. Similarly, on the WebCamNow, an emptied popularity bar represents a very low number of supporters of a particular room. Thus, it is assumed that nothing of interest to the majority

[7] Hille Koskela, "Hijacking Security? The New Moral Landscapes of Amateur Photographing," in *Technologies of Insecurity: The Surveillance of Everyday Life*, ed. Katja Franko Aas, Helene Oppen Gundhus, and Heidi Mork Lomell (Abingdon [England], New York: Routledge-Cavendish, 2008), 147-170.

of WebCamNow users is usually happening in that chat room. A partially full or fully coloured popularity bar represents a high number of supporters.[8]

Someone logging to the platform will instantaneously know which webcam is generally popular.

After rehearsing for two weeks, *cctvecstasy* was organised around a loose script that developed from our daily encounters with the WebCamNow community. A variety of hetero and LGBTQ (lesbian, gay, bisexual, transgender and queer) people operate their webcams, playing with multiple strategies: from the staged authenticity of those that set up the webcam in their rooms, placing their life under scrutiny, to others that masquerade into hyperstaged versions of femininity/masculinity and fetish, performing to a particular group of devotees. We used the webcamming and textual chat tools freely available to us to work synchronously across separate rooms and communicate with other videochat rooms. We attempted to develop a textual, audio and visual language that responded to the context and arose from the issues affecting us.

The scenes developed into eight interventions in eight different channels and highlight the willingness of the Webcam Operators to engage with what we felt were the spectatorial conditions inherent in that webcam portal. For the performance proper, seven Webcam Operators were webcamming live in real time (four in London, three in Malmo), whilst myself—the eighth operator—performed live at the QUAD in Derby, in front of a live audience that was also captured in a live feed and streamed into a channel. The audience sat behind me, and could see my face projected onto the screen every time I zapped into my channel. Throughout the twenty-minute performance, the Webcam Operators played with concepts of self-representation and spectatorial power by controlling forms of visibility and destabilising fixed viewers' positions.

[8] Marie Josianne Agossou, *Webcam Operators: Field Work in WebCamNow,* 2009, http://www.mariepix.co.uk/wordpress2/?p=99 (accessed July 18, 2009).

Plate 8.1. Paula Roush with the Webcam Operators, *cctvecstasy*, 2009. Live synchronous performance at the WebCamNow and the QUAD, Derby. Courtesy the artists, AGM09: under_ctrl and the Radiator Festival, Nottingham.

Sometimes they used irony to resist the promise of photographic authenticity associated with webcams. In the "marie_pix" channel, Marie Josianne Agossou alternated between micro-scenes of digital labour and leisure: close-ups of her hands took turns knitting and text-chatting with the audience that populated the chatroom. In her channel, "ByMe" Lara Morais covered her face behind a 1:1 scale self-portrait from where she deleted her mouth, swapping this for other drawings as the performance developed. In the "Opeaen" channel, Lina Jungergård was masked and wearing an orange overall moved in and out of visibility, brandishing a long spade. The weapon went on threatening an invisible victim...or the viewer. In "deedee4000" channel, Deej Fabyc set up a still life with two mannequins in an old fashioned bedroom, one standing up, wearing only a jacket and a hat, her back to the cam, the other laying naked in bed, her

body only half visible. Nothing else happened in the visual field but female shouts interrupted the scene.

Other actions supported the Webcam Operators play with the camera and control over the spectator's gaze through an empowered sight. In "Alfazema" channel (Maria Lusitano), an extreme close-up of fingers caressed the calix of a pomegranate; as time unfolded, the pomegranate was opened and the seeds spread into Alfazema's eyes. "Anne Marte" channel presented a wide-angle view of her living room where she was absorbed in a daily routine of house cleaning and removing festive decorations from a large Christmas tree. Eventually she dragged the tree across the room and threw it out of the window (to the applause of the audience that had been gathered around her channel). In "deMontesse" channel, Aaron de Montesse performed an act of transsexual dragging for the audience in real time.

Cyberformance in intimate networks

In our practice, WebCamNow became the equivalent of a contact zone, "a social space where cultures meet, clash, and grapple with each other, often in [...] asymmetrical relations of power," an idea imported from the autoethnographic field and applied to our performance research amongst other webcammers.[9] Within a reflective research practice, it is possible to draw parallels between our webcamming and other autoethnographic approaches, such as subcultural video documentaries. As José Muñoz puts it: "where the artists inhabit their videos as subjects who articulate their cultural location through their own subcultural performances as others."[10] This ideological effect was explored as we rehearsed, improvising within the confines of the software.

The challenges for artists working with hybrid modes of digital performance are many. A mode of intimate theatricality might be emerging from the conflicts and ambiguities posed by the network, with artists displaying close working and emotional relationships with the other in their online work. Such performance practices are developing within the areas of networked performance, web 2.0 sociable software applications and theatre, at a time when notions of audience have been destabilised because both internet users and artists that stage events online share the same tools and potentially the same type of multimedia production.

[9] Mary Louise Pratt, "Arts of the Contact Zone," *Profession,* vol. 91 (1991), 34.
[10] José Muñoz, *Disidentifications: Queers of Color and the Performance of Politics* (Minneapolis: University of Minnesota Press, 1999), 82.

Plate 8.2. The Webcam Operators, *cctvecstasy*, 2009. Live synchronous performance at the WebCamNow and the QUAD. Courtesy the artists, AGM09: under_ctrl and the Radiator Festival, Nottingham.

The theoretical work that Helen Varley Jamieson has developed along that of Avatar Body Collision, the group of distributed collaborators she works with is a good example of this and provides a practical and theoretical background for the project in WebCamNow. Since 2001, they have been performing amongst online communities. *Screen Save Her* (2002), for example, reveals some of the traits of cyberformance: the use of free internet tools such as iVisit video conferencing for webcamming and "The Palace" chat environment to stage the theatrical event, and the interaction with other online users. Three members perform remotely online, live in real time, via webcamming whilst the fourth member performs in the proximal space of the hosting venue. The audience sees her on stage together with the projected images of the others via webcams.[11]

This project fits into definitions of cyberformance: "a live performance form with an audience that is complicit in the completion of the work in real time."[12] The genre is embedded in the participatory culture and shared performative space of the web 2.0 and is linked with the concept of "intermedial audience." This extends that of "intermedial theatre" developed by Freda Chapple and Chiel Kattenbelt of "a space where the

[11] Karla Ptacek, "Avatar Body Collision: Enactments in Distributed Performance Practices," in *Digital Creativity,* vol. 14, no. 3 (2003), 180-192.

[12] Helen Varley Jamieson, *Adventures in Cyberformance*, op.cit., 30.

boundaries soften—and we are in-between and within a mixing of spaces, media and realities," to characterise the audience itself.[13] The notion of an intermedial audience mentally and physically multi-tasking accounts best for the mediatised audience, that is placed in "a limen, in-between the physical and the virtual, in-between performer and spectator, computer-mediated and adopting multiple roles (spectator, performer, author, reader, commentator, chatter, lurker) within the media."[14] The intermediality of the encounter, placing artist and the other in close proximity, helps framing works that address the resultant connection.

Other artists that address intimacy via networked performance include Susana Mendes Silva. Her *BedTime Story* (2007) consisted of a Skype encounter between Silva and the applicant, booked by email. In the performance, she read the story the participant would like to hear before going to sleep.[15] Silva also worked in the cam portal WebCamNow in the project *Art_room* (2005), where she made herself available in a videochat room to answer people's questions about art.[16] Another project addressing online proximity is *The Big Kiss* (2008) by Annie Abrahams,[17] a networked kiss of two people via webcams. All these projects explore ambiguous intimate relationships with their intermedial audience. They also share a hacker mentality that exploits the low-tech end of technology. This consists of a D.I.Y (Do It Yourself) aesthetics that places the artists in the same hypersurface of computer screen, mobile devices and web 2.0 applications as their audience.

Webcamming and everyday theatre

Webcamming's "theatrical resonance," combining references to theatre, installation art and live performance, can be traced back to JenniCAM.[18] This is one of the first female projects to bridge the domestic

[13] Freda Chapple and Chiel Kattenbelt, *Intermediality in Theatre and Performance* (Amsterdam: Rodopi, 2006), 12.
[14] Helen Varley Jamieson, *Adventures in Cyberformance,* op.cit., 78.
[15] Performed in the programme *INTIMACY Across Visceral and Digital Performance*, Goldsmiths Digital Studios, London, 2007. http://www.goldsmiths.ac.uk/intimacy/ (accessed October 15, 2009).
[16] Luis Silva, "An Artist in the Chat Room." *networked_performance*, July 15, 2005, http://www.turbulence.org/blog/archives/001121.html (accessed October 15, 2009).
[17] Annie Abrahams, *The Big Kiss*, June 2008, http://www.bram.org/toucher/TBK.html. (accessed October 15, 2009).
[18] Steve Dixon, *Digital Performance,* op.cit., 452.

and online spaces in a durational live art project that lasted from 1996 to 2003. Jennifer Ringley's personal take on the genre of webcamming has been described as "theatrical authenticity."[19] What distinguished Jennifer as "the authentic cam girl," was the placement of webcams throughout her house, capturing daily life, rather than using a computer webcam and keyboard direct interaction; without a programme of scheduled webcam shows, there was instead a preference for spontaneity and the allowance of casual glimpses into her everyday.[20]

Ringley was highly influential for other women webcam operators. Firstly, for her development of a hybrid self that seemed to represent what it meant to live under surveillance and, secondly, for the control she exerted over her visibility. Krissi Jimroglou's analysis of JenniCAM reveals that in spite of the everyday aesthetics there were complex strategies at play, underlying the development of a hybrid and multiple subjectivity.[21] Jimroglou analysed JenniCAM based on Judith Butler's perspective of the performative self. JenniCAM enacted the technological drag, a tactic of masquerade that denaturalised essentialist perceptions of woman and machine.[22] She also posited JenniCAM and fulfilled Donna Haraway's prediction of the cyborg as a multiple subjectivity that challenged the traditional public-private divide.[23] Crucially, the project played ironically with fixed notions of online subjectivity, and provided an emergent model of self-representation for subsequent generations of women webcam operators.

Many followed on the JenniCAM model of self-made home pages with continual stream from domestic home cams but took her mutant identity approach to an extreme of hyperstaged performance. Roberta Buiani distinguished a "second generation of webcam girls" that included the CAMchicks.com, two girls webcamming from the house they shared with other friends, and the Vera Little Media Project, an artist who build a character named Vera Little based around her disability (she is a fingers

[19] Theresa Senft, *Camgirls: Celebrity & Community in The Age of Social Networks* (New York: Peter Lang, 2008), 18.
[20] Roberta Buiani, *Those Brave Girls: What Can You See through the Webcam?* PhD dissertation, York University Toronto, 2003, 8.
[21] Krissi M. Jimroglou, "A Camera with a View: JenniCAM, Visual Representations and Cyborg Subjectivity," in *Virtual Gender: Technology, Consumption and Identity*, ed. Alison Adam and Eileen Green (London: Routledge, 2001), 286-301.
[22] Judith Butler, *Bodies that Matter* (New York: Routledge, 1993).
[23] Donna Haraway, "A Cyborg Manifesto: Science, Technology, and Socialist-Feminism in the Late Twentieth Century," in *Simians, Cyborgs and Women: The Reinvention of Nature* (New York: Routledge, 1991), 149-181.

and below the knees amputee).[24] They staged hyper-feminine performances for the camera in a busy webcasting schedule filled with pre-programmed shows. They also followed Ringley's form of self-surveillance that included searchable biographical archives, including photography and writing.

Life-logging and empowerment

Other projects where artist-researchers placed themselves under surveillance form a second strand of works, where the emphasis is placed on the archive of these experiences. This is called life-logging, the activities encompassing documentation of an individual's daily life with the help of surveillance technologies. Data captured with wearable cams and then shared online, have contributed to geo-spatial archives of the self, where the fictional, even meaningless minutiae of the everyday brings into question the authenticity of the surveillant databases.

An example of life-logging is the work of Steve Mann, an artist that from 1994 used a wearable wireless Internet streaming system to upload "Cyborglogs" (or videologs) onto an online database as a critique of the increasing urban surveillance.[25] This double activity of upload and storage of personal data developed into the current "Glogger" community. A "glogger" has the ability to create "life storyboards" based on the photos uploaded from the mobile phone.[26] This "glogging" theory of sousveillance is particularly relevant to the practices analysed in this essay. I am particularly interested in the definition of sousveillance as "personal experience capture: recording of an activity by a participant in the activity," as Mann puts it.[27]

Life-logs as comprehensive first-person archives as individuals lead their lives under self-produced surveillance (or sousveillance) include MyLifeBits, the full lifelogging project initiated in 1998 to digitally preserve Gordon Bell's life, an experiment in lifetime storage using

[24] Roberta Buiani, *Those Brave Girls*, op.cit., 6.
[25] Steve Mann, "CyborgLogs" (commonly abbreviated to glogs), http://wearcam.org/glogs_etymology.htm (accessed July 28, 2009).
[26] Steve Mann, "Glogger Community," http://glogger.mobi/ (accessed July 28, 2009).
[27] Steve Mann, "Sousveillance," *wearcam.org*, 2002, http://wearcam.org/sousveillance.htm (accessed July 28, 2009).

scanners, a wearable "sensecam," and an indexing-retrieval software.[28] Alberto Frigo's *Records of a Lifetime* is the digital archive of the first six years of a life-logging project that started in 2003 and will span a period of thirty-six years from the age of twenty-four to sixty. The first documents stored in six digital archives, can be accessed online at albertofrigo.net and include photos of all the objects that Frigo has used with his right hand and film sequences of visited public spaces.[29] A sousveillance archive made available online as part of counter-surveillance tactics includes *Tracking Transience* (2004-ongoing) by Hasan Elahi, a geo-tagged photographic archive constantly updated from wearable wireless camera, ready to be used as a pre-emptive alibi against accusations of terrorist activity.[30]

Identity 2.0 and participatory surveillance

The webcamming and life-logging phenomenon that was initiated in the mid 1990s culminated in the development of the micro-celebrity phenomenon in the age of social networks one decade later. With the rise of web 2.0 platforms, the personal webcam site lost currency and has been replaced by a multiplatform multimodal approach to the broadcast of one's everyday life that includes blogging, photoblogging, tweeting, videostreaming and lifestreaming. Social life-logging is this intersection of life-logging and social networking, occurring across several social networking sites. Women that conduct their careers as social media entrepreneurs, relying on a mix of well established social life-logging platforms to promote their brand include Sarah Austin who explains in her pop17's show: "no scripts, no producers, mobile cameras, anyone can relate."[31] And Lisa Batey, who streams live as "Nekomimi Lisa" on Justin.tv and Ustream.tv since 2007, and writes in her blog: "Life is livestreaming. Livestreaming is life."[32]

[28] Gordon Bell and Jim Gemmell, "A Digital Life," in *Scientific American Magazine*, March 2007, http://www.scientificamerican.com/article.cfm?id=a-digital-life (accessed October 18, 2009).

[29] Frida Cornell, ed. *Records of a Lifetime: 6 Works in Progress by Alberto Frigo* (Uppsala: Uppsala Konstmuseum, 2009).

[30] Hasan M. Elahi. *trackingtransience.net.* http://trackingtransience.net/ (accessed June 27, 2009).

[31] Sarah Austin, "God's Love We Deliver Charity Mission with Ford...," *pop17's Channel*, http://www.youtube.com/user/pop17 (accessed June 21, 2009).

[32] Lisa Batey, http://nekomimilisa.com/ (accessed June 17, 2009).

The notion that social life-loggers are constantly uploading and updating versions of their multimedia biographies online has called for a revised concept of identity performance. "Identity 2.0" is the corollary of the web 2.0 and like the social life-logging applications it relies on, is in perpetual beta: an open identity, never finished, going through continual revisions as a result of constant additional input; it is also networked and distributed, no longer accommodated in a personal website or single network site but spread across different applications, some specialised in receiving photographic documents, other focused on video stream, all interlinked via programmable code that connects these diverse biographic outputs.[33] This open identity that is part of online social networking is perceived by Anders Albrechtslund as resulting from a culture of participatory surveillance that is "potentially empowering, subjectivity building and even playful."[34]

Current webcamming and social life-logging practices fit within a new phase of people's reaction to surveillance characterised by the "hijacking of surveillance" described by Koskela. The ubiquity of technologies facilitating the recording and online sharing of the self (widespread use of mobile devices equipped with photo and video cameras) has had an impact on people's reactions to surveillance. An initial phase was a passive acceptance of surveillance, an optimistic attitude expressed as "I have nothing to hide;" this was followed by a critical approach that fostered public debate, research projects and surveillance-critical attention in the media and art circles; followed by the various counter-surveillance practices developed by vigilant individuals, NGOs and artists. The new phase is beyond passive acceptance or critical debate, even beyond purpose-oriented counter-surveillance. It consists of people using various items of surveillance equipment that are embedded in their everyday to produce visual material "for their own purposes with different motivations, sometimes not for critical statements, not for political aims" but certainly raising ethical and political issues related to the production and circulation of such images in the network.[35]

[33] Anne Helmond, "Lifetracing: The Traces of a Networked Life," in *networked, a (networked_book) about (networked_art)*, (Turbulence, 2009), http://helmond.networkedbook.org/ (accessed July 9, 2009).
[34] Anders Albrechtslund, "Online Social Networking as Participatory Surveillance," *First Monday*, vol. 13, no. 3, March 2008, http://www.uic.edu/htbin/cgiwrap/bin/ojs/index.php/fm/article/view/2142/1949 (accessed July 9, 2009).
[35] Hille Koskela, "Hijacking Security?," op.cit., 164.

Performative uptake of sousveillant-surveillant space

The times we spent rehearsing at WebCamNow revealed to us the blurred lines between amateur webcam and performance events staged in cam portals, as well as the increasing adoption of the surveillance aesthetics as part of everyday webcamming. This raised methodological issues related to the development of a site-specific work within that particular community of webcammers. The close proximity of webcamming to intimacy has often been confused with porn availability or more generally with the porn industry. Particularly when analysing women webcam operators, as noted by Michele White who reviewed the perception of women webcam operators amongst public media and scholarly reports and found that, most critics failed to grasp that even when revealing their bodies women asserted control of the relationship with the "other" and over how they wanted to be seen by the spectator.[36] This was done through specific strategies which included the operator's decisions over when and how to be seen, the use of extreme close-ups and absence from the screen.

These hybrid online-offline practices typical of the intermedial time space are characterised by the aesthetics of bodily morphing and synthesis. As White writes:

> Whether male or female, the webcam spectator is literally mirrored, doubled, and confused with the screen. The webcam spectator is situated in a place where voyeurism is constantly promised, yet theoretically uninhabitable, because the viewer has relinquished a distanced position.[37]

This way, webcamming can be seen as a medium of resistance, in which the computer spectator is "feminised," placed in the role of the woman not as a distant voyeur but projected onto the screen, "too close to see."[38]

To understand the representations produced via webcamming, theories of film spectatorship have limited use. These have tended to emphasise the gaze, and relied on a scopophilic approach focused on the dynamics of exhibitionism and voyeurism that usually relies on a clear separation between those who look and those that are looked at. The analysis of webcamming representational practices, require hybrid critical models that

[36] Michele White, "Too Close to See: Men, Women and Webcams," in *New Media & Society,* vol. 5, no. 1, Sage Publications, (March 2003), 7-28.
[37] Ibid., 23.
[38] Ibid., 23.

account for specific Internet and computer settings. A theory of the grab challenges film theory's reliance on ocularity with a web-specific tactility. As Theresa Senft argues:

> On the web, spectatorship functions less as gaze than grab. By 'grab' I mean to clutch with the hand, to seize for a moment, to command attention, to touch, often inappropriately, sometimes reciprocally. To grab is to grasp, to snatch, to capture. Grabbing occurs over the Web in different ways during each stage of production, consumption, interpretation and circulation.[39]

In the sousveillant-surveillance space it is possible to identify the increasing deployment of a "surveillance aesthetic" aligned with the practice of amateur webcamming. As described by David Bell in "Surveillance is sexy," this happens when the technologies of surveillance structure narrative actions and the adoption of the "porn look" articulates a "sexualisation of surveillance."[40] Such narratives may have a reality feel but they are primarily staged for the camera, a quality that places them in the field of outer-course or alter-sexuality. They present "a kind of liminal experience where both intimacy and sexuality may be reinvented in a context of loosened temporal, physical, and normative constraints."[41] This aesthetic is recognisable in WebCamNow, when browsing through a variety of channels that include bedrooms, kitchens and living rooms where people in varied stages of undressing present themselves for the camera.

To discuss such practices requires a critical model that involves the structures of desire and identification, which can be seen as potentially counter-hegemonic to the dominant structures of surveillance. In his theatrical analysis of the surveillant space, John McGrath suggests that the linguistic notion of uptake may support the concept of "performative spaces" of surveillance:

> ...the experience of space under surveillance may involve uptake by the viewer and/or 'viewee' of the notion that surveillance space is neither equivalent to the geographical space of the initial event nor a

[39] Theresa Senft, Camgirls, op. cit., 46.
[40] David Bell, "Surveillance is Sexy," *Surveillance & Society*, vol. 6, no. 3, 2009, 203-212, http://www.surveillance-and-society.org/ojs/index.php/journal/article/view/sexy/sexy (accessed June 7, 2009).
[41] Dennis D Waskul, "Ekstasis and the Internet: Liminality and Computer-mediated Communication," in *New Media & Society*, vol. 7, no. 1. Sage Publications, (February 2005), 59.

representation of it. In the experience of surveillance, the uptake of this new space carries with it spatially related effects such as the transition from privacy to display, the implication of the absent viewer, the incorporation of future experience into the present moment, the experience of the borders of the surveyed and the divergence of the visual and sound spaces.[42]

It supposes that the relation to surveillance technologies is sexually complex and individuals integrate the technologies of surveillance into sousveillant practices to deal creatively with the post-private society.

Conclusion

In "The Ethics of Forgetting in an Age of Pervasive Computing" (2005), the report on life-logging and digital memory, Martin Dodge and Rob Kitchin appeal to software programmers to counter the potentially oppressive tendencies contained within life-logging technologies, and create built-in dysfunctions, errors and flaws into these systems. They express concern for the ethic dilemmas in the current shift from surveillance (exterior recording by organisations external to individuals) to sousveillance (personal recordings by the individuals watching themselves). Namely, the increase in sousveillance-based surveillance, risks producing "a society that never forgets and has a permanent socio-spatial archive traceable through space and time."[43] An emancipatory politics of the image, on the contrary, would allow people to dispose of their digital traces and forget.

However, all these personal video-streaming and logging activities leave digital traces that can be aggregated by data-hungry browsers and other online searching tools. The question is whether life-logging contributes to a person's empowerment, in terms of the accountability of others and the self, compared to the intrusive surveillance activities of organisations and governments? Since it is a "constructed identity," it can be shared or enhanced by integration or cross-reference with information from others and provide a database of facts and images that can be invoked to counter hegemonic representations from the authorities.[44] I

[42] John McGrath, *Loving Big Brother: Surveillance Culture and Performance Space* (London: Routledge, 2003), 119.

[43] Martin Dodge and Rob Kitchin, "The Ethics of Forgetting in an Age of Pervasive Computing," in *CASA Working Paper Series*, no. 92 (March 2005), 17.

[44] Kieron O'Hara, Mischa M. Tuffield, and Nigel Shadbolt, "Lifelogging: Privacy and Empowerment with Memories for Life," in *Identity in the Information Society*, vol. 1, no. 2, 2009, http://eprints.ecs.soton.ac.uk/17123/ (accessed July 26, 2009).

would also ask whether it risks becoming yet another source in sousveillance-aided government surveillance? Since this socially logged identity is highly persistent, "beware...your imagination leaves traces," as Bruno Latour argued.[45] As highlighted by Anjewierden and Efimova, the indexing of all self-generated material in the social logging and networked sites and via search engines raises issues related to preservation of these "digital traces," and the relationship between memory and surveillance.[46]

The absence of an archiving feature in the WebCamNow software, its inability to contribute towards one's life-log, and incapacity to be indexed by search engines raises interesting questions for performative projects in the surveillant-sousveillant space. The software appears to have been programmed with a "loss of memory" similar to the ethics of forgetting advocated by Dodge and Kitchin.[47] The systematic failure to account for one's online performance is already embedded in WebCamNow and its almost antisocial software may be the reason why so many people choose it over other videostreaming platforms such as justin.tv or Ustream.tv. It appears that WebCamNow's focus on live stream videochat without life-logging capabilities works as an emancipatory process that frees us from problematic effects of the surveillant-sousveillant space.

[45] Bruno Latour, "Beware Your Imagination Leaves Digital Traces," in *Times Higher Literary Supplement,* April 6, 2007, http://www.bruno-latour.fr/poparticles/poparticle/P-129-THES-GB.doc (accessed August 3, 2009).

[46] Anjo Anjewierden and Lilia Efimova, "Understanding Weblog Communities through Digital Traces: A Framework, a Tool and an Example," in *On the Move to Meaningful Internet Systems 2006: OTM 2006 Workshops* (Berlin/ Heidelberg: Springer), 280 (272-289).

[47] Martin Dodge and Rob Kitchin, op.cit., 17.

SEEING YOU/SEEING ME:
ART AND THE DISEMBODIED EYE

LIAM KELLY

Many Northern Irish artists have looked upon the city as a "written" text to be deconstructed. The cities of Belfast and Derry were heavily fortified and defended and as such are where the physical and psychic apparatus of the "political troubles" can best be experienced. These cities have been marked, segregated and intensively surveilled. Both communities in Northern Ireland mark their respective territories by painting kerbstones with appropriate symbolic colours (those of the Union Jack or Irish Tricolour) and by the flying of bunting and flags. Political murals register their echo and call within and between communities—they give notice as communal bulletins. Temporary barricades between the two rival communities have been erected or dismantled over the years or settled into permanent acceptance as necessary so-called peace lines. Army and police vehicles and helicopters have daily paraded or surveyed the cities, while army and police stations have become more and more designed for long-term fortification.

Derry's ancient walls have been symbolic of political and religious inclusion and exclusions for centuries. The role of the walls of Derry (built in the 1600s) has not changed. As with strategic buildings (those in the New Lodge area of Belfast) extensive and sophisticated surveillance equipment surveil "hot" areas of the city.

This essay will examine the emotional fabric of the surveilled environment and how Northern Irish artists have represented, interrogated or engaged with surveillance and the seeing/being seen binary. A number of artists have dealt with issues of surveillance and intelligence gathering, notably, Willie Doherty, Locky Morris, Philip Napier, John Aiken, Dermot Seymour, Rita Duffy and Paul Seawright.

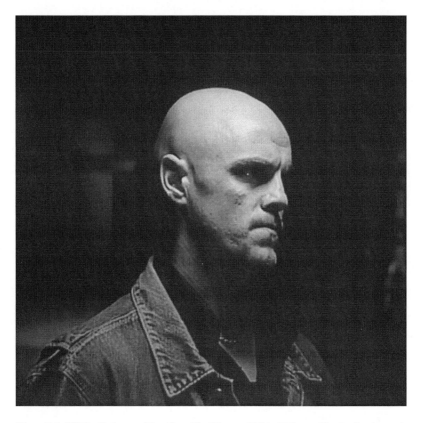

Plate 9.1. Willie Doherty, *Non-Specific Threat,* 2004. Video still, single channel video installation, duration: 7.45. Courtesy of the artist, Matts Gallery and Alexander & Bonin, New York, London.

Willie Doherty, in his photo/text works of the 1980s, dealt with concepts of land, identity and the watchful eye. Words were superimposed on images, one to interrogate and subvert the other. In *Fog:Ice/Last Hours of Daylight* (1985) nature is usurping a covert activity—who is the viewed and who is the viewer? In *The Walls* (1987), the artist arranges text to settle over sections of a horizontal panoramic view of the Bogside area of city in daylight, and the elevated dark inner side of the city walls from which we/the artist, the colonised/the coloniser, take in the view and take up a position. *The Walls* lingers with the legacy of the colonised and the coloniser in its absences and presences. From the inner, walled city, captioned "within/forever" (in loyalist blue), we survey the outer/other, the

Bogside, captioned "always/without" in Loyalist Green. Jean Fisher points to the fragility of the seeing/being seen relationship in *The Walls*:

> As we imagine that, with powerful lenses, we could penetrate the interiors of the facing windows, so we also become aware that those eyes may see us. Indeed, were it not for the presence of this gaze of the other, we should not be able to assume the sovereignty of power that this position affords us. The seeing/being seen dyad is a question of both position and disposition: I see you in the place I am not. However, what *The Walls* brings into relief is that this narcissistic relation between oneself and one's other beyond the given boundary is inscribed with a profound uneasiness.[1]

The Walls, then, deals with inclusion and exclusion, and Derry, in microcosm, reflects a siege mentality that is culturally endemic in Northern Ireland as a whole. In one of his most recent works, *Non-Specific Threat* (2004), Doherty explores threat and trauma by way of duplicity, but in a more universal and globalised manner than his earlier works. The language here is that of post 9/11 paranoia. In the late 1980s the British government banned direct interviews with Sinn Fein representatives, so that we got a curious form of image and dubbing by way of a disembodied voice acting in place of the speakers own voice. It testified to the distancing of the government from direct and apparently more dangerous speech, and implied the acceptance of indirect speech as more tolerable and acceptable:

> I was reminded of the Irish context with the 9/11 attempts to again close down language and close down possibilities of discussion around Islam and around the reason for a war, the reasons for a conflict. The work *Non-Specific Threat*, although the figure is a white western male as opposed to someone from an Islamic country, references the way that language has been made part of the arena again. And it foregrounds some of the same issues. It was interesting having lived through the troubles here to see many of the same issues and dilemmas being replayed again in another kind of conflict.[2]

In *Non-Specific Threat*, the "vocal" camera pans, through 360°, a male figure, specialising him as a surveyed subject. It is not clear, however, whether the voice-over is that of the subject himself, or another disembodied,

[1] Jean Fisher, *Willie Doherty, Unknown Depths* (Ffotogallery, Cardiff, in association with the Orchard Gallery, Derry and Third Eye Centre, Glasgow, Scotland: 1990), np.

[2] "Marking Time and Place," Liam Kelly interviews Willie Doherty and Frances Hegarty in *Prepossession*, exhibition catalogue, ed. Jill Bennett, Felicity Fenner and Liam Kelly (Sydney, Australia: Ivan Dougherty Gallery, 2005), 26.

dislocated and empowered voice and eye. Is the relationship panoptic but with the surveyed offering resistance to the dominant gaze by his demeanour and fixed, hard countenance? Or are we eavesdropping on self-reflective power? The sense of paranoia in the mental interior space evoked by and in language is further reinforced by a *film noir* sense of physical place—a heavily invested chiaroscuro of the psycho-spatial. The duplicity of the seeing/being seen dyad is at work again, in this case with the probing use of language and the mediation of the threat of the global terrorist. It also has to do with a state of mind. The Panopticon has to do with the power of positioning and knowledge, but can a state of mind be surveilled?[3] Is Doherty suggesting a blind spot unreachable by an apparently omniscient panoramic eye or camera in this mind game?

Like Willie Doherty, Locky Morris's early works are about surveillance in his native city of Derry. *Creggan Nightlife* (1986) and *Town, Country and People* (1986) both objectify the routine experience of military surveillance by helicopters, which hovered daily over "active" sections of Northern Ireland such as Derry. *Creggan Nightlife* was made just after college, and is more a modelling of the experience, more an illustration of an event. On the other hand, *Town, Country and People* is more resolved and self-sufficient, both as an object and as encapsulation of this aerial drama, sucking up the town's portable secrets.

Of course, the most common military unit of defence/resistance in Northern Ireland is the police grey Land Rover, as it tours the streets of towns and cities. In *Cortege* (1988), the unit or "cell" works like a biological organism's defence mechanism going into action. Here, an IRA funeral cortege is militarily chaperoned front and rear along a twisting roadway. Works like these, made of the simplest materials, such as cardboard, masking tape and paint (which adds to their sense of the ridiculous) explore the complexity of meanings and counter-meanings in the local situation. At the same time their economy of means carries a charge of recognition beyond the local resonances.

[3] The Panoptican was a design for a circular prison by Jeremy Bentham in the eighteenth century. The design principle, with the prison cells built around a central observation post, allowed for an observer to observe the prisoners without them being able to tell if they were being observed or not.

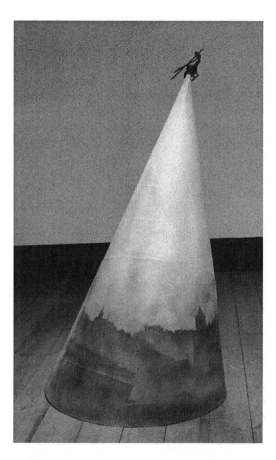

Plate 9.2. Locky Morris, *Town, Country and People*, 1986. Detail of the mixed media installation. Courtesy of the artist.

Morris's current studio is located within Derry's inner walled city, above a musical instruments shop. In 2004 he made *Of Note*, a ten-minutes looped video work taken by a camera directed out from his studio rear door and overlooking the classic view of the Bogside area of the city. Given the heavy and sophisticated surveillance equipment stationed on the walls, it is clear that the artist has produced an ironic "take" on the official viewing of the area. What is also evident is that there is nothing of note to record—a woman passes by, it rains, an external air conditioning unit kicks in to operation. The footage is banal and boring now that the drama of the Bogside has been played out. Its banality is further reinforced by the

accompanying monotonous sound track, inspired by the regular piano tuning sessions sounding up from the music shop below, which also contributed to the artwork's layered title *Of Note.*

There is also a kind of comic resistance in the mimicry of the work, if not menace, as Ashcroft, Griffins and Tiffin identify:

> The colonised subject may accept the imperial view, including the array of values, assumptions and cultural expectations on which this is based, and order his or her behaviour accordingly. This will produce colonial subjects who are 'more English than the English', those whom V.S. Naipaul called 'The Mimic Men' in the novel of that name. More often, such conversion will be ambivalent, attenuated, intermittent and diffused by feelings of resistance to imperial power, leading to what Homi Bhabha calls 'mimicry,' a 'conversion' that always teeters on the edge of menace.[4]

There is also a passing reference to Willie Doherty's previously discussed *The Walls,* offset by a now vertical rather then a panoramic view of the Bogside.

Philip Napier's art practice is not only an interrogation, but a detonation of language around and through an axis of power. His 1997 work *Gauge,* commissioned and developed for the Orchard Gallery, was conceived as a two-part project. Part 1 occurred as an installation in the Orchard Gallery space, whilst Part II was presented as a temporary site-specific public artwork in the Bogside area of Derry. It was also driven around town and sounded out from a public address system attached to a mask-like tower structure. Initially the events of Bloody Sunday (the 25th anniversary, January 30, 1997) provided the contextual point of reference for this work. It was conceived against a backdrop of sustained calls for an apology from the British Government for the events of Bloody Sunday on January 30, 1972, when fourteen unarmed civilians were shot dead by the British Army.

The installation consisted of fourteen audio speakers suspended by wire from circular dialled weighing scales, the traditional type you once saw in grocery stores. These speakers relayed a continuous litany of spoken apologies, "I'm sorry... I'm so sorry... I'm sorry about that... Sorry... I apologise." The sincerity of these apologies was being measured by way of the agitation of the needle on the face of the dial. The slipperiness of language, its ambiguous disposition, especially in colonialist or conflict situations, was in effect being "gauged." The work evolved as a

[4] Bill Ashcroft, Gareth Griffiths and Helen Tiffin, *Key Concepts in Post-Colonial Studies* (London: Routledge, 1998), 227.

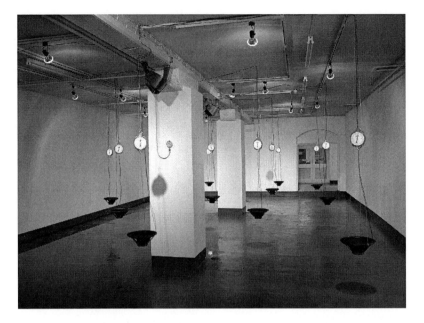

Plate 9.3. Philip Napier, *Gauge*, 1997. Multi-media installation (Part 1), Orchard Gallery, Derry. Courtesy of the artist.

proposition that language alone cannot be adequate, indeed that no measure of language can be enough because it is always contextual and conditional. It is a question of power relations, as if a bureaucratic apology could ever be enough to eradicate a communal wrong.

In Part II, this work was reconceived and installed in a derelict Housing Executive dwelling in Glenfada Park in the Bogside. The installation faced a courtyard, which was the site of some of the shootings and one of the last architectural remnants of the events of 1972, lingering now amidst widespread redevelopment. The work was installed as though in hiding in this largely unreconstructed derelict house, and was encountered through torchlight amidst unsettling blanket darkness.

The house chosen for the installation was itself, amidst other houses in the area, subject to the panoramic surveillance from the walls above. As such, it is a case in point of Jean Fisher's previously quoted remark "...that those eyes may see us." However, with *Gauge* there is the shift from "seeing" to "listening" and an eavesdropping on "...a profound uneasiness." There is also a spiritual fatigue in the repetitiveness of the rhetorical language and in its interrogating litany.

The central theme of these two presentations of the work focused on the value and nature of an apology. Who is apologising and to whom? Can mere words be adequate? Are words measured or can they be "measured?" The discourse surrounding the problematic of the nature of apology echoes with the registers of colonial and post-colonial situations the world over. In that year alone, to my knowledge, this debate about apologising had stretched from Japan and its treatment of World War II POW's, to South Africa and its Commission for Truth and Reconciliation, to the Bosnia War Crimes tribunal in The Hague.

In Philip Napier's *Gauge,* it is not specified who is asking for an apology, who is apologising or to whom they are apologising. This public and private experience is left to address the cultural and political baggage of its audience. The act of mediation here arises from its local and universal outreach. Tom McEvilley acknowledges this issue of both local and global relevance in his catalogue essay on *Gauge,* as he experienced at first hand this site-specific work:

> Encountered in Glenfada Park, the piece seemed to refer to the Irish demand that the British apologise for Bloody Sunday. Indeed its appropriateness to the site combined with its sense of dark hiddenness—was uncanny, almost eerie. Still, as one listened, its resonances seemed to pass beyond the specific situation and approach the universal. Not only the British relation to the Irish seemed involved, but the relationship of all colonisers to all the colonised peoples everywhere. It reminded me of Hegel's parable of the Master and the Slave, from the second book of the *Phenomenology of Spirit,* where History is seen as a long slow shift of relationship through struggle, in which the antagonists' attempts to overcome one another through annihilation culminate in a mutual overcoming through a kind of absorption, a reception of the other as the negation which completes oneself.[5]

McEvilley raises two pertinent points here. Firstly, the universal outreach of Napier's work beyond but extending out of the local, the immediately known. Secondly, the role or possibilities of language in bringing about wholeness or resolution between colonised and coloniser or resolution within a state of interdependence. In this he embraces, by way of Hegel, Homi K. Bhabba's *Third Space of Enunciation* as a necessarily ambivalent space.

[5] Tom McEvilley and Philip Napier, *Gauge,* exhibition catalogue (Derry: Orchard Gallery, 1998), 6.

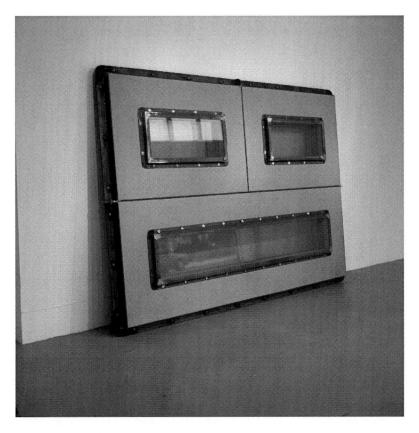

Plate 9.4. John Aiken, *About Face*, 1991. Steel, wire reinforced glass and wood, 316 x 216 x 25 cm. Courtesy of the artist.

In *About Face* (1991), John Aiken turned again to his former "bunker" concerns—shelter, defence, surveillance, refuge—the formal expression and attractions of what Paul Virilio calls the archaeology of the bunker. Virilio considers the city within a "space of war...a space having its own characteristics:"

> I suddenly understood war was a space in the geometrical sense, and even more than geometrical: crossing Europe from North to South. From the shelters of German cities to the Siegfried Line, passing by the Maginot Line and the Atlantic Wall, makes you realise the breath of total war. By the same token you touch on the mythic dimension of a war spreading not only throughout Europe, but all over the world. The objects, bunkers,

submarine bases etc. are kinds of reference points or landmarks to the
totalitarian nature of war in space and myth.[6]

Anyone familiar with Belfast knows how heavily protected it became
by armoured police Land Rovers; also by police stations and army
fortifications. They are truly forts within the city, some stationary, others
on patrol: both faceless to the citizen. In *About Face*, made of steel, wood
and wire-reinforced glass, the notion of surveillance is embedded, gasket-
tight, into and through the anthropomorphic of the military deity of
defence. *About Face* may be read as a capsule, a symbol of Belfast as
fortress, metal hard and only looking out. The symbolic nature of the
military voyeurism of the piece is further extended by the street aspect of
the Orpheus Gallery, Belfast, where it was first exhibited. The gallery
functioned as a street capsule, except that passers-by can see in and,
indeed, come in. There was a power in the casualness with which *About
Face* leaned against the gallery's rear wall, and a resistance in the fact that
it will never hang on the wall. In *About Face*, we will never know if we are
being well looked after.

Dermot Seymour is fond of incorporating military insignia, flags and
graffiti in his paintings as forms of making and categorising. It is, however,
the titles of his paintings that set the riddles off. His titles do more than
merely describe. They humorously extend the meanings by interlacing
them, as in *The Queen's own Scottish Borderers observe the King of the
Jews appearing behind Sean McGuigan's sheep on the forth Sunday after
Epiphany* (1988). The words roll together the series of juxtapositions in the
imagery: military intrusion and surveillance; religious expression and rural
circumstance.

The convoluted nature of local historical reference, anecdote and myth
is interlaced into the titles like tatted lace—a world without end. The
complications of our culture come out of locations, like pookas at night. A
crossroads is not just a junction, it is where someone was shot, a patrol
ambushed, a 300th anniversary celebrated each year, or where traffic is
monitored or surveyed. That is the nature of the land question in Ireland.
Seymour's townland or locale is always on the brink. In *A Lysander over
Ballymacpherson, County (l) Derry* (1984), a figure floats in a world of
optical displacement. Viewed from a spotter plane (a Lysander), a reclining
female figure on the land is "brought up" by the voyeuristic tendency of a
British soldier on surveillance above. This was the first of a number of

[6] Paul Virilio and Sylvere Lotringer, *Pure War* (New York: Semistext Inc.,
Columbia University, 1983), 10.

works that would probe the potentially wayward and dangerous nature of surveillance.

Images of security watchtowers have been evident in Rita Duffy's work for the past twenty years. In this body of work she has moved between the more pictorial depiction of their spectral presence on the landscape, to more intimate and personal engagement with their potent symbolism and threat. As a young woman growing up in Belfast during the political troubles, Duffy was aware of, and sensitive to, the military male gaze, whether by street patrolling soldiers or the hidden observer from a surveillance tower. *The Dark* (1997) is a politically and indeed sexually ambivalent drawing. The artist appears to be subsumed and consumed by a watchtower on its hilltop. She seems to be wearing it like a gown in which she swoons in a reverie-like trance, acknowledging if not indulging in a sense of loss, where something has been given up or taken away. That sense of loss, and the power of surveillance to destroy something precious and private by its persistent viewing, is at the heart of the colonialist condition and enterprise. It is beautifully expressed in Suzanne O'Shea's translation of the poem *Donall Og*, where she appropriates its wailing sentiment in reflecting upon "the power of the dark" in Duffy's work:

> You have taken the sun
> You have taken the moon from me.
> You have taken the stars
> And before
> And after from me.
> And my fear, it is great,
> That you have taken my God from me.[7]

Duffy is also attracted by the anthropomorphic features of these virile erections on the landscape, with their primitive-like blockheads recalling fortified warriors. There is a painting by the Australian artist Sidney Nolan (*Ned Kelly*, 1946), from his Ned Kelly series in which he depicts the bushranger as an armoured horseman riding in the hot, mirage-inducing, Australian outback. The painting is essentially about the nature and relationship of the landscape to the all-pervading myth of the Kelly story. To achieve this compound interrelational state between figure and ground,

[7] Suzanne O'Shea, *Banquet, New Works by Rita Duffy*, exhibition catalogue, (Belfast: Ormeau Baths Gallery and Dublin: Hugh Lane Gallery, 1997), np.

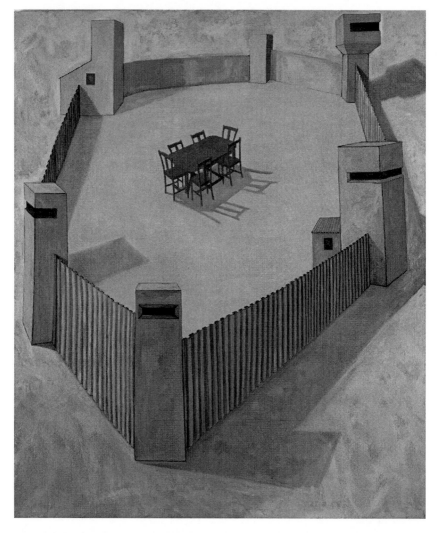

Plate 9.5. Rita Duffy, *Banquet*, 1998. Oil on linen, 122 x 183 cm. Courtesy of the artist.

so-to-speak, Nolan embodies Kelly as the armour in black outline shape with the squared-off helmet as a "watchtower." Through a slit in the helmet/tower the sky with billows of gun shot smoke can be viewed. The viewer and the viewed are one, the depersonalised Kelly is "in" and "of" the landscape, and the legacy of folk heroism in invested in the landscape by the power of myth.

The military watchtowers, which dot and occupy the borderland landscape of the North of Ireland, take on the appearance of great warriors. They remind Duffy of the Japanese Samurai tradition with its layering of body armour, and more paradoxically of the Celtic warrior tradition. In many respects Ulster was the most Celtic of the four provinces—tribal, wayward and violent: always worth watching.

While the watchtowers are potent physical symbols of the vigilant presence of the British to the nationalist community, Duffy has also been attracted to their metaphysical ramifications and emotional provocations. She has painted a number of dreamlike spare images of defensive forts, reminiscent of Giorgio de Chirico, and the fossilised immobility of his "pictura metafistica." Works such as *Banquet*, *Plantation* and *Settlement* (all 1997), painted in "shot" colours, witness the propagation and ring-fencing of disturbance and control.

There are no figures in these duplicitous works. *Banquet*, with its big house associations, has a table set for dining (or is it a conference table for planning?) placed in the open space of a military fort. *Plantation* has a vegetable "plot" in its interior, while *Settlement* has a "bullet" hedge corralling domestic-scale houses into order. In all three paintings the legacy of history and memory permeate the present and intrude on the personal and domestic. They play on the relationship between subject, the condition of subjecting and the nature of subjection.

Policing in Northern Ireland has always been a very contentious issue since the political troubles began. The Royal Ulster Constabulary (RUC), recently reformed and renamed the Police Service of Northern Ireland (PSNI), has been accused by Nationalists/Republicans of collusion with loyalist terrorists in a number of high profile murders, and, with a largely Protestant membership, of generally acting in favour of Unionists. More recently, as the reformed PSNI, they have been attacked and criticised by Unionists for using heavy-handed tactics against their community. Whatever view is taken of their impartiality, they have been at the centre of world media attention for the last number of decades in their role as the state's security agents in situations of civil unrest, and yet much of their activities remain covert.

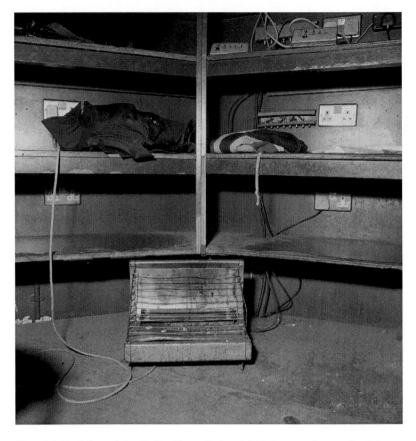

Plate 9.6. Paul Seawright, *Police Force Series*, 1995. C-type print on aluminium, 100 x 100 cm. Courtesy of the artist and the Kerlin Gallery, Dublin.

In 1995, artist Paul Seawright was given open and free access to travel around with the police in their patrol vehicles, experiencing their daily routine and their operating environment. As a result he produced a series of photographs, *Police Force*, registering the banality of security work and intelligence gathering—it psychographic tawdriness. As David Chandler saw it:

> The work emerges as a series of fragments, Seawright's camera moves furtively, inspecting areas normally unseen or unnoticed, distorting and reshaping the familiar into the strange. The low viewpoint—a recurring motif of his work—is again used to throw the pictures into a different

register, an alternative strata of vision in which looming shapes, figures and objects appear threatening and at times grotesque.[8]

All the photographs in the series avoid personal identities, concentrating on the apparatus of control and surveillance, and drawing attention to mundane but telling detail. Two figures in black uniforms with waist-belt gun and portable radio, basic tools of the trade, are silhouetted against the spectral blue void of a searchlight. Body parts are zoomed in on—a listening ear, a prosthetic hand, a police dog's snarling teeth. It is a fragmented world, dislocated, menacing at times in its ordinariness; at other times plain ordinary. Seawright, by way of a perambulating and wayward camera, recorded, indirectly and by stealth, material and psychological evidence of an inner world—a probing surveillance of the condition of surveillance and control.

The police service has been continuously present on our TV screens by way of news reportage. In Seawright's photographs they are there in their absence, invested in the fabric of their operating environment, but still enigmatic and posing yet more questions than answers.

The artists considered in this essay have responded to the formal as well as the layered values that get laid into walls, fortifications, and buildings—the psychic fabric of the city. Their work is an act of continual interrogation. In this interrogation they often deploy the strategy used by state surveillance itself, namely the use of the camera by stealth (the disembodied eye), or engage with intelligence gathering's more physical or dramatic outward display. In either case, what this artistic interrogation has established is the corrupting nature of difference, by way of a tendency to either include or exclude, to locate or dislocate. Within this political and social construction, as it is applied to Northern Ireland, the wall becomes the dividing line between the "cultured" inner and the "riotous barbarous" other. In relation to this, the surveillance tower, the hovering helicopter, the roving police vehicle allowed for the supervision of the extra mural. The technologies of surveillance set up a hierarchy of dominance of "controller" to "controlled." They are like disembodied eyes that act like mechanical and electronic organs of perception that recurred without any historicising on contextualising vision.

[8] David Chandler, from the series "Police Force," in *The Lie of the Land,* ed. Christine Redmond (Dublin: Gallery of Photography, 1995), np.

This text was originally published by Liam Kelly in *Art and the Disembodied Eye, Collective Histories of Northern Irish Art* (Belfast: The Golden Thread Gallery, 2007). Some aspects of the text have also been published in *Thinking Long, Contemporary Art in the North of Ireland*, by Liam Kelly (Kinsale: Gandon Editions, 1997).

CONTRIBUTORS

Anthony Downey is the Programme Director of the MA in Contemporary Art at Sotheby's Institute of Art, London and an editorial board member of *Third Text*. He has published essays, criticism and interviews in numerous international journals. Recent and forthcoming publications include "Zones of Indistinction: Giorgio Agamben's 'Bare Life' and the Politics of Aesthetics," *Third Text*, vol. 23, no. 2 (2009); "At the Limits of the Image: Representations of Torture in Popular Culture," *Brumaria*, no. 14 (2009); "Thresholds of a Coming Community: Photography and Human Rights," *Aperture*, no. 194 (February 2009) and "Camps (or, the Precarious Logic of Late-Modernity)," *Fillip*, issue 14 (2010); and "An Ethics of Engagement: Collaborative Art Practices and the Return of the Ethnographer," *Third Text*, vol. 23, no. 5 (2009). Downey is currently researching a book with the working title, *The Ethics of the Real: Politics and Aesthetics* (forthcoming, 2010).

Christine Eyene is Editor of *Creative Africa Network*, a project of puma.creative, and member of the editorial board of the French journal *Africultures*. She is also a research student at Birkbeck College, University of London, with Professor Annie E. Coombes; a member of the advisory board of the South African Visual Arts Historians: Comité International d'Histoire de l'Art, as part of the colloquium "Other Views: Art History in (South) Africa, and the Global South" to be held in South Africa in 2011. Recent and forthcoming publications include: "Yearning for Art: South African Exile, Aesthetics and Cultural Legacy," in Lize Van Robbroeck (ed.), *Visual Century: South African Art in Context, 1907-2007*, vol. 2 1945-1976 (forthcoming, 2010); "Past Virginity: Women, Sexuality and Art," in Bisi Silva, *Like a Virgin: Lucy Azubuike and Zanele Muholi* (CCA, Lagos: 2009;) "George Hallett: The Human Face of History," *Art South Africa*, vol. 6.3 (autumn 2008).

Liam Kelly is Professor of Irish Visual Culture at the School of Art and Design, University of Ulster, Belfast. He is a writer and broadcaster on contemporary Irish and international art. His publications include *Thinking Long: Contemporary Art in the North of Ireland: The City as Art*

(ed.) and *The Disembodied Eye*. He has also curated both solo and thematic exhibitions in Ireland, Australia, USA, France, Slovenia and Hong Kong. He took part in *L'imaginaire Irlandais*, a major festival of Irish culture, as curator of *Language Mapping and Power*, exhibited in Paris in 1996. From 1986-1992 he was Director of the Orpheus Gallery, Belfast and from 1996-1999 Director of the Orchard Gallery, Derry. He is a Vice-President of The International Association of Art Critics and former executive board member of Association of Art Historians (UK). Currently he is a member of the BBC Northern Ireland Audience Council and a board member of the Ormeau Baths Gallery, Belfast.

Robert Knifton is currently a Lecturer at the Centre for Museology, University of Manchester. He completed a collaborative doctorate at MIRIAD, MMU and Tate Liverpool in 2009, examining artistic representation of Liverpool since 1945. For his PhD, he co-curated the Tate Liverpool exhibition *Centre of the Creative Universe: Liverpool and the Avant-Garde, 2007*.

Verena Kyselka is an artist based in Berlin and Erfurt. Her work explores experience in contemporary history. Kyselka's recent projects have focused on former East Germany and East Europe and include the exhibitions: *Andreas Gegenüber* (Andreas Opposite, Erfurt, Germany, 1999); *Inclusion* in a former Stasi prison (Erfurt, Germany, 2005); *Conspiracy Dwellings* (Erfurt Germany, 2007 and Bracknell, UK, 2007-2008); *Territory of Intimacy // Forbidden Kisses* (Galeria e Vogel and Gallery at the Ministry of Culture, Tirana, Albania, 2008); the 6th Gyumri Biennale (Gyumri, Armenia, 2008-09); *re.act.feminism: East European Performance* (Academy of Arts, Berlin, Germany, 2009) and *Territory of Intimacy // Transcaucasian Identification* (Museum of Modern Art, Yerevan, Armenia, 2009).

Maciej Ożóg is a media theorist, researcher and musician. He works at the Electronic Media Department in the University of Lodz, Poland. His research focuses on the history and the theory of media arts, surveillance culture and information society. He has published on the aesthetics of interactive art, the history and the theory of avant-garde film and video art, and experimental music. In 2007, he received a postdoctoral research fellowship from the Polish Ministry of Science and Higher Education. As a musician he released several albums with Spear and Ben Zeen. In addition, Ozog established Ignis, the label for experimental electronic and electro acoustic music and has curated and organised concerts, festivals

and exhibitions, including *Poza horyzont* (*Beyond Horizon*, 2005), a project of new media art and experimental music. Ozog is currently working on a book, *Surveillance as Theme and Method of New Media Art*.

Outi Remes is a curator and art historian. She is Head of Exhibitions at South Hill Park Arts Centre in Berkshire and lectures on modern and contemporary art and gallery studies at Birkbeck, University of London. She has curated a wide range of exhibitions and live art projects, including *Rules and Regs* live art residences (2007, 2008 and 2009) and the *Sound:Space* exhibition season (2008) that included thirteen sound artists such as Max Eastley. Her research interests include contemporary art in relation to media culture, cultural interaction in public spaces and the production of the self. She has a PhD from the University of Reading (2005) and has recently published on photography, sculpture and the production of the artistic self.

Paula Roush is an artist, researcher and lecturer in digital photography at the London South Bank University where she teaches courses on artists' work with archives, photo-books and self-publishing, performativity and surveillance space. She also teaches art theory on MA, Art and Media Practice at the University of Westminster. She is the founder of *msdm* (msdm.org.uk), a platform exploring mobile strategies of display and mediation. Roush co-curated the exhibition-platform *Local Worlds: Spaces, Visibilities and Transcultural Flows* at Centro Cultural de Lagos, Portugal, on artists' diasporic strategies. Recent publications include: "Download Fever: Photography, Subcultures and Online-Offline Counter-Archival Strategies," in *Photographies* vol. 2, no. 2 (2009) and "Between Snapshots and Avatars: Using Visual Methodologies for Fieldwork in Second Life," in *Journal of Virtual Worlds Research*, vol. 2, no. 1 (2009).

Matthew Shaul has been the Head of Programming at the University of Hertfordshire (UH) Galleries since 1996 and has been involved in the production of pioneering projects at the UH Galleries in the arena of modern and contemporary photography including *Aftershock: Conflict, Violence and Resolution in Contemporary Art* (in collaboration with the Sainsbury Centre, Norwich, 2007) and *Do Not Refreeze: Photography Behind the Berlin Wall* (2007-09). Recent touring projects include: *Margareta Kern, Clothes for Living and Dying* (2008-2009) and *David Moore, the Last* Things (2008-2009). Shaul's curatorial freelance commissions include *The Art Marathon,* BBC TV (1995); the *BBC Design*

Awards Exhibition (Glasgow, 1996) and *Erasmus Schroeter: Hiding in Plain Sight* (CUBE, Manchester, 2004).

Pam Skelton is an artist and Reader in Fine Art at Central Saint Martins College of Art and Design, London. Her work has been shown widely in venues including the Imperial War Museum, London, (1995); Museum of Modern Art, Dubrovnik, (2002); Moscow Biennale, (2007); Ormeau Baths Gallery, Belfast, (2009). She is co-editor of the exhibition and book *Private Views: Spaces and Gender in Contemporary Art from Britain and Estonia,* (WAL, 2000); co-curator and co-author of the exhibition *Hygiene: The Art of Public Health,* London School of Hygiene & Tropical Medicine, London, (2002) and *Journal of Visual Culture* vol. 2, no. 1 (Sage Publications, 2003); "Restretching the Canvas" in *Unframed, Practices & Politics of Women's Contemporary Painting,* ed. Rosemary Betterton, (IB Tauris, 2004). Currently she is working with Jessica Dubow on the AHRC interdisciplinary art project *Archive of Exile.*